WebWorks

ROCKPORT

First published in the United States of America by
Rockport Publishers, Inc.
33 Commercial Street
Gloucester, Massachusetts 01930-5089
Telephone: (978) 282-9590
Fax: (978) 283-2742
www.rockpub.com

ISBN 1-56496-990-8

10 9 8 7 6 5 4 3 2 1

Design: Jerrod Janakus

Grateful acknowledgment is given to Ken Coupland for his work on pages 8–61; to
Jason Mills and Daniel Donnelly for their work on pages 62–107; to Katherine Tasheff
Carlton for her work on pages 108-169; to Martha Gill for her work on pages 160–221;
and to Thomas Forbes for his work on pages 222–261.

Printed in China

GLOUCESTER MASSACHUSETTS

ROCKPORT

PUBLISHERS

WebWorks
Exploring Online Design

Contents

getting

What can they tell us about...

from

A ←————————————————————————→ B

Navigation on the Web

Steering a Course to Better Navigation

by Ken Coupland

Once upon a time, in the World Wide Web's halcyon days, the concept of Web navigation sounded thrilling. It was as though you were embarking on a voyage of discovery. The new medium gave "navigation" an almost romantic ring. Taking its visual cues from models that had been developed for earlier interactive media, navigation was seen as little more than a means of providing an opportunity for designers to show off their graphic-design smarts and not as an integral part of Web functionality.

What a difference a few million more Web sites makes—not to mention the billions upon billions of dollars in revenue now moving through e-commerce and business-to-business online transactions. Today, navigation is less a warm-and-fuzzy concept and more a do-or-die proposition. It's also a two-way street. As the pace of development on the Web approaches warp speed, a huge audience awaits, an audience whose increasing sophistication and increasingly insistent demands are more than a match for the best navigation strategists. Meanwhile, the typical Web site is looking less like a work of graphic art and more like a product of industrial design. How visitors interact with what's in front of them online—and how well they find their way around while they are there—is a critical component of the design mission.

While good graphic design is still an undeniable asset, other factors have intruded on the designer's domain. As a result, the online graphic designer now joins a much larger team—of human factors experts, software engineers, and programmers among others—with more job categories constantly being added to the list. The much-touted "user experience," to adopt a phrase that describes the infinitely variable interactions that Web designers must coax the user to perform, draws on all sorts of capabilities. Often fickle and easily frustrated, users who encounter miscues or misdirections will flee in frustration, "abandoning the shopping cart" at the precise moment when the Web site's transactional mechanisms are poised to close the sale. In the brutally efficient feedback loop of Web commerce, it quickly becomes evident what works and what doesn't. Yet the biggest and best-equipped sites continue to disappoint users time after time.

The crux of the situation lies with navigation. Navigation, after all, has been fundamental to the Web's dynamic from its beginnings. And now, more so now than ever. Yet Web sites by their very nature provide few of the graphical and textual cues to navigation that audiences have come to take for granted in older media. Designers familiar with traditional media types need to learn new navigation strategies—and in some cases, unlearn old ones. Sites that reward visitors with ease-of-use and instant gratification will succeed. Sites that frustrate users and send them away will fail. New rules and new solutions are urgently called for.

How do Web designers create a satisfying customer experience? What are the hurdles they face, and how have they overcome them? What lessons have they learned and, perhaps most important, what can they tell us about what's in store down the road for navigation on the Web? In the pages that follow, you'll find as much concern with describing the process by which a navigation structure was derived as with the navigation itself. The journey, in other words, is as important as the destination.

The Discovery Homepage, redesigned, before
(left) and after (right), by the design firm, iXl.

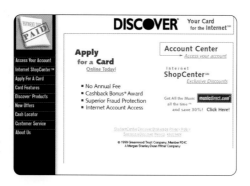
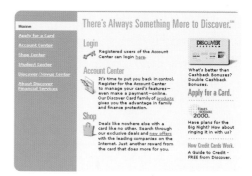

Many of the projects presented herein are redesigns of existing Web sites, which, for one or more good reasons, were due for an overhaul. As the Web has evolved from glorified "brochureware," in which it was enough for a company to announce its presence, to hard-nosed vehicle of commerce, the focus of the experience has shifted, and sites have been retrofitted to reflect the needs of users rather than a company's internal organization.

When they do talk about navigation, designers tend to speak in metaphors: based on botany, such as trees, trunks, limbs, and branches or, less frequently, on genealogy, such as grandparents, parents, and children. Hierarchies of information are either "shallow" or "deep." Generally, the principles of navigation are easy to comprehend.

Implicit in any discussion of navigation on the Web is a set of ground rules—although some may say these have usually been honored more in the breach than the observance. While you'll find any number of variations on the theme in how-to manuals in print and on the Web, the bulk of guidelines for good navigation tend to have a lot in common with each other. Bone up on the basic principles of navigation and dive into the illuminating explanations that follow. And have a pleasant and rewarding journey. ■

What's in store down the road

for navigation on the Web?

that good design is good business.

BBK has been recognized in almost every major graphic-design competition and has been featured in numerous books and magazines. Clients include Herman Miller, Ogilvy & Mather, Autocam, Grand Valley State University, VMF Capital, the Urban Institute of Contemporary Arts, and Priority Health.

BBK STUDIO is a multidisciplinary design firm specializing in communications consulting and web development. The 17-person firm was founded by Michael Barile, Kevin Budelmann, and Yang Kim in January 1997 and is based in Grand Rapids, Michigan.

Our design process includes the creative integration of business strategy and technology that maximizes resources to meet client objectives. We create informative and memorable brand experiences through collaborative planning, information architecture, and compelling aesthetics.

We believe that design can be a tool for advancing business and culture—that good design is good business.

FOREGROUND
BACKGROUND
WORK
PLAY
CONTACT

bbkstudio

Herman Miller Product Showroom

http://www.hermanmiller.com

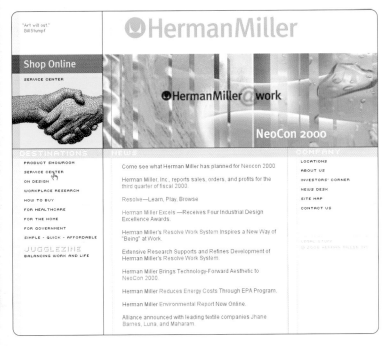

The Product Showroom/International Template navigation is a page template designed for displaying the company's product information through a browser. The project criteria included developing a content-management system by which information can be updated by nontechnical resources through a browser.

The International Template is a kind of "site in a box" designed for Herman Miller's subsidiaries abroad. It too allows for browser-based content management, but unlike the current version of the Product Showroom, it can accept multiple languages and page templates. The tool allows for content managers to create, delete, and update pages, and to customize the appearance of their site. By using the template, the groups can take advantage of preset global navigation and dynamically updated local navigation.

Each page provides both a primary and secondary navigation route. The primary navigation contains graphical headers that represent the site-specific and first-tier category content. The global navigation links to pages that are site specific, including a text-based site map and search features. A "bread-crumb trail" provides text-based links back up the trail through the category front page to the site front page, providing a consistent visual representation of the users location within the site. This constitutes the primary navigation.

To the left of the bread-crumb trail is a tab that, when expanded, provides a vertical listing of first-tier categories. Selecting a category on this list displays secondary listings of pages within that category. Selections here link directly to a particular page. This provides the ability to navigate from any page to any other page on the site, constituting the secondary navigation.

The combination of these two forms of navigation creates both a sense of place within the context of the site and a decentralization of content for return visitors who know where they want to go. The site map becomes a relic for users with newer browsers and nothing stands between users and the content they seek, once they become familiar with the basic navigation logic of the site.

One significant challenge in developing this navigational structure is meeting the technological demands without "fattening" the pages. The pages should average around 30k. To include a full site map of navigation without exceeding this limit requires a way of dynamically loading portions of the page in a manner that does not disrupt overall design of the page. The designers solved this problem through the use of cross-browser dynamic layers as opposed to frames, which are difficult to adequately position within a pixel-perfect design.

Client Herman Miller, Inc. **Team** Kevin Budelmann, creative director; Kevin Budelmann, Michael Carnevale, Yang Kim, Alison Popp, Matt Ryzenga, designers; Leah Weston, Courtney Schramm, producers; Scott Krieger, Von Neel, Jeff Sikkema, programmers **Since** April 1999

Tools BBEdit, Adobe Photoshop, Adobe ImageReady, Anarchie, HP Unix, Apache

Site Map

Classic Furniture

Eames
Eames Molded Plywood Lounge Chair
Eames Molded Plywood Chair
Eames Molded Plywood Side Chair
Eames Lounge Chair & Ottoman
Eames Molded Plywood Screen
Eames Sofa Compact
Eames Molded Plywood Coffee Table
Eames Elliptical Table
Eames Wire Base Table
Eames Dining Table
Eames Walnut Stools
Eames Hang-It-All
Eames Metal Leg Lounge Chair
Eames Soft Pad Lounge Chair
Eames Soft Pad Ottoman
Eames Aluminum Group Executive Chair
Eames Aluminum Group Management Chair
Eames Soft Pad Management Chair
Eames Three-Seat Sofa
Eames Two-Seat Sofa
Eames Rectangular Dining Table
Eames Aluminum Group Lounge Chair
Eames Aluminum Group Ottoman
Eames Chaise

Nelson
Nelson End Table
Nelson Platform Bench

Noguchi
Noguchi Table

Girard
Girard Pillows
Girard Table Runners
Girard Scrims

Covey
Covey Stool (Model 6)

Office Furniture

Beirise Collection
Beirise Table
Beirise Side Table
Beirise Corner Table
Beirise Corner Table Extension
Beirise Bookcase
Beirise Cabinet
Beirise Cabinet with Doors
Beirise Cabinet with Drawers
Beirise Mobile Storage Unit
Beirise Overhead Bookcase
Beirise Overhead Bookcase with Doors
Beirise Work Organizer
Beirise Display Shelf
Add-On Bookcase Shelf
Beirise Tackboard

TJ Collection
TJ Computer Desk
TJ Table Desk
TJ L-Return
TJ Two-drawer File Cabinet
TJ Mobile Drawer Pedestal
TJ High Desk Organizer
TJ Low Desk Organizer
TJ Overhead Bookcase

Newhouse Collection
Newhouse Desk with Display
Newhouse L-Return
Newhouse Return Bookcase
Newhouse File Storage Bookcase
Newhouse Storage Cabinet
Newhouse Two-Drawer File Cabinet
Newhouse Mobile Drawer Pedestal
Newhouse Corner Wedge

Puzzle
Puzzle Mobile Office

Office Chairs

Aeron
Aeron Highly Adjustable Work Chair
Aeron Side Chair

Equa 2
Equa 2 Adjustable Work Chair
Equa 2 Side Chair

Reaction
Reaction Highly Adjustable Work Chair
Reaction Adjustable Work Chair

Avian
Avian Work Chair
Avian Side Chair

Limerick
Limerick Side Chair

Office Accessories

General
File Drawer Organizer
Utility Tray
Pencil Drawer
Scooter Stand with Plastic Top
Scooter Document Stand
Scooter Stand with Wood Top
Adjustable Keyboard and Mouse Tray
Palm Rest
Ibis Light
Freestanding Task Light
Under-Shelf Task Light
Pavo Task Light
Paper Tray
Diagonal Tray
Foot Pillow
Relay Folding Screen
Beirise Wire Trough
TJ Wire Management Kit
Lapdog
Scooter Palm Rest
Footrest
Horizontal CPU Holder
Overlay Surface
Armature
Document Stand

Gift Ideas

Amenities
Eames House Tour Flip Book
House Construction Flip Book
Toy Trains Flip Book
Lounge Chair Flip Book
Powers of Ten Flip Book
House of Cards Small
House of Cards Medium
Eames House T-Shirt
Lounge Chair T-Shirt
Wire Chairs T-Shirt
Glimpses of the USA T-Shirt
Tanks T-Shirt
Computer House of Cards T-Shirt
DCM T-Shirt

Customer Services

Contact Us
Help & Information
FAQ
What's New
Privacy & Security
Seating Comparison Chart
Copyrights & Trademarks
Warranty Information
Sales & Return Policies

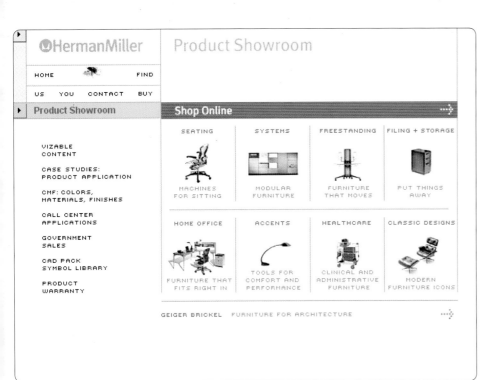

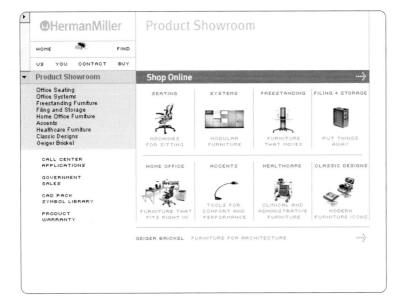

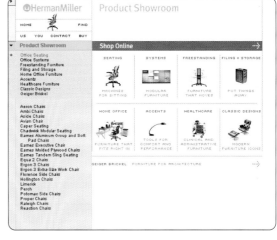

Users can drill down through menus to navigate from one page to another. The result of this path is a bread-crumb trail that can also be used as navigation.

The menu content is pulled dynamically and in real time from a database. The client can add and delete pages, as well as edit content using a Web-based interface. These changes are reflected automatically in the menu.

This kind of interaction allows for non-linear, non-hierarchical navigation through a site. A user can jump from one page directly to another page without having to load index pages.

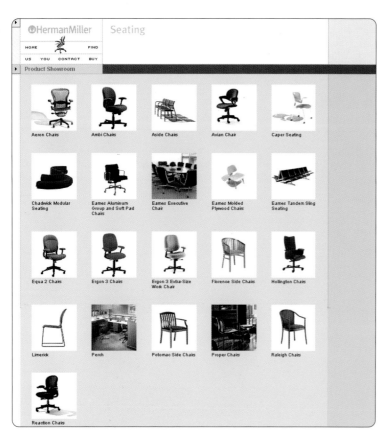

Users can reveal pieces of information, images, and multimedia by selecting from the menu. This kind of interaction allows for an experience less common in Web-based media. In this model, specific pieces of content are loaded on demand rather than jumping from page to page.

The content is pulled dynamically and in real time from a database. The client can add and delete pages as well as edit content using a Web-based interface. These changes are reflected automatically in the menu.

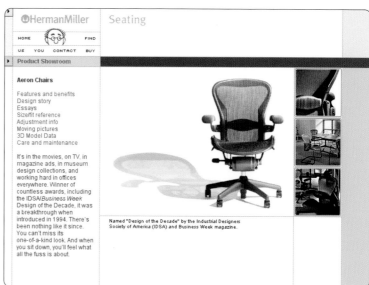

site: www.hermanmiller.com

HOME FIND
US YOU CONTACT BUY

▶ Product Showroom

Aeron Chairs

Features and benefits
Design story
Essays
Size/fit reference
Adjustment info
Moving pictures
3D Model Data
Care and maintenance

It's in the movies, on TV, in magazine ads, in museum design collections, and working hard in offices everywhere. Winner of countless awards, including the IDSA/*Business Week* Design of the Decade, it was a breakthrough when introduced in 1994. There's been nothing like it since. You can't miss its one-of-a-kind look. And when you sit down, you'll feel what all the fuss is about.

Features and benefits

- The Aeron chair's broad range of seat height adjustment allows its users to choose either the forward-bias or semi-reclined position—or anywhere in between—over the course of a long day and through a variety of tasks.
- The patented Kinemat tilt mechanism allows the body to pivot naturally and simultaneously at the ankle, knees, and hips—providing a smooth ride and proper support from forward-leaning to reclining postures.
- Its unique Pellicle material distributes weight evenly over the seat and back, conforming to each person's shape. The material lets air pass through, adding to long-term comfort by preventing body heat and moisture build-up.
- All adjustments are intuitively understandable and easily manipulated from a seated position.
- With its two-stage pneumatic lift, the Aeron chair has an unprecedented seat-height range — from a low of 14 3/8 inches (on the A-size chair) to a high of 20 7/8 inches (on the B and C sizes).
- The tilt-tension adjustment lets the user easily control the resistance felt when leaning back.
- The forward-tilt adjustment positions the seat angle 5 degrees forward, a posture favored by many computer users.
- The lumbar pad can be adjusted vertically through a 4 1/2-inch height range. Its depth can be set at 3/4 inch or 1 1/4 inches.
- Armrests pivot inward 17.5 degrees to support forearms for keying, outward 15 degrees to provide a comfortable base for mousing.
- Arm heights adjust independently within a 4-inch range.
- Complies with global standards and codes.
- Exceeds ANSI/BIFMA performance standards.

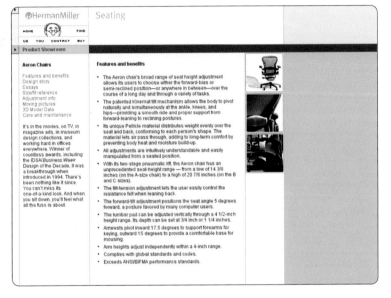

⑪HermanMiller Seating

HOME FIND
US YOU CONTACT BUY

▶ Product Showroom

Aeron Chairs

Features and benefits
Design story
Essays
Size/fit reference
Adjustment info
Moving pictures
3D Model Data
Care and maintenance

It's in the movies, on TV, in magazine ads, in museum design collections, and working hard in offices everywhere. Winner of countless awards, including the IDSA/*Business Week* Design of the Decade, it was a breakthrough when introduced in 1994. There's been nothing like it since. You can't miss its one-of-a-kind look. And when you sit down, you'll feel what all the fuss is about.

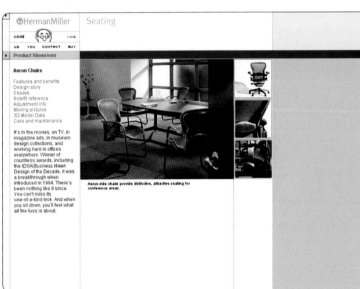

Aeron side chairs provide distinctive, attractive seating for conference areas.

⑪HermanMiller Seating

HOME FIND
US YOU CONTACT BUY

▶ Product Showroom

Aeron Chairs

Features and benefits
Design story
Essays
Size/fit reference
Adjustment info
Moving pictures
3D Model Data
Care and maintenance

It's in the movies, on TV, in magazine ads, in museum design collections, and working hard in offices everywhere. Winner of countless awards, including the IDSA/*Business Week* Design of the Decade, it was a breakthrough when introduced in 1994. There's been nothing like it since. You can't miss its one-of-a-kind look. And when you sit down, you'll feel what all the fuss is about.

Design story

Herman Miller turned to designers Don Chadwick and Bill Stumpf to design a totally new kind of chair. Chadwick and Stumpf's previous collaboration had produced the groundbreaking Equa chair. The two designers began this development process with a clean slate, with no assumptions about form or material, but with some strong convictions about what a chair ought to do for a person.

Ergonomically, it ought to do more than just sit there. It should actively intercede for the health of the person who sits in it longer than she should. Functionally, it ought to move and adjust as simply and naturally as possible. It should support a person in any position he cares to assume, at any task his office job serves up.

Anthropometrically, it ought to be more inclusive than its predecessors. It should do more than accommodate small or large people; it should really fit them.

Environmentally, it ought to be benign. It should be sparing of natural resources, durable and repairable, designed for disassembly and recycling.

The design that fulfilled these criteria met all expectations by shattering some of them. It wasn't upholstered. It wasn't padded. It was dimensioned in three models that looked exactly alike and that had nothing to do with their users' job titles. It didn't look like any office chair ever seen before. And its revolutionary concept incorporated more patentable ideas than any previous Herman Miller research program.

The chair was tested for comfort with scores of users, pitting it against the best work chairs available. Leading ergonomists, orthopedic specialists, and physical therapists evaluated the chair's fit and motion, the benefit and ease of its adjustments.

The design team conducted anthropometric studies across the country, using a specially developed instrument to calculate

⑪HermanMiller Seating

HOME FIND
US YOU CONTACT BUY

▶ Product Showroom

Aeron Chairs

Features and benefits
Design story
Essays
Size/fit reference
Adjustment info
Moving pictures
3D Model Data
Care and maintenance

It's in the movies, on TV, in magazine ads, in museum design collections, and working hard in offices everywhere. Winner of countless awards, including the IDSA/*Business Week* Design of the Decade, it was a breakthrough when introduced in 1994. There's been nothing like it since. You can't miss its one-of-a-kind look. And when you sit down, you'll feel what all the fuss is about.

Groovy Movie

Why do people love their Aeron chairs? Is it the science or the cool? Take this groovy tour to ponder the answer. (299k Flash movie)

Are Flash files new to you? You'll need the Macromedia's Flash 4 plug-in to read this file. Click here to download this free software.

Aeron Quicktime Video

The Official Chair of Office Hockey (2.8mb)

[QuickTime Get 4 logo]

Are Quicktime files new to you? You'll need the Apple Quicktime player to read these files. Click here to download this free software.

Pair Game

Peanut butter and jelly, beans and rice, George and Gracie, here's a game made for matching up perfect pairs.

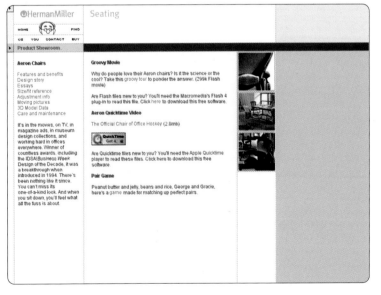

>>

\>\> Each page provides both a primary and secondary

navigation route. The primary navigation contains

graphical headers that represent the site-specific

and first-tier category content. The global navigation

links to pages that are site specific, including a text-

based site map and search features.

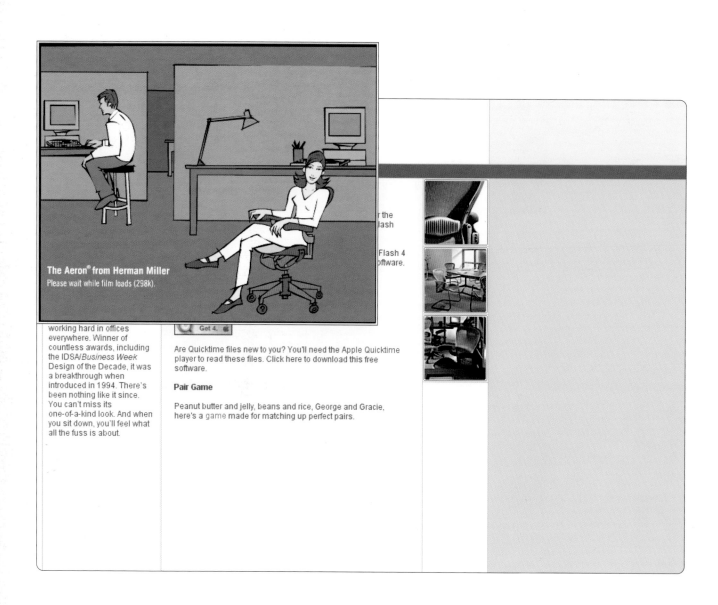

The Aeron® from Herman Miller
Please wait while film loads (298k).

working hard in offices
everywhere. Winner of
countless awards, including
the IDSA/*Business Week*
Design of the Decade, it was
a breakthrough when
introduced in 1994. There's
been nothing like it since.
You can't miss its
one-of-a-kind look. And when
you sit down, you'll feel what
all the fuss is about.

r the
lash

Flash 4
oftware.

Get 4.

Are Quicktime files new to you? You'll need the Apple Quicktime
player to read these files. Click here to download this free
software.

Pair Game

Peanut butter and jelly, beans and rice, George and Gracie,
here's a game made for matching up perfect pairs.

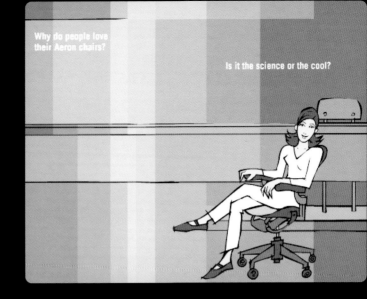

After clicking on "Moving Pictures" on the Aeron chair page, the site asks, "Why do people love their Aeron chairs? Is it the science or the cool?"

Viewers can take this "groovy tour," created in Macromedia Flash, to "ponder the answer."

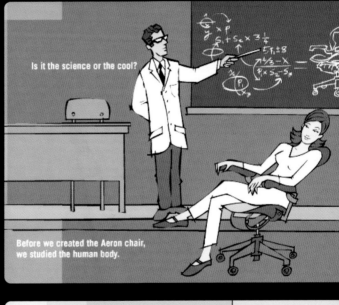

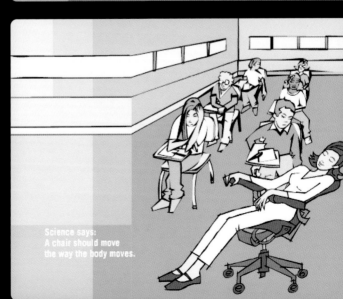

Deepend
[London, England]

>>

Founded in 1994, Deepend offers expertise across the spectrum of digital media design and production. Driven by creative vision and technical innovation, the studio is now one of the leading independent digital media agencies in the United Kingdom and is widely recognized for its creative talent. At Deepend's London office, a team of ninety works across six areas of expertise: Web, multimedia and games development, 3-D visualization and animation, moving image, events production and convergent media. The studio recently opened an office in New York City.

A diverse range of academic backgrounds and interests forms an extremely strong team within the industry. Traditional product and industrial design provide thorough understanding of the spectrum of issues involved in the design process, while graphic, interaction, and new-media design ensure visually compelling, functionally efficient, and effectively communicated media solutions. Marketing, media, business, and communications disciplines provide strategic insight, strong project management, and client-servicing support.

Refined by experience, this resource of knowledge and skills is nurtured by a flexible structure with a minimal hierarchy, where creative involvement in all aspects of the design process is encouraged. The result—an energetic and innovative company culture that consistently produces highly acclaimed work. Clients include Apple Computer, London Design Museum, New Beetle/ Volkswagen UK, British Telecom, Cartoon Network, FT.com, Virgin Radio, Andersen Consulting, Sony, Calvin Klein, Yellow Pages, Shell, Rapido TV, NTL, Telewest, and Pictor.

site: www.deepend.co.uk

Stock Answer
Pictor

http://www.pictor.com

>>

PICTOR

This site is optimised for a 1024x768 screen resolution and will automatically resize on entering the site.

This is NOT a royalty free site. By entering the Pictor site you are agreeing to the terms & conditions of use.

ENTER

Pictor is a stock-image agency. The stock-image industry is already digitized, with a vast majority of players in the market having a Web presence. Global stock-image users now expect to be able to do business over the Internet and those companies that cannot offer this service will not survive.

The site had three main objectives. First, to Support Pictor's repositioning and rebranding. The desire was to move Pictor to a higher creative level through the provision of superior image quality and new forms of digital delivery. The Web site would support this transition to allow Pictor to become a digitally enhanced quality brand. The development of a unified Web brand name across both European and U.S. markets was required.

The second objective was to establish a unique point of difference for the online presence that would make Pictor the image library of choice for the creative industry. Pictor had arrived late in the digital market and needed to use this as an advantage to leapfrog over its competitors. It could not offer just another Web site; a combination of design and functionality had to differentiate Pictor from other stock-image companies.

Lastly, the site had to provide the creative industry with an intuitive environment that would facilitate the search process and differentiate Pictor as a company that truly understands and delivers innovative solutions for creative people. To the consumer, the Web site had to offer the opportunity for a unique and engaging Pictor experience that would stimulate repeat visits and purchases.

After initial analysis of the standard search models used by competitors, Deepend recommended a navigational search tool that was based on intuitive visual selection, rather on the standard tedious Boolean choices. These types of searches, which require mouse-clicking through lists or typing keywords before viewing an image, can lead to a very frustrating experience for the user.

This visual search tool was developed to address the creative mindset of the target audience, who tend to be image focused. They are accustomed to browse catalogs, light boxes, or contact sheets with a magnifier, moving from one image to another as they mentally refine their search.

Deepend's recommendation was to create a more ambitious, visually based search facility to cater to the creative community. Visual searching, with backup from standard keyword and category entry points, would provide a real competitive edge.

Client Pictor International Ltd. (Stephen Kay, chairman, Stephen Harvey Franklin, chief operating officer, Harry Mole, director of e-commerce, Lee Spokes, IT director) **Team** David Streek, creative director; Frances O'Reilly, designer; Andrea Harding, producer; Guillaume Buat-Menard, James Donelly, programmers **Since** January 2000 **Target** Agencies, editors, photographers, students, internal team, and agents worldwide

Tools Adobe Photoshop, Adobe Illustrator, Adobe ImageReady, Allaire HomeSite, HTML, DHTML, JavaScript, PERL, Database (velocis), Pictor's Search Engine

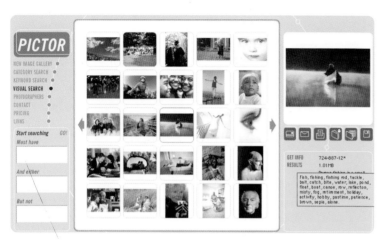

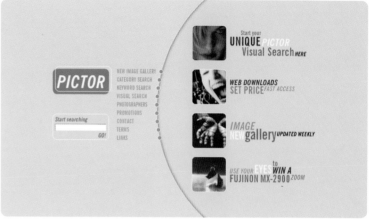

>> Deepend recommended a navigational search tool

that was based on intuitive visual selection, rather

on the standard tedious Boolean choices.

site: www.pictor.com

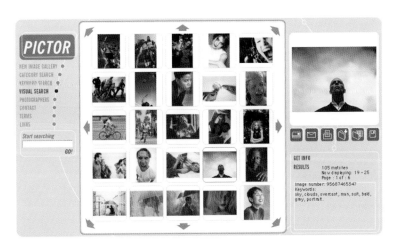

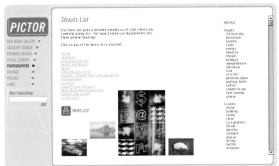

This facility allows the user to visually browse or navigate through a virtual landscape of imagery in an intuitive manner. This virtual landscape is organized into groups of images linked by a common theme or concept. Instead of being divided into "hard" sections, the images are presented in a series of blended transitions between category areas. The user wanders from one area to another with image attributes changing gradually over the terrain.

In terms of designing the navigation in the Pictor site, there were two objectives that drove all the brainstorming and rationalizing throughout the entire developmental process: intuitive and user-friendly functionality, and aesthetically strong and compelling interface design. The navigation was designed to satisfy three fundamental requirements:

1) Introducing the site and how to use it most effectively, and providing clear navigation through top-level pages

> New Image Gallery
> Category Search
> Keyword Search
> Visual Search
> Photographers
> Promotions
> Contact
> Terms
> Links

2) Presenting the visual search grid in an easily accessible—download speeds, refreshing, etc.—and user-friendly format. (The minimum thumbnail size that allows a clear image impression was determined at 85 x 85 pixels per inch (ppi). After extensive usability research, the image landscape was limited to twenty-five images within a five-by-five grid.)

3) Presenting the top-level navigation, the Visual Search grid, and selection-specific tools on the same screen in a user-friendly and aesthetic format. The Selection tools include:

> Purchase facility: Buy This Image
> Email this image or folder facility
> Print this image facility
> Add image to Folder
> View Folder
> Download image

The selection of images into My Folder has been designed and developed to be as intuitive as possible with familiar folder names and the drag-and-drop facility. For maximum convenience, the My Folder facility can be used without registration requirements and works with a cookie application that saves and can "remember" the individual user's selections, which may comprise up to fifty images.

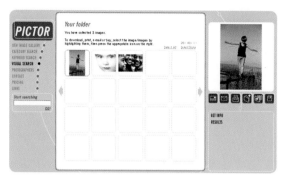

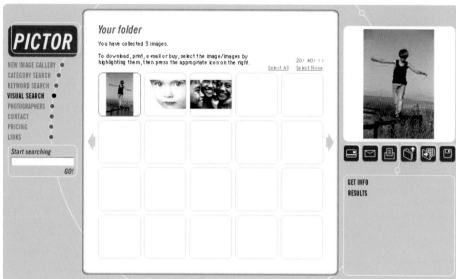

>> Additionally, this area of the navigation includes an image preview window that accommodates a portrait or landscape format with a longest side restriction of 213 pixels per inch, and an image information box that presents keyword definitions and format details on a selection.

Because so much information needed to coexist in the browser window at any one time, the screen automatically resizes to fit any browser window size, although the decision was made to optimize the viewing field for large screen monitors at 1024 x 768 ppi. This was decided because creatives generally work with large-screen monitors.

Also, as the drag-and-drop facility is a standard and much-valued feature of image-based and publishing software applications, it was included as a feature in this image library context. The screen size was therefore deliberately restricted to 920 x 540 ppi to provide a strip of visible desktop to which images can be conveniently dragged.

The navigation layout on the screen follows a logical pattern: The top-level navigation follows a traditional and logical left-hand screen format for easy reference. This is followed by the visual search grid, which occupies a considerable amount of the visual field. Finally the image selections are dragged to folders on the

site: www.pictor.com

right hands side of the screen, which also contains the preview and information windows.

Because the designers wanted to avoid the irritation of multiple windows launching and refreshing after each selection, the decision was taken to take advantage of DHTML, which enables textual content to be served to the information box dynamically, without the need of refreshing. This, of course, limited the browser choice to the latest version, and a "soft landing" or friendly browser-detection facility was written into the splash page to alert users, giving them the option to upgrade their browser if needed.

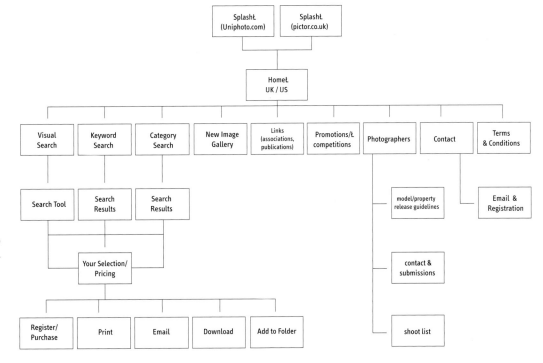

25

Fork Unstable Media was founded in 1996. The current partnership consists of Jeremy Tai Abbett, David Linderman, and Manuel Funk. The partners, along with a young team of American and German designers, programmers, and brand experts known for solving communication problems with unusual but effective ideas, round out the Fork team. Much of Fork's inspiration comes from questioning the seriousness of current media programming or propaganda and juxtaposing this seriousness with humor and a healthy lack of respect. Clients include Beiersdorf AG, makers of Nivea skin products; Lufthansa Systems Network, a daughter firm of Lufthansa Systems; Universal and Urban Records Germany; Reemtsma (a tobacco manufacturer), and the Media Academy Cologne, to name a few.

Fork Unstable Media's idiosyncratic vision has been widely recognized by the press, and many projects have been published in books and magazines. The San Francisco Museum of Modern Art has acquired three of Fork's projects for their permanent collection. "The most interesting interaction is that of a baby and its environment," says Jeremy Abbett. "A baby has little experience to base its reactions upon, so multiple attempts are made. This is not unlike the way we like to create a lot of our interfaces for navigation. Users may not understand it at first, but after successive attempts, they will be able to assimilate the meaning. To move ahead we have to keep things fun and frustrating, and at the same time make sure that it is all playful."

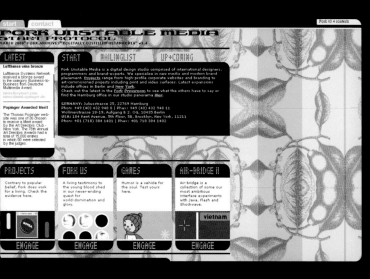

01 02 03 04 05 06 07 08 09

site: www.fork.de

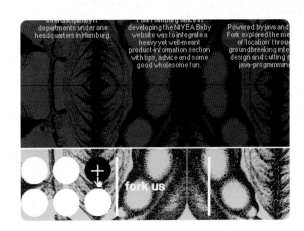

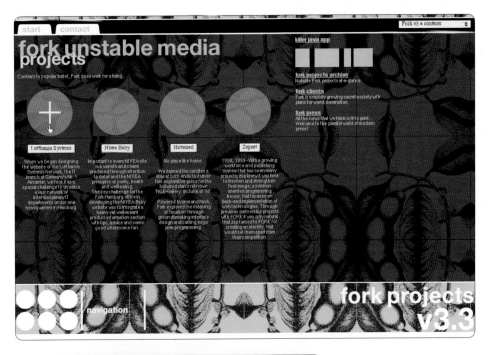

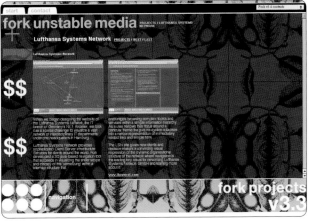

Visualizing IT
Lufthansa Systems Network

http://www.lhsysnet.com

>>

When Fork Unstable Media began conceptualizing the site for Lufthansa Systems Network, one of the information technology (IT) agencies of Germany's top airline, the designers took it as a special challenge to visualize a vast network of interdisciplinary IT departments under the company's head office in Hamburg, Germany.

Lufthansa Systems Network provides sophisticated infrastructure IT services for clients around the world. Fork Unstable Media developed a three-dimensional, Java-based navigation tool that succeeds in visualizing the sheer scope and intricacy of this network. The 3-D navigation encourages browsing complex topics and services within a simple information hierarchy. As the user concentrates on a particular theme, the navigation zooms into a focused representation of immediately related topics. The 3-D model can be manipulated by users, allowing them a feeling of how the various points of the model relate to one another and as a whole. Audio clues are also used, as well as visual clues that respond to the user's actions.

Client Lufthansa Systems Network/ POB **Team** Jeremy Tai Abbett, creative director, designer; Manuel Funk, project manager; Jan-Michael Studt, technologist; Andrea Mittmann, screen designer **Since** March 1999 **Target** Clients and decision makers interested in the IT services Lufthansa Systems Network has to offer

Tools Adobe Photoshop, Adobe Illustrator, Allaire Homesite Builder **Awards** Bronze Award from the German Multimedia Awards in the Business to Business category

site: www.lhsysnet.com

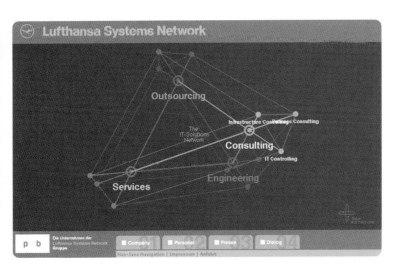

>> As the user concentrates on a particular theme, the navigation zooms into a focused representation of immediately related topics.

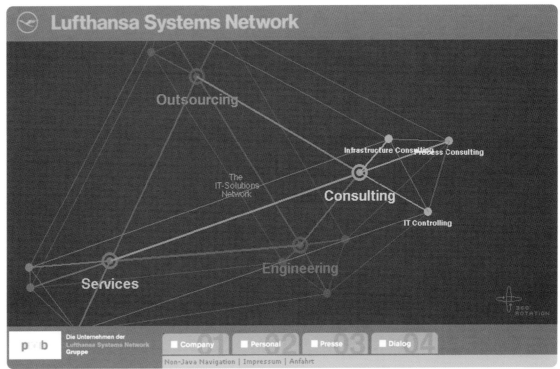

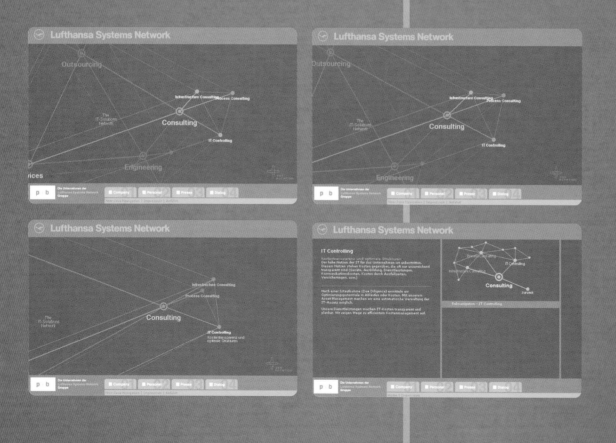

>> "The most interesting interaction is that of a baby
and its environment. A baby has little experience to
base its reactions upon, so multiple attempts are
made. This is not unlike the way we like to create a
lot of our interfaces for navigation."
— Jeremy Tai Abbett, partner

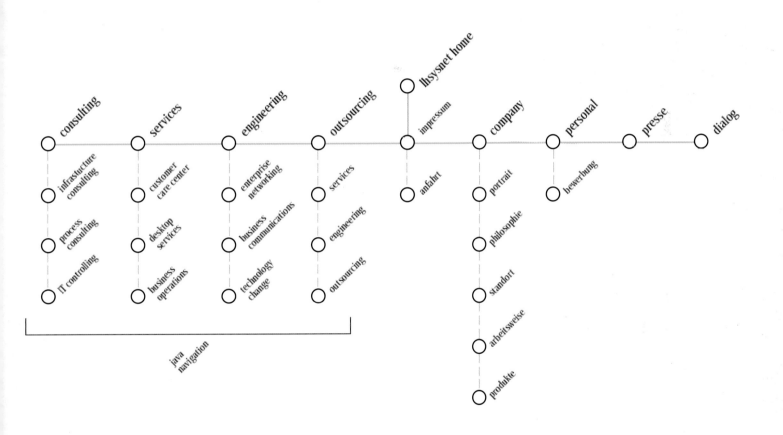

>>

LiveArea is a Web design and development company based in New York City. Company founder Peter Comitini defines LiveArea's mission: "The Web provides new opportunities to express and build relationships with the public," he says. "LiveArea manages the process of transforming data into information and information into understanding. This is the most competitive communications environment ever, with about 360 new sites being launched each hour. Helping our clients achieve a truly distinctive presence is what our development process is all about. Intelligent content creation, design, and navigation make the critical difference in a Web site's success or failure."

LiveArea has its roots in Peter Comitini Design, a strategic design practice for clients that included Nickelodeon Online and Discovery Communications. No stranger to creating a dialogue with a worldwide audience, Peter Comitini sharpened his editorial and design skills as cover art director of *Newsweek* magazine during the first half of the 1990s. His work was included in the Mixing Messages show in 1996 at the Cooper-Hewitt National Museum of Design in New York City, and has been recognized over the years in every major awards competition including the AIGA, Society of Publication Designers, NY Art Directors Club, *PRINT*, and *Communication Arts*.

LIVE AREA

| 01 | 02 | 03 | 04 | 05 | 06 | 07 | 08 | 09 | **10** | 11 | 12 |

Ergonomically Correct
OXO

http://www.oxo.com

OXO International's Good Grips products could be said to have reinvented the housewares category. But research showed that consumers did not easily associate the OXO brand name with the products, so making the brand name more memorable was a key objective. Since local retailers don't always carry the entire product line, making the complete OXO product catalog available for sale everywhere was an important second goal. Telling the OXO story and providing recipes, a search tool, and links to Web resources, rounded out LiveArea's design mission.

OXO products follow the principals of universal design, and as a result they are more comfortable for everyone. They are simultaneously chic and playful—beautiful objects to hold and behold. These qualities set the standard for the site design and navigation. From the moment you enter the OXO site, the design—with its simple, fresh graphic approach—has a sense of both purpose and playfulness. For example, an intuitive connection between the brand name OXO and the classic children's game of tic-tac-toe becomes a permeating feature of the site's design—a navigational metaphor, organizational trait, and an actual interactive game developed in Shockwave.

Client OXO International **Team** Peter Comitini, creative director, interface designer, designer; Andrea Pinto, designer; Susan Saunders, Michelle Sohn, Evelyn Krasnow, writers; Dino Karl, Craig Wolman, Tavis Jeffries, programmers; Mathew Siee, Rebecca Johnson, graphic production; David Wagner, Jeff Lederman, digital video producers; MYK, photographer (catalog); Alan Donaghey, 3-D animator **Since** March 1999 **Target** The general public; anyone who cooks or uses a hand tool of any kind is a potential user

Tools Cold Fusion, BBEdit, HTML, JavaScript, Java, Microsoft Active Server Pages (ASP), Microsoft Sequel Server (SQL), Adobe Photoshop, Adobe Illustrator, Macromedia Director, SoundEdit, GifBuilder, Apple QuickTime. Developed on the Macintosh and Windows NT platforms. Hosted on a dedicated Compaq Pro-liant running Windows NT **Traffic** 2,000 hits per day and up **Awards** *Communication Arts*, Interactive Design Competition 5

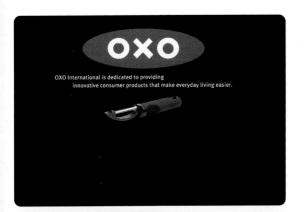

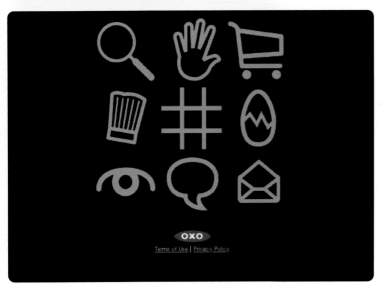

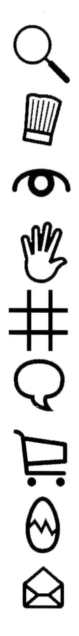

The black strip running across the top of each screen contains the global site navigation icons. Users can link to any of the nine main sections from any section's page by using the top navigation bar. The top bar serves navigation by providing a way around the site and feedback on one's current location. The logo appears in this area on every screen of the site, assuring that a link to the site from anywhere on the Web will carry the brand identity. Clicking on it links back to the home screen.

The navigable destinations operate much as they do on the home screen, with mouse-over responses and a verbal explanation of their destinations. Graphic text and a static icon in red identify the current section. The current window's title bar also identifies the location of a user. The designers also provided a redundant, static, icon system for browsers that do not support the JavaScript, which enables the mouse-over animations.

Section navigation menu

Each main section has a linear structure. A red navigation bar runs down the left of each page. It contains a menu specific to navigating only the current section. The links in this menu can be used to jump to a specific item of interest within the section. The menus change to reveal more detailed content as one drills down into a section.

For example, at the topmost level of Chef's Choice, the menu contains a list of the chefs whose recipes appear in the section. Clicking into a particular chef's section, it contains a selection of recipes. In this way, the section menus give section location feedback and links within the current content area.

Content page

Content screens are broken down into logical components, and users can scroll down to view longer pages. Oversized graphic arrows and in-page text links are used throughout.

Special media and features

Pop-up windows are invoked for QuickTime movies and the OXO Search Tool features. These smaller windows launch over the current one. The OXO Search Tool in particular uses multiple windows to query different search engines. LiveArea implemented JavaScript that continually pushes the window containing the search tool interface to the front, which lessened the possibility that users might lose their place behind multiple open windows.

Dynamic sections

Developing and distributing a growing line of products is at the core of OXO's business. LiveArea developed a database-driven publishing solution that can grow with OXO's product lines and business. The OXOnline shop, Just Out, and the intermittent Sneak Preview sections are dynamically generated site areas programmed in Microsoft Active Server Pages (ASP). This technology permits images and text to be called out of a database, written into an HTML page layout, and served over the Internet to a user's browser on the fly.

>> An intuitive connection between the brand name OXO and the classic children's game of tic-tac-toe becomes a permeating feature of the site's design.

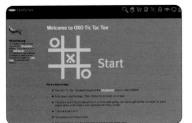

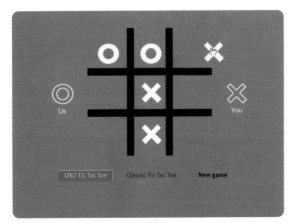

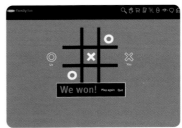

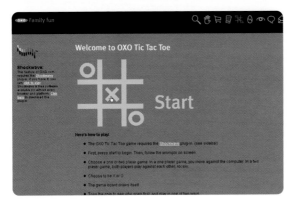

A unique user experience is what has made OXO's products so popular. Besides working flawlessly, they look and feel different. It was important that OXO translate these same qualities to their Web space. The tactile and visual experience of the home screen's interface design intuitively reflects the qualities of OXO's products. This screen is not only a table of contents, but an interactive poster for the brand as well. LiveArea created a group of navigation icons that become the defining site design statement. The icons create a sense of place that OXO "owns" on the World Wide Web. They serve as an interactive table of contents upon entry and then as a navigational palette and location signpost as one journeys deeper into the site. The OXO home page introduces the nine interactive icons with an engaging, gamelike quality. Each icon responds to user actions by changing color and animating when a mouse rolls over it. Each mouse-over also invokes a verbal description of the section it links to.

Giving users a consistent and intuitive system to browse a site supports usability and, when done right, feels seamless. The basic site page structure places navigational interface elements into well-planned and graphically distinct page areas. Each supports a different way of helping users to navigate and access the site's content.

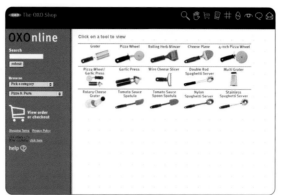

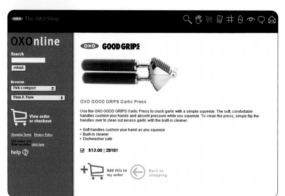

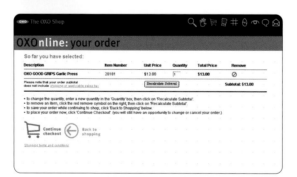

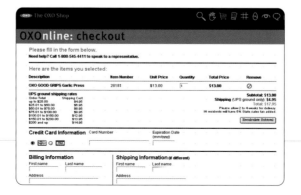

The Online Shop

Interface design is a highly visual browsing and shopping experience that follows the same basic page structure conventions used throughout the site. Its structured system of pull-down menus permits users to browse freely. A search field enables users to find specific items using keywords relating to tasks, foods, or products. LiveArea art directed the photography and optimized the images to assure fast delivery over the Web, enabling an extensive use of multiple and large product shots to be used. The studio created a browseable and searchable system of pull-down menus, thumbnails, and large product shots. Shopping cart and on-line ordering is supported, plus a custom database-administration tool permits the adding and editing of products, categories, and keywords. The Just Out section operates in a similar fashion for newly introduced housewares not yet available in stores.

site: www.oxo.com

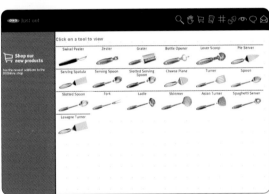

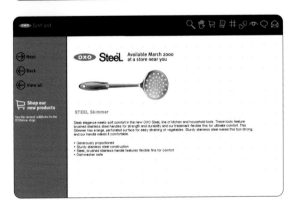

>> The navigational challenge is not just within a site but across the entire World Wide Web. There is little sense of owning a visually unique Web property.

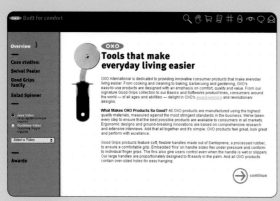

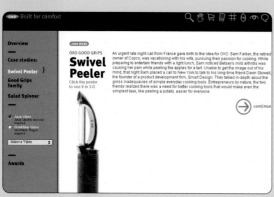

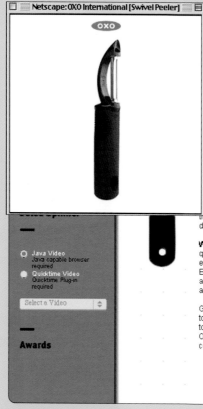

site: www.oxo.com

OXO GOOD GRIPS 🌐 Global Search

1 enter a search term 2 choose a search engine 3 see results 4 refine search term 5 click the globe ? help

search engine ⬍ ☑ see results in a new window

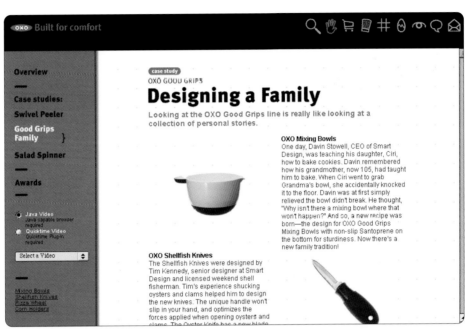

Built for comfort

Overview

Case studies:

Swivel Peeler

Good Grips Family }

Salad Spinner

Awards

⦿ Java Video
Java capable browser
required
⦿ Quicktime Video
Quicktime Plug-in
required

Select a Video ⬍

Mixing Bowls
Shellfish Knives
Pizza Wheel
Corn Holders

case study

OXO GOOD GRIPS

Designing a Family

Looking at the OXO Good Grips line is really like looking at a collection of personal stories.

OXO Mixing Bowls
One day, Davin Stowell, CEO of Smart Design, was teaching his daughter, Ciri, how to bake cookies. Davin remembered how his grandmother, now 105, had taught him to bake. When Ciri went to grab Grandma's bowl, she accidentally knocked it to the floor. Davin was at first simply relieved the bowl didn't break. He thought, "Why isn't there a mixing bowl where that won't happen?" And so, a new recipe was born—the design for OXO Good Grips Mixing Bowls with non-slip Santoprene on the bottom for sturdiness. Now there's a new family tradition!

OXO Shellfish Knives
The Shellfish Knives were designed by Tim Kennedy, senior designer at Smart Design and licensed weekend shell fisherman. Tim's experience shucking oysters and clams helped him to design the new knives. The unique handle won't slip in your hand, and optimizes the forces applied when opening oysters and clams. The Oyster Knife has a new blade

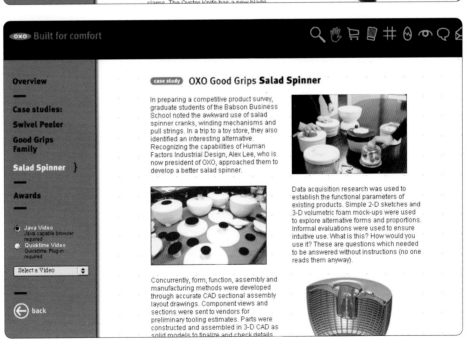

Built for comfort

Overview

Case studies:

Swivel Peeler

Good Grips Family

Salad Spinner }

Awards

⦿ Java Video
Java capable browser
required
⦿ Quicktime Video
Quicktime Plug-in
required

Select a Video ⬍

⟵ back

case study OXO Good Grips **Salad Spinner**

In preparing a competitive product survey, graduate students of the Babson Business School noted the awkward use of salad spinner cranks, winding mechanisms and pull strings. In a trip to a toy store, they also identified an interesting alternative. Recognizing the capabilities of Human Factors Industrial Design, Alex Lee, who is now president of OXO, approached them to develop a better salad spinner.

Data acquisition research was used to establish the functional parameters of existing products. Simple 2-D sketches and 3-D volumetric foam mock-ups were used to explore alternative forms and proportions. Informal evaluations were used to ensure intuitive use. What is this? How would you use it? These are questions which needed to be answered without instructions (no one reads them anyway).

Concurrently, form, function, assembly and manufacturing methods were developed through accurate CAD sectional assembly layout drawings. Component views and sections were sent to vendors for preliminary tooling estimates. Parts were constructed and assembled in 3-D CAD as solid models to finalize and check details.

>>

39

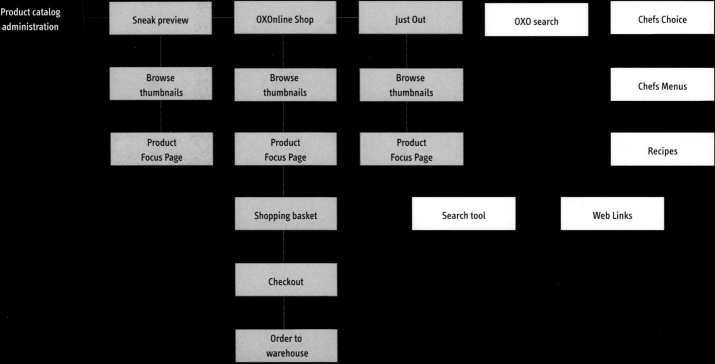

Product catalog administration

| Sneak preview | OXOnline Shop | Just Out | OXO search | Chefs Choice |

Browse thumbnails — Sneak preview
Browse thumbnails — OXOnline Shop
Browse thumbnails — Just Out
Chefs Menus

Product Focus Page — Sneak preview
Product Focus Page — OXOnline Shop
Product Focus Page — Just Out
Recipes

Shopping basket
Search tool
Web Links

Checkout

Order to warehouse

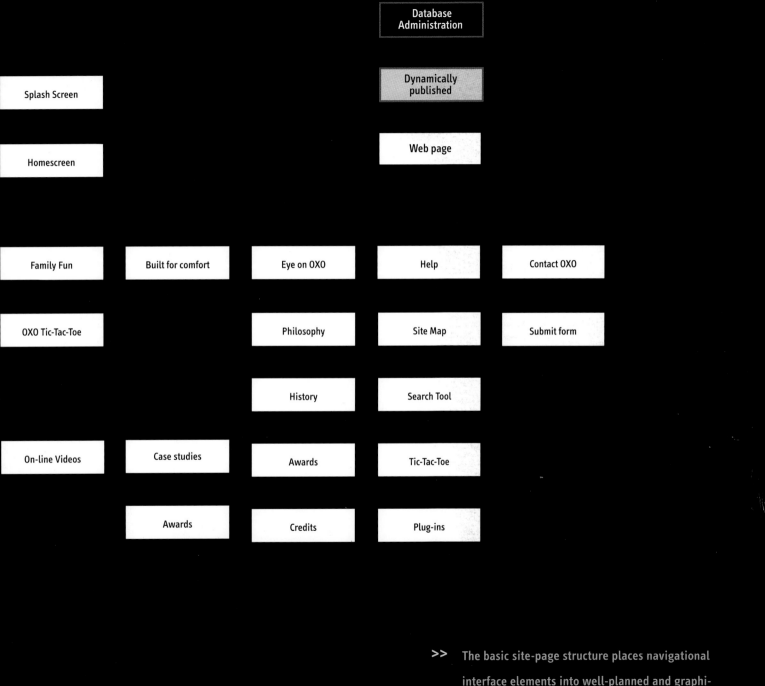

Database Administration

Dynamically published

Web page

Splash Screen

Homescreen

Family Fun

Built for comfort

Eye on OXO

Help

Contact OXO

OXO Tic-Tac-Toe

Philosophy

Site Map

Submit form

History

Search Tool

On-line Videos

Case studies

Awards

Tic-Tac-Toe

Awards

Credits

Plug-ins

>> The basic site-page structure places navigational

interface elements into well-planned and graphi-

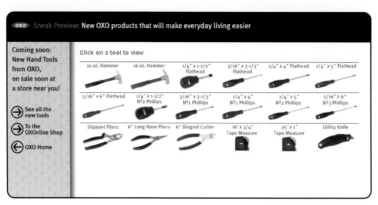

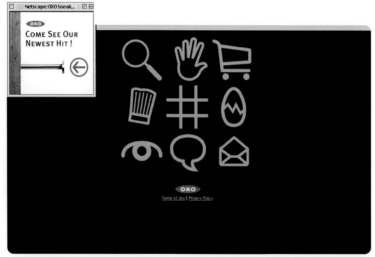

Sneak Preview section

A special case arose when OXO wanted to promote a couple of new product categories for the hardware and automotive markets. LiveArea provided development of a new dynamically published section called Sneak Preview. This area is designed as a special promotional section to introduce new lines of business before they come to market. LiveArea wanted to create a different sense of location here; apart from the main site, the screen designs in this section intentionally break the rules set up on the rest of the site. The section navigation bar appears in a steel boilerplate pattern, and the top navigation bar carries a promotional message instead of icons. Users can move out of the section by clicking on the home button. There is a balance of the familiar and the new. Users "get" that they are in the same neighborhood but on a block they have never seen—much like the transition of OXO's featured products, going from peelers and garlic presses to screwdrivers and wrenches. Because of the promotional nature of the section, it needed to be available only during new product introductions, as opposed to being a permanent site feature. Instead of creating another site section, the designers created a database-driven feature that could be turned on and off via an administration tool. When the feature is enabled, users logging onto the home screen accept a pop-up window containing an invitation to preview the new products. They click through to a special hidden section of the site. Here, they can browse through the new products and return to the home page.

Creating a sense of location

Implied in any conversation about navigation is the idea that you are going somewhere. Yet, so many of today's Web sites look alike. They are uninspired reflections of the database technologies driving content to the screen. They have no sense of being unique places, no matter how useful or special their offerings may be. The navigational challenge is not just within a site, but across the entire World Wide Web. There is little sense of owning a visually unique Web property. Sure, the usability research guys will say things like "tabs provide an easily understood metaphor" (translation: we are dealing with a pretty dumb audience). By encouraging conformity, they are underestimating users and robbing content providers of their strongest strategic asset—to build a richer and more unique user experience. In fact, many of these companies must rely on huge advertising budgets to build their brands. Just think of the real value that they would gain by designing their on-line products to impart a real sense of location. As the Web continues to grow and mature, the public perception of who's who will become increasingly important. It's not just about a creative use of technology. The on-line industry is starting to understand the need to differentiate their services using strong ideas, expressed through design. Content providers with the talent to create unique environments have a bright future in this world.

Nofrontiere

[Vienna, Austria]

>> Nofrontiere Design GmbH is a design platform for creative people from around the world. The identity of the agency is plastic and shifts according to the particular collection of "Nofrontierans" in the place at any given moment. Communication is central. Nofrontiere develops standardized hybrid languages to mediate various disciplines, languages, and cultures. These hybrids allow the studio's creatives to have new perceptions and to make innovative design solutions. The nature of each [co]operating system is project based; it is a chemical balancing act, performed through flexible configurations of particular Nofrontierans. The idea of a [co]operating system is informed by the perception of design as a coordinating tool. It is closely allied to the concept of a *gesamtkunstwerk*, where different disciplines, as in the Viennese Secession or the Bauhaus, would be integrated to produce a totally unified polysensory work.

With Nofrontiere on the brink of fifty people, the system has become more complex than a family circus of autonomous performers. A mental map of the larger system could be imagined through an idea of blobs. These blobs are virtual operative units consisting of design, consulting, conceptual, research, project management, and IT, among others, which overlap to form a floating system linked by common goals and interests in the international context of the design world. Clients include Deutsche Bank, Bank Austria, ORF ON, BMW, Philips, Procter & Gamble, Lego, Swatch, Connect Austria, and UNYSIS.

Comes the horseman known as Zorro, Miau, Miau

ETHICS CD-Rom Application 1995
Produced for the french publisher Flammarion, "Sink The Warum, A Tangled Tale Of Ethical Choices" is an exploration of the world of philosophy though a virtual theatre setting and moral interactivity.

"*You die young when you know too much.*"
Janek Zelynick

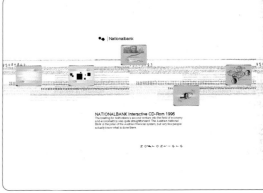

NATIONALBANK Interactive CD-Rom 1996
The briefing for Hohnstein's second venture into the field of economy and econometrics was quite straightforward. The Austrian National Bank is the pillar of the Austrian financial system, but very few people actually know what is done there.

A Virtual Theme Park
Swarovski Crystal Worlds

http://www.swarovski-crystalworld.com

>>

The official Web site of the Swarovski Kristallwelten at Wattens in Tyrol, Austria, offers visitors complete information about one of Austria's most visited tourist attractions: how to get there, opening hours, an interactive Shockwave tour through the Chambers of Wonders showcase, special product presentation, press information including a picture archive, and an on-line form to make reservations for upcoming events.

The designers' intention was to translate the incomparable experience of architecture, visions, and sound of the Swarovski Kristallwelten at Wattens, a popular industrial theme park, into a sophisticated virtual environment. Various interactive features invite the user to enter the gateway to fantasy and encounter a unique spectacle in the "magic kaleidoscope of wonder."

The voyage of discovery into the Swarovski Crystal Worlds leads users into a new dimension: the crystal interface generates a truly intuitive interactive experience. On the other hand, the Web site also offers complete information about the theme park, special product presentations, and press material, and allows on-line reservations for upcoming events.

The client's main interest was to provide on-line information for tourists, journalists, and Swarovski crystal collectors. Nofrontiere proposed to reflect the audiovisual impressions that visitors to the Wunderkammern Wattens in Tyrol encounter in a state-of-the-art, on-line application. Therefore, Nofrontiere created a crystal interface focusing on the "kaleidoscope of wonder" as a central navigation tool. The designers furthermore developed a special language, based on Swarkovski founder André Heller's individual approach to words and texts, to support an emotional setting: the world of magic.

Client The Swarovski Kristallwelten **Team** Fritz Magistris, concept; Nicki Mayrhofer, art direction, design; Oskar Habermaier, Nick Meinhart, copywriter; Pedro Lopez, translation; Raimund Schatz, Martin Seiter, Wolfgang Schreder, programming; Anna Weidinger, project manager **Since** August 1999 **Target** Tourists worldwide, collectors of Swarovski products, journalists, event managers, designers, and artists

Tools Adobe Photoshop, Macromedia Director, SoundEdit, GifBuilder, DeBabelizer, QuickTime, HTML, Shockwave **Award** Best of the European Web 1999

The Web site of Swarovski Crystal Worlds became a symbiosis of an interactive journey and first-hand information. The main navigation follows a spatial and thematic separation between interactive experience (the wonder world) and information level. The Web site offers three spheres: the Kaleidoscope of Wonder, an illustrative tour, and the information level. To follow the intuitive, playful navigation through the kaleidoscope is a unique adventure by itself. Within the tour, a shallow navigation was implemented to guide the visitor through the organic Chambers of Wonder.

To put all information content on one level, the designers used a shallow navigation with a broad entry using rollovers to optimize space restrictions. In concert with the client, special attention was paid to the definition of titles for the information menu bar. One of the problems they encountered was to fit all eleven equally important "chapters" into a clearly structured main menu that can easily be activated from all parts of the journey.

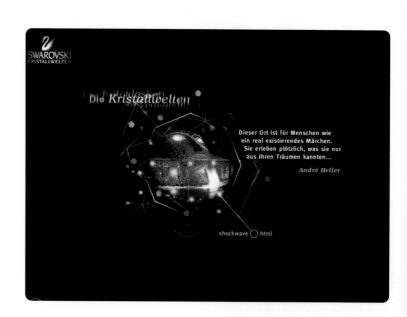

site: **www.swarovski-crystalworld.com**

46 **WEBWORKS**

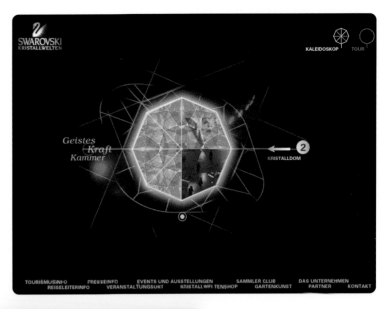

One major technical hurdle was to divide the screen carefully into the different sections to jump between the Shockwave application and HTML to implement two versions of the kaleidoscope for those users who are unable to use plug-ins.

The standard browser navigation was intentionally enabled to channel all moves of the user within the content frame. To highlight the site's exclusivity, no standard interfaces were used. The user can choose among different ways of navigation: icons, or word or picture links.

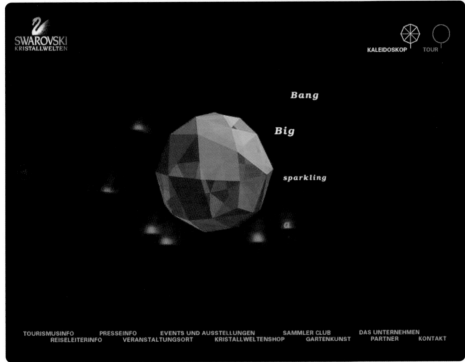

>> The voyage of discovery leads users into a new dimension: the crystal interface generates a truly intuitive interactive experience.

>>

The most significant idea within the whole concept was to tempt the user into the Swarovski Crystal Worlds. Crystals have many characteristics: they create reflections, they sparkle, they have facets. These attributes are reflected in the diverse and comprehensive offerings of this Web site. The Shockwave version of a kaleidoscope is equipped with a "handle" that provides full functionality, just like a real kaleidoscope. This is an experience, the designers believe, that is unique to the Web.

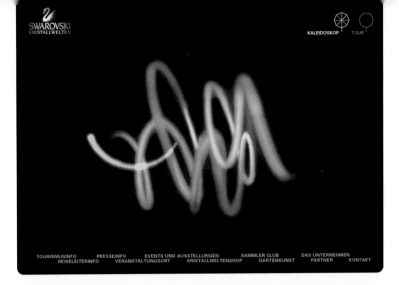

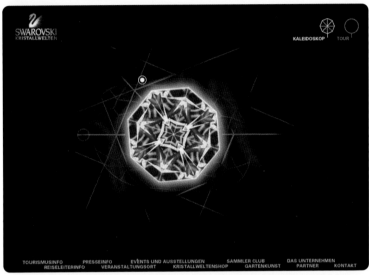

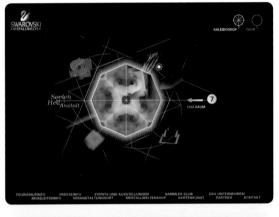

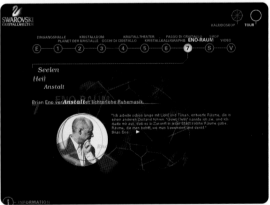

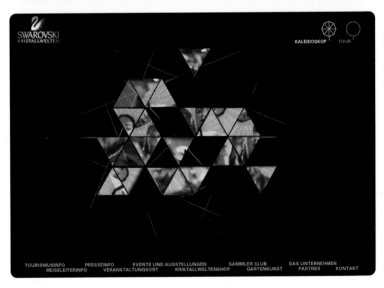

Kodak: Venice Dream Team

No home page,
just a first page (1).

DreamWorks Records
Tunnel (T), Home (H)

Second Story

>> Since 1994, Second Story has created interactive experiences delivered on the Web and through disk-based media. Principals Brad Johnson and Julie Beeler work with teams of artists, writers, illustrators, and programmers to produce an inventive blend of technology and storytelling on topics ranging from adventure travel, architecture, and natural history to corporate merchandising and promotions. Clients include DreamWorks Records, Kyocera, NASA, *National Geographic*, Nike, Universal/MCA, Kodak, and PBS.

Second Story's projects have been recognized by major interactive design competitions, and published in dozens of books and magazines. The company's work has also been inducted into the Smithsonian National Museum of American History's permanent research collection on information technology.

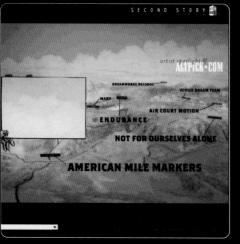

"We don't have a rigid design philosophy we apply to every site," Julie Beeler says. "Our approach is to create a unique, custom experience for every project that is derived from the content and not only through the visual design but through the experience of navigating through the site as well. We're reinventing the wheel every time."

"When I first got into this industry, there was no graphical Web as we know it today, only CD-ROMs, and there were two different directions I could go," Brad Johnson adds. "I could make entertainment-based games or design for businesses." Producing editorially-based work for the Web, however, has allowed Second Story to do both. "What's exciting now is that there's a real niche for us to make sites that fulfill corporate needs by developing entertainment-based content," Johnson concludes, "and doing it in a media-rich way that gets us back to our roots in multimedia.

National Geographic, King Cobra

http://www.nationalgeographic.com/king cobra/index-n.html

>>

This companion site to the 1997 Explorer television season premiere of "King Cobra" was created to provide an educational and entertaining accessory to the television show. With the purpose of educating visitors about the facts behind king cobra folklore, the Web site's full-size depiction of the snake reveals the story behind the serpent throughout the course of a narrative inspired by medieval Indian court painting.

The snake itself serves as both a navigation and content device, allowing users to access the content either randomly or according to the narrative. Using the "snake key," visitors instantly access the serpent's eleven segments and learn more about the particular nature of the snake within each distinct section. JavaScript rollovers activate the different sections of the snake and highlight the content titles. After visiting different areas of the snake, the key automatically updates itself with a line drawing that fills in to display fully rendered art indicating where the user has been.

Users' capabilities posed the biggest hurdle in creating the site. It was very important that users on low-end machines didn't receive a "dumbed-down" version of the site and that the nuts and bolts were still available to them. The designers had to forget about incorporating nifty navigational elements in order to develop a viable user interface. After many hours of writing and testing code, the team came up with a variety of options.

Their final decision was to have each segment in a frame, so users could click on arrows to load other segments of the snake. This meant they had to split users off at the root level based on the browser. Doing so involved some minor browser "sniffer" code, while avoiding the necessity to build two completely different sites. Although some pages needed to be duplicated, for the most part, both versions of the site could share the same Web site files. This fall-back format wasn't nearly as engaging as the fully functioning JavaScript version, but it was enough to satisfy the client.

Client National Geographic **Team** Julie Beeler, designer and programmer; Brad Johnson, designer; John Beezer, programmer; Paul Krater, illustrator; Laura Carter, producer for *National Geographic* **Since** August 1997 **Target** *National Geographic* readers **Awards** High Five Award, Yahoo Daily Pick, Project Cool "Cool Sighting," *USA Today* Hot Site

Tools Adobe Photoshop, Adobe AfterEffects, JavaScript, Adobe Premiere, GIFBuilder, Adobe Illustrator, BBEdit, HTML, RealAudio

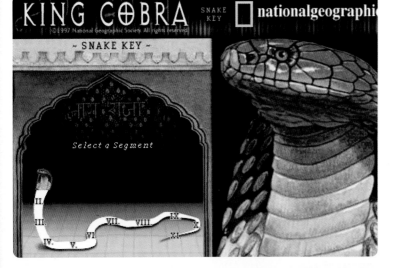

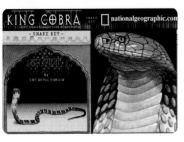
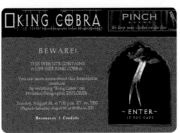

An introductory GIF animation of the king cobra's tongue sets the stage for the site. The playful homepage states, "Beware, Enter if you Dare. This Web site contains a life-size King Cobra." Upon entering, users are presented with a depiction of the snake that serves as both a navigation and content device, allowing them to access the content either randomly or according to the narrative. Using the "snake key," visitors can instantly access the serpent's eleven segments and learn more about the particular nature of the snake within each distinct section. JavaScript rollovers

activate the different sections of the snake and highlight the content titles. After visiting different areas of the snake, the key automatically updates itself with colorized artwork indicating where the user has been.

The metaphor for the snake key was derived from traditional "You Are Here" maps. Using this idea as a springboard, the designers were able to transform the life-size king cobra into a miniature version allowing instant access for users and a small download, since the segments were broken up into eleven specific sections.

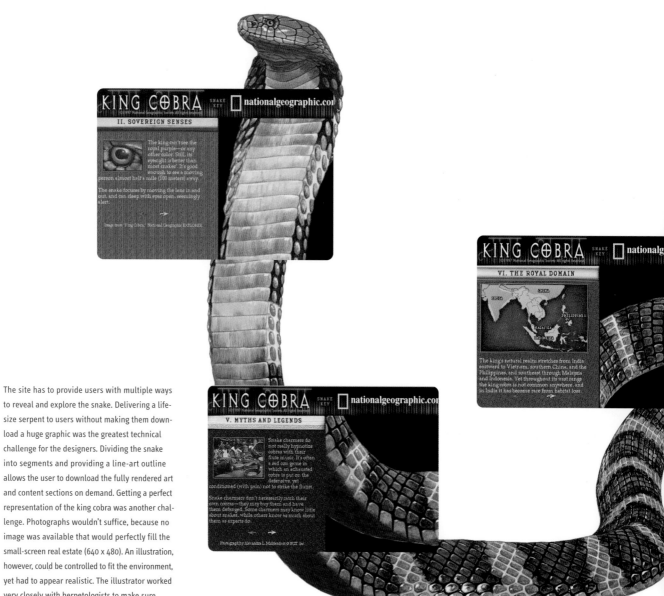

The site has to provide users with multiple ways to reveal and explore the snake. Delivering a life-size serpent to users without making them download a huge graphic was the greatest technical challenge for the designers. Dividing the snake into segments and providing a line-art outline allows the user to download the fully rendered art and content sections on demand. Getting a perfect representation of the king cobra was another challenge. Photographs wouldn't suffice, because no image was available that would perfectly fill the small-screen real estate (640 x 480). An illustration, however, could be controlled to fit the environment, yet had to appear realistic. The illustrator worked very closely with herpetologists to make sure every detail was accounted for, right down to the individual scales.

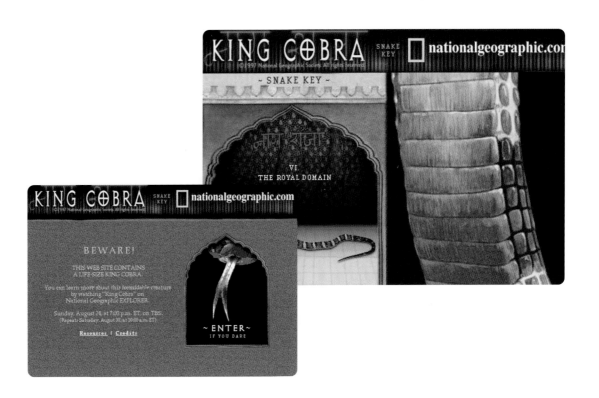

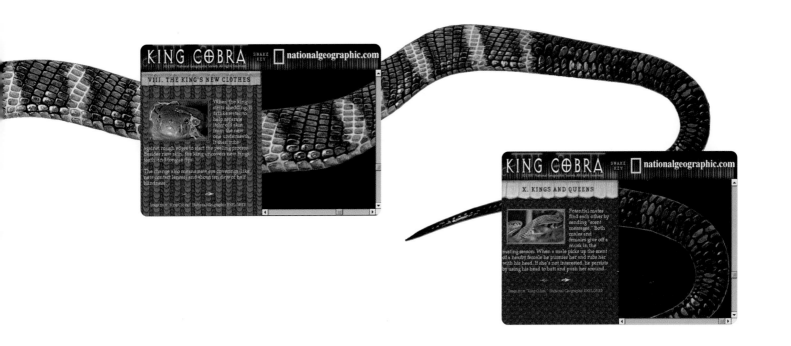

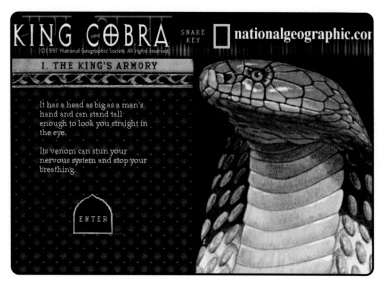

Once users decide to view a section of the snake they are presented with content-rich information about one aspect of the king cobra. A subnavigation allows them to explore the informative content or load other snake segments. Balancing a narrative path with random accessibility is a navigational principle Second Story builds into every site. That means having a compelling sequential path users can experience, while at the same time having the ability to jump around anywhere they want. This strategy presented an interesting challenge in the case of "King Cobra": If visitors could jump anywhere in the site, the designers had to keep track of where they had been so the programming would only download graphics users selected.

By allowing visitors to select their own navigation path the site can appear to be shallow to some, yet deep to others, while still being fulfilling. It is critical not to overwhelm the user with choices, but at the same time a "thin" site must be apparent to the user from the start. By delicately balancing a narrative, linear path with random accessibility the designers were able to satisfy a wide variety of users. Since users' capabilities determine the site's shallowness or depth, they need to be immersed in the material so that when they leave the site, they realize the depth and scope of all the content.

site: // http://www.nationalgeographic.com/king cobra/index-n.html

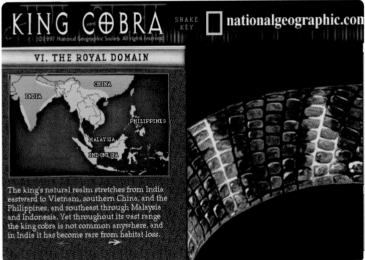

The technical requirements to realize this site are outdated now, although they were a huge consideration at the time of its launch. Most of what the designers were trying to achieve at the time had to do with downloading segments on demand without having to reload pages and graphics. Using very complicated JavaScript they achieved their goals. The idea they explored with this site has become a reality over time with the notion of layers and streaming technology. With the use of Flash, QuickTime, RealMedia, DHTML, etc., users only have to download the specific segment they want and they are delivered a very smart back-end browser experience hooked up to databases. At the time this site was created, none of these technologies were available, yet the site can still be considered up-to-date and technically savvy.

Before the advent of compact discs, designers for record publishers enjoyed the luxury of vinyl formats in which a lot of visual real estate could be used to promote an album. When CDs displaced vinyl, some retailers offset the smaller packages with "listening booths" where consumers could browse albums by listening to the tracks. The DreamWorks Web site strives to revitalize the browsing experience by developing a new interactive paradigm that rewards customers' curiosity about the music.

Design and technology together create a compelling end-user experience. Without one or the other, the site would be flat, boring, and vacuous. This site goes beyond the norm and breaks through into the next generation of immersive motion, sound and interaction. A "thin" metastructure was important for the label branding and global navigation but it couldn't be prominent or over-designed because it would then compete with the artists' contributions that appear on the Web site's "stage." The stage takes over the site and transforms it so as to be particularized to the specific artist.

Listening Booth
DreamWorks Records

http://www.dreamworksrecords.com

>>

Client DreamWorks Records **Team** Brad Johnson, creative director, designer; Julie Beeler, producer and designer; Sam Ward, designer; Kim Markegard, programmer; Ken Mitsumoto, programmer **Since** July 1998 **Target** Music consumers

Tools Macromedia Flash, Adobe Photoshop, Adobe Illustrator, BBEdit, HTML, MediaCleaner, SoundEdit, RealMedia **Awards** 1999 *Communications Arts* Interactive Design Annual; IPPA Design Excellence Award; Netscape's What's Cool; *Communication Arts* Site of the Week; Macromedia Flash 3.0 Gallery; Shocked Site of the Day; Netscape's Studio On

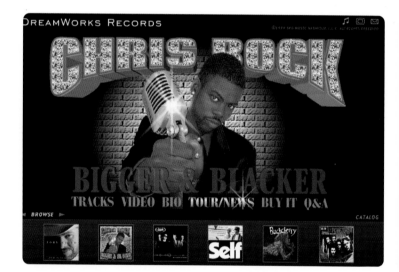

In developing the navigation for this site, the designers applied the same rationale and ideology behind many of their projects: The site must have random access and a linear path. The path is clearly defined in the "album bin," where titles are put on display for sampling. Simple, clean pull-down menus allow instant access to the entire DreamWorks catalog. The basic structure is simple: three frame-sets, with the center frame serving as the stage. Both top and bottom frames relate to the stage itself, and users can easily participate in a unique experience depending on the artist selection. A number of different visual artists are involved in the ongoing realization of this site—a critical consideration in keeping the content fresh and diversified.

site: www.dreamworksrecords.com

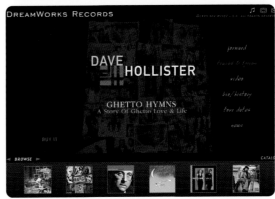

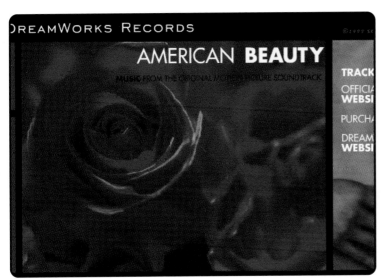

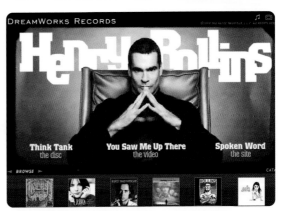

Second Story's goal was to create a site as diverse as the Dreamworks Records' label itself. It was critical that the site be diverse enough to cover all genres of music, ranging from urban to pop, rock, to country. There was no better way to do this than to let each artist and related album define the look and feel of the site. Users browse the album covers displayed in a features frame to see what's new, or search the complete discography of the label. When they have made a selection, visitors immediately experience full-screen visuals, copy, animation and sound related to the album. (Code has already detected each user's browser type, plug-in possession and monitor resolution, and created a new window with an interface that fills the screen.) These "interactive covers" were created in Flash animation by many different artists inspired by the music, each of them as unique as the album they promote. Many of the tracks on each album are available in three different audio formats, and every music video is streamed on-demand. Going deeper, users can link directly to an on-line retailer of their choice, and get in-depth biographical information, tour dates, and links to artists' sites.

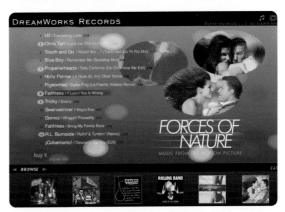

> In developing the navigation for this site, the designers applied the same rationale and ideology behind many of their projects: The site must have random access and a linear path.

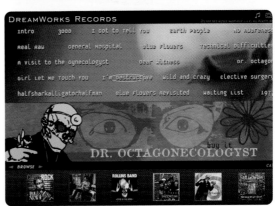

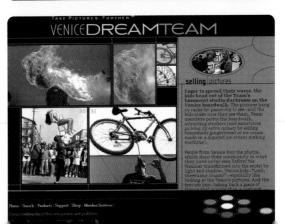

The Venice Dream Team Web site tells the story of a group of young photographers in Venice, California, and their mentor, named Bagwa. The team is continually in motion, traveling to various cities and countries, photographing events and celebrities, and then selling their work to fund travel expenses for their next destination.

Photo Hub

Venice Dream Team

http://www.kodak.com/US/en/corp/features/veniceDreamTeam/frame.

Client Internet Marketing Group of Eastman Kodak Company **Team** Brad Johnson, creative director, designer; Julie Beeler, designer and programmer; Sam Ward, designer; Tom Allen, writer; Suzanne Mattson, assistant. Kodak: Cindy McCombe, editor; S. Blaine Martin, design director; Jennifer Cisney, visual interaction designer; human factors: Jack J. Yu **Since** August 1999 **Target** Kodak clients to promote brand awareness via a human-interest story about picture taking

Tools Macromedia Flash, Adobe Photoshop, Adobe Illustrator, BBEdit, HTML **Awards** *Communication Arts* Site of the Week, Shocked Site of the Day, *USA Today* Hot Site

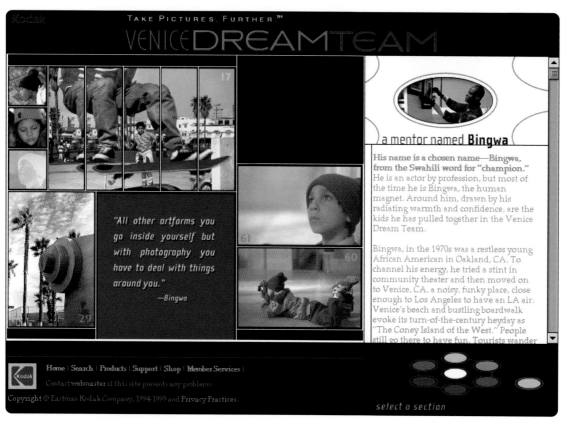

The site showcases the team's photos and captures the spirit of their creative cycle by using a unique circular architecture that reflects the structure of the team experience. The hub or center of the site profiles the man who keeps the team in motion. From there, users jump into the cycle and follow the team through its creative rhythm, learning about photography, taking pictures, going on assignment, printing pictures, and selling them. Viewers can randomly navigate through the cycle using a circular Flash tool or click through the HTML zone.

>> Any site that needs a site map to define the navigation route has not succeeded in presenting an intuitive navigation foundation.

site: www.kodak.com/US/en/corp/features/veniceDreamTeam/frame

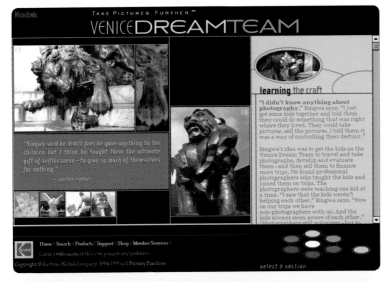

>> If navigation is overwhelming and confusing it is
very easy for users to become frustrated and not
get an intuitive "lock" on the site's structure.

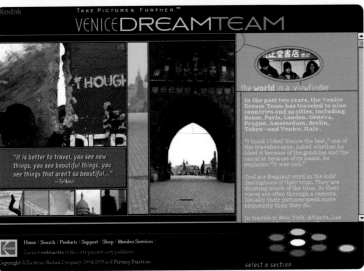

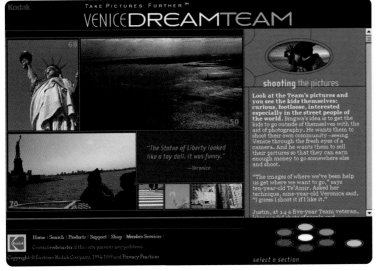

To showcase the Venice Dream Team's photographs and capture their creative energy, Flash was used to enable a full-screen, scalable interface. The interface presents a grid that displays an interactive photo gallery, which places the photos in thematic context without depending on the accompanying narrative. The gallery displays the photographers' range of work, and mousing over thumbnails calls up new galleries and quotes from the photographers, their parents, and mentor. Additionally, Flash allowed Second Story to time the presentation of their work through animated transitions and interactivity. Building a hybrid site enabled the designers to bridge the gap between Flash and HTML, using both languages to create the Web site. Flash has its strengths for certain types of content, but not all, nor is it the appropriate medium for text-based information. Using DHTML on the back-end allowed the designers to create seamless environments.

Creating a sound site structure is as important as determining how best to tell the story. If navigation is overwhelming and confusing it is very easy for users to become frustrated and not get an intuitive "lock" on the site's structure. A simple circular device told the complete story of the Venice Dream Team and made for intuitive navigation. Color coding allowed the sections to be easily distinguishable, and text rollovers provided feedback about what to expect in each section.

Users following the story links could easily continue throughout the site without ever having to interact with the circular device. Dual navigation applies to a diverse audience and lets them select their path and determine what content they wish to view. However, too many navigation paths or too many buttons linking to the same content can become very confusing and frustrating. Any site that needs a site map to define the navigation route has not succeeded in presenting an intuitive navigation foundation.

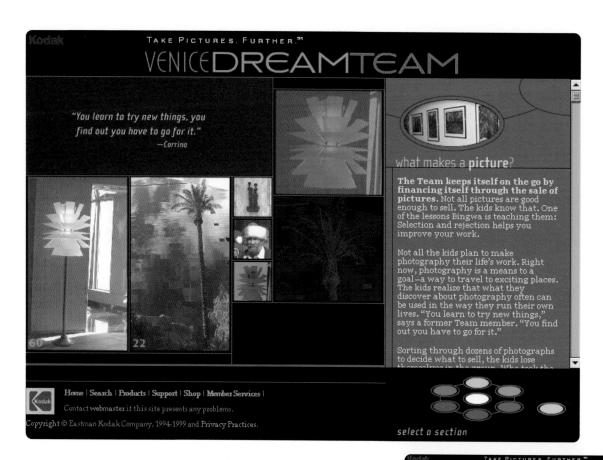

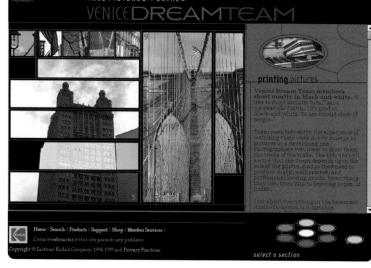

site: www.kodak.com/US/en/corp/features/veniceDreamTeam/frame

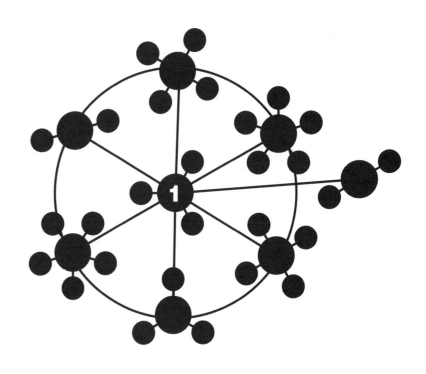

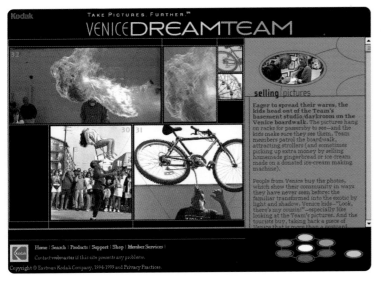

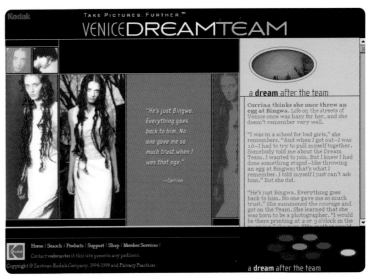

Typography on the Web

LETTERFORM CHARACTER SETS: TYPOGRAPHY
BY DANIEL DONNELLY

Words are the building blocks of modern communication. Whether these groups of let-terforms are presented in print, broadcast, or on the Web, a typeface is selected to visually enhance—or to facilitate the conveyance of—each word's message. Fonts can communicate as much as the words they form.

Immediately after the movable-type printing press was invented, typefaces such as Bembo, Bodoni, and Baskerville were painstakingly hand-carved by printers, and became "trademark" character sets that branded each printed manuscript as being the work of a specific printing house. The jobs of designing and laying out type were gradually handed over to type designers and typographers, respectively, as demand for printed reading matter surged.

Today, type designers face new advantages and challenges posed by technological advances in typeface design. Just about anyone with enough imagination and com-puter skill can create a digitized font (and a few can create outstanding fonts). Consequently, the typographer's primary task—the selection of the perfect typeface to convey a given message—has become more difficult. There are now thousands of digitized fonts offered by a diverse range of talent on Web sites and in printed cat-alogs. Prices for typefaces, dingbats, and ornaments can range from minimal (such as freeware or shareware) to extravagant (a proprietary typeface can command thou-sands of dollars).

No typographer or graphic designer has time to survey and sift through the ever-grow-ing collection of type-oriented sites on the World Wide Web. That's where *WebWorks: Exploring Online Design* becomes an indispensable resource for type, providing a broad sample of the character sets created by the new breed of type designer. Some of the people and work represented in this volume may be familiar to you, while others are new discoveries that also deserve recognition.

The international roster includes highly skilled, experienced artisans and type foundries such as T-26, Emigre, and International Typeface Corporation. Each designer tells what spurred his or her interest in font creation; discloses who or what fuels their typo-graphic imagination; and instills sage advice geared toward young aspiring designers who want to try their hand at type design.

The Web provides an equal footing for any type designer to sell fonts. But this elec-tronic marketplace of letterforms still faces one limitation—presentation. Many designers are resorting to graphic-text samples, animated GIFs, and interactive applets accompanied by HTML text to present their fonts. The jury is deliberating on Cascading Style Sheets (CSS) which designates the use of a specific font residing on the viewer's hard drive. Nor are most designers comfortable with Web Embedding Font Technology (WEFT) which embeds the actual fonts into a Web page file so viewers can access specific typefaces without needing to download or add the fonts to the brows-er's hard drive. *WebWorks* explores how these same designers have overcome the Web's typographic limitations, presenting a variety of alternative design solutions.

A vital link between the design and communication of a specific message, font selec-tion is a critical part of any graphic design project that employs type. *WebWorks* opens the doors to the vast world of type and typography. It's a valuable reference tool for both typeface purchasers searching for fresh fonts and type designers looking for inspiration and advice from the pros.

clicking into **Oblivion**

If you think that you're programming more and designing less, you probably are.

Even if you dispense with the illusion that the bulk of print work is primarily two dimensional, it's still important to note that new media design is not possible without compromise to that fourth dimension—time. While in the past we designed booklets intended to be read—from front to back and left to right through time—we relied on the persistent nature of the medium to ensure that each element would still be gotten to. It still had a chance. No matter how long it took to read the assorted pieces of the final product, the end user's ownership of the book or magazine or booklet would reliably contribute to the odds that it would be read. And even if the reader took it upon himself to browse the booklet backwards or in some random order as he sat there, it would still be impossible for him to completely skirt the intentional order or fail to recognize the implicit flow of information.

Strangely, however, now that time is more thoroughly under our control through animation, load sequence, and presentation length, we find ourselves less assured that content will be disseminated according to our intentions.

It's the nature of the Web that it allows data to be re-strung along any framework we can imagine, putatively without loss. Whereas it was once the job of the designer to carefully solve the problem of displaying information to fit the needs of the project, now it is perhaps the job of the database engineer. We can call ourselves information architects, data foundation planners, or Primary Lumination consultants (i.e., the guy who changes the light bulb), but it won't make one ounce more sense out of a senseless string of pure related data or encourage one more enthusiastic Web citizen to sit still for fifteen minutes straight without clicking into oblivion. Things are not always as they seem.

Throughout this book, you'll see some interesting examples of design in an ether where design no longer attempts to fulfill its principal purpose. If it seems as though these sites are designed to manage information, solve problems, and encourage the flow of the story, that is possibly an illusion fostered by the print display on these pages, which compresses and simplifies these sites, like a frozen slice of anatomical criminal. The design of these sites can't be reasonably replicated here in this linear, two-dimensional format any more than a cube can be reasonably replicated on a page without resorting to artificial 3-D perspective lines. The design isn't useful in this context when removed from the program/script/method. Daily, it becomes more difficult for one person to design graphics for a Web site without an eye toward their final implementation, and harder for a programmer to address a Web presentation without intentionally designing or placing text in such a way that it is geared toward a purpose.

Which brings us to Web typography. As much as it might sound advantageous for the type designer or typographer to steer reasonably clear of this whole mess, it isn't possible. The typographer who found himself or herself

to be the frontline of information dissemination in the past has a mixed and vague job description when confronted with this new medium. At the Open Type Jamboree held in early 1998 at the Microsoft Campus, there were many dissenting opinions on whether or not Web Font Object Embedding would violate current licenses for type vendors and their preexisting (legacy) typefaces. As might be expected, most of the discussion revolved around whether embedded type on the Web most closely resembled type applied to documents and distributed, or type embedded within applications and sold. The first would obviously be covered under the terms of most licensing agreements but the second is an issue to be examined by users and type suppliers alike.

It's no longer a matter of whether to assume a bulk of your audience has Comic Book Sans and Arial Black installed on their computers. Type designers and typographers working within existing technology have new questions in front of them now, related to an individual font's ability to represent itself in the various ways demanded by the Web. Type can't afford to be just for the printer now, any more than design itself can. It has to be fluid and fourth dimensional as well if it intends to compete with imagery in this medium in the same way traditional typography evolved to meet the needs of computer imaging. If type is to stay relevant to the increasing number of Web users, the term "text only display" needs to be stretched around a progressively larger chunk of our imagination. One day the sort of experimentation that made the fonts Beowolf and Cosmik so unique may be applied across all

the interactive media. Fonts with rollover and depress alternates, fonts with integrated orthographic alterations, fonts that morph between weights and styles over time, and fonts with stand-alone animation algorithms may become commonplace. The proliferation of applied hypertext environments and non-linear authoring applications is the first step toward this dynamic, living model for type. As a result, our children may look through printed books interpreting all stylistically underlined words as "nodes" leading to ancillary topics. We already automatically click on every underlined word we see, even at the supermarket. To testify to the universality of this phenomenon, we've only been ejected twice.

Of course, there was a little person inside our heads who had been trying to tell us that navigating the vast number of options in various page-layout programs was somehow becoming more than merely designing and setting type, but we hadn't listened. We no longer have the freedom to decide where type and image meet, where document and application meet, or where designer and programmer meet. We've lost those freedoms sequentially through Web placement of typography, integrated and managed site applications, and now the new routines of information display. What we've gained, however, is a complexity that will one day allow for the fittest idea to emerge, unrestrained by images, animations, type or format.

Carlos Segura and Jim Marcus
T-26 Fonts

65

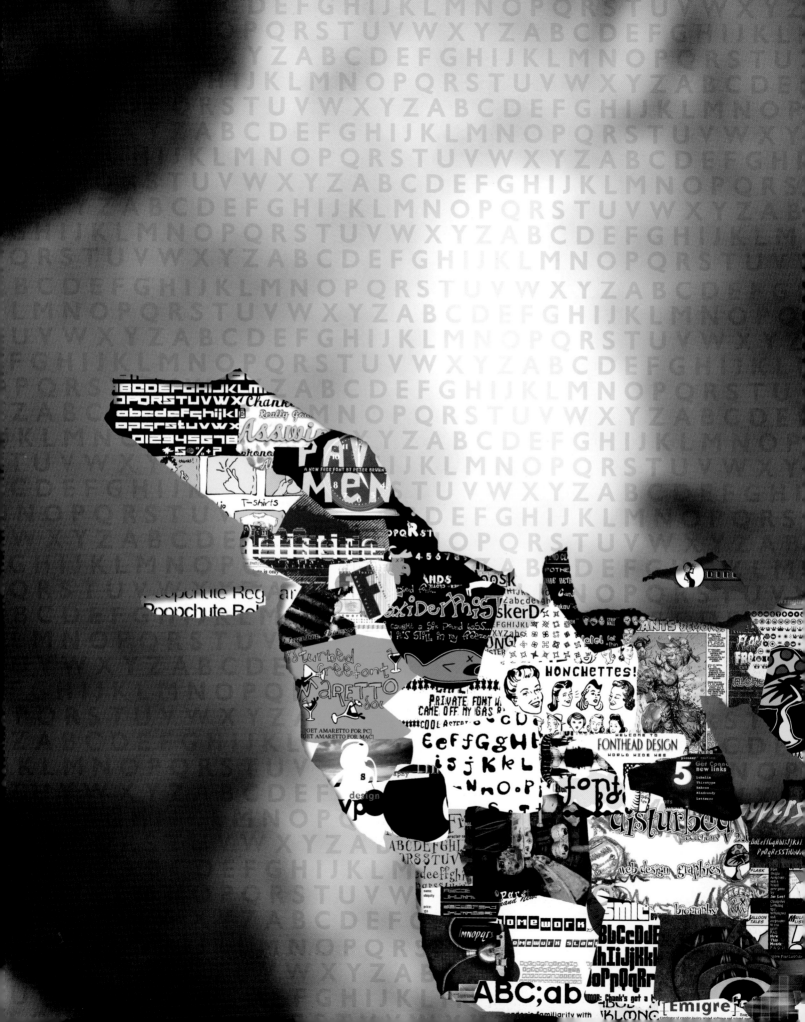

Type on the Web

Despite being limited by poor resolution, many have turned their efforts on the World Wide Web toward typography. The popularity of type design software and ease of the Web have put the control for selling and distributing typefaces in the hands of the type designer. This freedom to sell and market one's own type has lead to a Renaissance in type design, with more and more designers releasing new faces at a daily rate.

Countering this new fascination with type design is the ease with which font files can be passed around using the Web. Sites that do nothing more than collect font files to give away for free appear at an alarming rate. While many of these sites do deal only with freeware and shareware faces, a number of them contain font files that are commercial faces or 'knock-offs': font files that have been renamed and sold or given away by someone other than the original publisher. By downloading these files and using them on your computer you are probably breaking the law.

As a member of TypeRight (www.TypeRight.org), I have a set of guidelines that I recommend to anyone who is concerned with font files that they find on the Web. When you are looking through the many type-related sites or searching the font archives of the web it pays to remember these three rules.

1. The best source for a typeface is the designer of the face.

Many shareware designers have Web sites online where you can get free samples of their faces. By using their sites to download faces you are letting them know that you appreciate their effort, and if you have problems with their files they are better able to help you than the people running archives.

2. If the font does not have a Read Me file attached, don't use it.

Type designers generally want you to know who designed a typeface. With shareware and freeware faces there is generally a Read Me file with the font that lets you know about the typeface's designer and how he/she can be contacted. Archives which have fonts without Read Me files either have commercial faces or 'knock-offs' in their collection.

3. If the owner of the site is not taking responsibility for the files there, stay away.

Many Web sites have fonts for downloading with a disclaimer that says the owner of the site is not responsible for commercial faces being available. Would you shop in a store that might be selling stolen goods that could get you arrested? You would be doing the same thing by downloading fonts from a Web site that does not take the time to check their own legality.

Even with the limitations of the Web, it is a very exciting medium for typography. While type designers and the people who use their type continue to explore the capabilities of the Web it is good to remember that everything you see on the Web is not free, even if it says it is.

Chris MacGregor
chris@macgregor.net

ARTISTICA MAGAZINE

■ ● ● ● ● ●

Artistica Magazine is a monthly e-zine that promotes experimental typographers and type faces. Three new fonts are designed in-house for each issue. The works of other type designers are also presented in the e-zine's Fontworks Gallery. Each showcase page is linked to the typographer's or type designer's own site.

Based in Louisiana, Artistica's founder and lead designer, Carlos R. Canas, has been developing Web sites for the past two years. Like many Web designers, Canas is completely self-taught in this medium, but had some formal design training. As far as type design goes, he thinks the hardest part was, and at times still is, learning how to use font-creation software such as Fontographer correctly. He feels that type design and typography are two of the highest forms of graphic design possible, stating, "It's creating the tool without which we could not communicate in the same way."

Canas' advice to aspiring type designers is to take care in the development process. Be willing to learn about lettering. Look at books, magazines, and Web sites. See what's current in design. Look at typeface catalogs. "Don't just slap down some simple type designs to make a quick buck or to get popular," he warns. "If you're serious, make a font and learn from your first one how to make your next one better. With the new software available these days, anyone can slap up a type foundry. However, real designers never quit. And like all fields, those who stay true to type design will set the new level in typography."

"Typography is both intellectual and emotional. When you first start off developing type, you can't do anything but feel the joy of seeing your own creation in a list of very historical and respected ones."

e-mail: crch@artistica.org

Artistica's Fontworks Galleries feature new type designers and typographers. Each review showcases a select Web site and provides a hypertext link attached to an image so viewers can experience the complete Web site.

When Artistica started, the designers were unaware of compression programs and aimed at having decent downloads geared for a 28.8 modem. However, as the magazine has matured, so have the designers' techniques and they have discovered some alternatives: piecing together graphics instead of creating one huge image, applying compression and optimizing programs, and producing smaller graphic images.

IO GRAFIX / TIPOGRAFIA

KKLLMMNN
TTUUVVWW
12345678
+=|\{}[]

AaBbCcD
KkLlMmN
TtUuVvW
12345678
+=|\{}[]<>

...dered who made international typefaces. I finally
...us US folkd just put out a set of 26 uppers and
...t a complete set! Well, Europe is always showing
...re more letters in their alphabets, which means
...re complete type faces produced by europeans!
...think? Well I suppose it should be so...
...t least, but anyhow, I introduce to you Iñaki
...ain. I say I've never seen such structured fonts
...tters aren't your average grunge type... but rather,
...cally speaking, they're very artistic. I was really
...y they are free, I don't know... maybe Iñaki could
...k him, and while you're at it, thank him for the
...how you for March! Oh and don't forget to visit

AaBbCcDdEe
NnOoPpQqRr
0123456789
+=|\{}[
ōçêêēïÄÅÈ

The site's main text is written in HTML which improves both production and download time. But to heighten the visual effect of each page, graphic text headers using in-house typefaces are incorporated into the design.

Artistica is most frequently designed in plain sans serif faces. The design blends type and image into an effective, communicative whole. Canas believes the western world is finally seeing type in a new perspective. He notes that Japan, China, and Arab countries take greater pride in type, creating more visual characters, and using both horizontal and vertical type placement to communicate.

71

fluII capacitor by rob dobi karloff by rob dobi hyper kinetic by rob dobi **ARTISTICA**

| Fonts | What Tha? | Buy 'Em | Say Hi | Other Crap | Free Stuff | Unfinished Fonts |

Welcome! **Updated** April 14th. Every font family is **Now Only $10!**
We've been busy here lately! We have a new **FREE** Font: Grumpybutt
Buttwriter is finished and we also have a print catalog that
I'll send to you upon request. I've been developing my **portfolio** pages and
I designed a website for a cool recording studio: **Freeworld Digital.**
Our new **FREE** font: **Buttweasel** and our our cool dingbutt Font: **Buttheads**
are also here! I also added a link to My Russian Friends Page.
Come back often and as always, don't take any crap… :)

Location: | HTTP://WWW.BUTTFACES.COM

BUTTFACES DIGITAL TYPE FOUNDRY

■

Hailing from Dallas, Texas, Tobias Tylus of Buttfaces Digital Type Foundry is a one-man operation. He tries to produce new faces every few months. But lately he's been busy with Web design and general design department business at his day job. He still has a backlog of fonts that are either in the design stage or partially finished.

His Buttfaces site and fonts depict the irreverent whimsy and sense of fun that he personally believes should exist in an unre-stricted creative outlet. He always keeps his eyes open to spot something that will gener-ate an idea: signs, graffiti, traditional comic books, underground comic artists like R. Crumb, and cartoons.

It all started about twenty years ago when he was ten years old, looking at the labels on his mother's cosmetic products while spending time in the bathroom. (Hence, Buttfaces.) He eventually doodled on enough math class notebooks to get himself a design degree and a graphic design career. Doug Harp of Harp & Company made him realize that design is not all about Swiss-style design grids, Helvetica, and minimalism. He inspired Tylus to have fun.

Tylus thinks that it is possible to become a self-educated typographer, saying, "I think that we are all typographers in one sense or another. We all create messages with hand-writing that can influence others, and we are all influenced by visual presentation of the written word."

His advice to newcomers is to get into the business for the love of typography. He also adds that the type design business does give good designers the satisfaction that "your creations can help to influence people and cause change."

> **"** I think we will see a trend that will take us back to the basics for a while with clearer layouts and less illegibility. Certain markets such as video and computer-game advertising, music television, and other ads aimed at the youth market will proba-bly stay with a more raw approach. I think Generation X has become comfortable with this degenerated look and identifies it as its own. **"**

e-mail: tobiast@buttfaces.com

................ ■

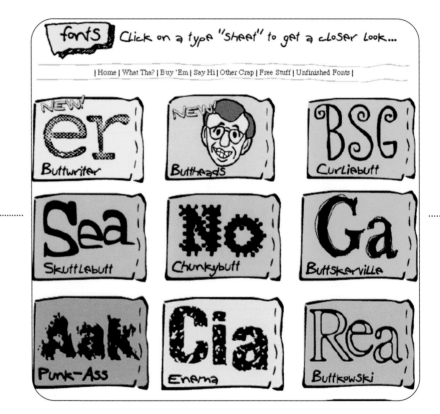

Tylus believes if you can't keep viewers' attention long enough to see your message they may leave and probably never return. Tylus uses HTML text

for long blocks of information if it's not pertinent that the font convey the mood or tone of the site and to help decrease download times.

Tylus knows he's got a good mix of both print and Web/New Media designers visiting his site, even though he doesn't track every hit, which can be costly on most commercial servers. He has a guest book that users can sign and be put on

either his e-mail or snail-mail lists to receive a print catalog.

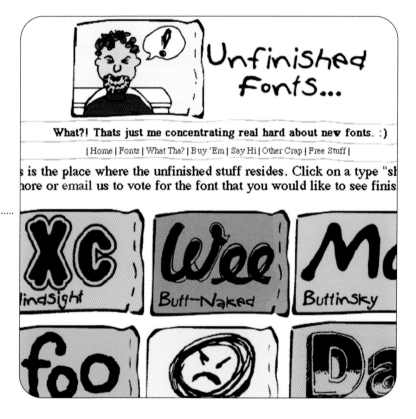

The power of the written word is a magical thing. People are familiar with typography and can be affected by it greatly. Tylus thinks it's great that type is making a comeback in ads and Web design. Making typography more visually interesting and dynamic helps to attract and hold the attention of the viewer and probably explains the experimental use of type.

As Tylus explains, "You won't get rich creating fonts but you can receive great satisfaction from it. Selling on the Web is a great way to close a sale. People tend to lose their enthusiasm if they have to write a check and wait. On-line ordering is the key."

enema buttkowski headbutt BUTTFACES DIGITAL TYPE FOUNDRY

CHANKSTORE

■ ■

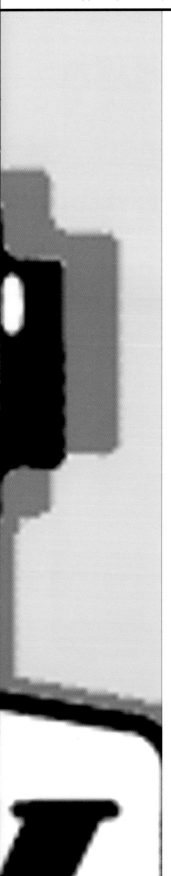

"I hate junk mail. And I'm reluctant to send out e-mail. But with the Font-of-the-Month Club I know I'm giving each person something. I'm going to send out treats that they can hold in their hands a couple of times every year, too. **"**

"I'm trying to turn new people on to fonts" Chank Diesel says. "There are a lot of them out there; a lot of people who aren't designers, that don't build Web pages, who just think fonts are cool for writing letters to their friends. Those are the people I'm trying to reach." Not every type designer with a Web presence aspires to see his fonts used in a flyer that says "Garage Sale This Weekend." But the twenty-nine-year-old Diesel admits that from his Minneapolis studio he maintains a Web site that gives away about 100,000 freeware fonts per month and 80 percent of those are downloaded by PC users. The fonts he actually sells on his site are purchased by Mac users.

His typographic influences come from popular culture sources such as *Sesame Street*, Dr. Seuss, Peter Max's early commercial work, and comic books. "*The Electric Company*, too," Diesel adds. "Do you remember that guy who ripped a letter off his chest, threw it at a word, and changed it? That guy ruled!"

The Chank Army of type designers featured on the Chankstore site is mainly made up of people who are making fonts because they're bored with video games: this is just a new game for them. Creating the alphabet is something they do for fun. As Diesel remarks, "You know everything about the alphabet that you're going to know by the time you're ten. You've learned all the letters and you just keep working with them, and after six or seven years, you're good." Because of this natural affinity for the letterform, Diesel encourages all aspiring designers to try creating fonts.

e-mail: info@chank.com

▪▪▪▪▪▪▪▪▪▪▪▪▪▪▪▪▪▪▪▪▪▪▪▪▪▪▪▪▪▪▪▪

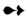

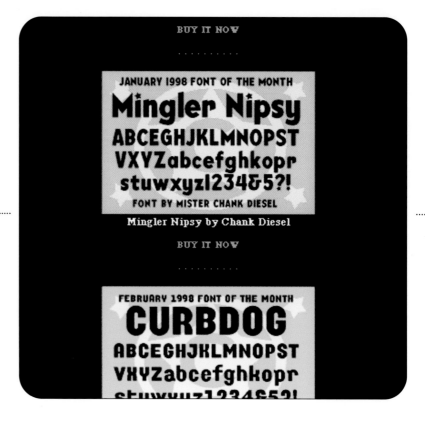

Diesel admits to having a short attention span: if his page doesn't load in fifteen seconds he doesn't think anyone is going to look at it.

He generally puts one simple, static 4-bit picture on the top of every page and occasionally a little 4-bit animation at the bottom of every page, and with HTML text in the middle. That's it.

There are a lot of different ways Diesel gets people to visit his site. Every time somebody buys a font or sends mail to his post office box, he sends them a packet of goodies: trading cards, a type catalog, a disk, and some wrapping paper.

He doesn't think many actual sales come from direct mail, but it does bring people to the site.

... the fonts of chank diesel ...

INSTANT PLEASURE

CHANK STORE

Ammonia
Badoni Asswipé
osmic
Bonehead
Brainhead

CHANK'S ARMY

AN ARMY OF CLOWNS

There's another marketing trick he uses on the site. "There's a page that shows a coupon," he explains. "You print it out and send it in with a check or money order."

Diesel has sixty-eight paying members in his Font-of-the-Month Club right now. He's building the font club pages the same way he built his successful free-font pages over the past two years: create a font, display it on a Web page, and let people download it. He simply e-mails club members that the font is ready and where to download it.

mister frisky space toaster badoni CHANKSTORE

Location: HTTP://WWW.GIRLSWHOWEARGLASSES.

DINCTYPE

■

Created by type designer and typographer Diane DiPiazza, Dinctype is a type design company located in Lodi, New Jersey. Besides distributing high-quality, original fonts, Dinctype's Web site is intended to convey a sense of the "carnival-like" feeling that DiPiazza herself gets when she stumbles onto a particularly great Web site.

All dincFONTS featured on the site were designed by DiPiazza, which she says sometimes makes it difficult to feature new fonts. "Rather than work on one typeface straight through, I'll start five or six different designs," she admits. So most often, she'll release a whole group of fonts simultaneously.

DiPiazza views design in general as a form of fashion, a trend that comes and goes, which she feels is a good thing. According to her, it's the best thing about design: the freshness, the newness.

Influenced by television, print, pop music, and popular culture, DiPiazza studied and worked in the graphic design field even though she never received a formal design education. And as she admits, "I don't think anyone could say designing typefaces is easy. It's pretty difficult starting out. Just from the standpoint of working with the computer software alone; it's very meticulous. Each letterform has very detailed construction. But at the same time, there's the big picture: those difficult elements make a typeface unique and interesting. So another step in the process is to continue to evolve those letterforms into a new typeface."

DiPiazza advises aspiring type designers to keep learning about their craft. "It's very challenging," she says, "whether you're first starting out or an experienced type designer. I think the nature of typeface design is that there's always more to learn."

"

I really consider myself to be a student of popular culture, which is ever-changing. There's always more to learn, always something new, always a new direction. That's really indispensable to me: the willingness to learn.

"

e-mail: dinc@girlswhowearglasses.com

■ ■

Updated 04.17.98

Be sure to see our newest free fonts, Carlie and Carlie Bold just for you from Meir Sadan. Available in both Macintosh Postscript and PC True Type formats, download Carlie on our Free page. Don't forget to say thanks to Meir!

We have two new dinc! commercial fonts: Kingbats and Whatnot. See the new Kingbats and Whatnot Font Family on our Fonts page. The Whatnot Font Family is also available from Fountain, the friendly type foundry.

Free Stuff!
Get a bunch of dinc! promo items free with your font order. Yo-yos, pennants, rubberducks. See them here.

Brand New:
dinc T-Shirts

Individual dincFONTS are $29US. dincFont families are $49US. The dinc Six-Pack offer allows you to purchase any six individual fonts of your choice for $99US. Complete font families cannot be applied as one font in this Six-Pack offer. Individual styles from font families may be chosen as one font. To see the fonts, click on the name and a new browser window will open. When you're done viewing the page, simply close that window. This page should still be here for you to make additional selections.

Kingbats
Whatnot
Speedometer
Dinette Font Set
Roundup
Bit-Thing
Thinman
Homework
Alvin
Sugar
Recordhop

Loading time is so important to the Web medium that slow-to-load really equals bad Web design according to DiPiazza. She keeps the dimensions and the file size of her graphics small and minimizes the number of colors. She also uses an Adobe Photoshop plug-in called

PhotoGif from BoxTop Software which works well to reduce GIF sizes. "It's really helpful in using the least amount of colors possible, without sacrificing the quality of the graphics," she says.

DiPiazza makes sure that she doesn't sacrifice the Web site's design to make pages download quicker, but she also understands the limitations of bandwidth and stays away from any unreasonable designs that could hamper downloads. She considers the Web to be a unique medium that must be developed to create a pleasant overall experience.

Most dincFONTS are display faces created to be used in sizes over 18 points in height. DiPiazza uses them in the graphic-text headers that appear on each page and within the graphic images created to promote each typeface.

DiPiazza sees most modern typefaces as being so elaborate and unique that they are design elements in themselves. Most dincFONTS fall into this category. "Since I really approach design from a 'less is more' standpoint, I choose type depending on whether the type itself is the design element. If it is, I design around the type, making the type the page's main graphic. If some other element needs to stand out more than the type, I use very generic type," she explains.

loverboy

amplifier

jetace

DINCTYPE

graphic design related software a

ing with the birth of the Macintos

f centered around personal compu

ce designs created by a roster of

illustrations is available in Type

[Emigre]

Emigre, Inc. is a digital type foundry, publisher and distributor of graphic design related software and printed materials based in Northern California. Founded in 1984, coinciding with the birth of the Macintosh, Emigre was one of the first independent type foundries to establish itself centered around personal computer technology. Emigre holds exclusive license to over 200 original typeface designs created by a roster of contemporary designers. Emigre's full line of typefaces, ornaments and illustrations is available in Type 1 PostScript and TrueType for both the Macintosh and PC.

Emigre's designs have won numerous awards; Emigre is the 1994 recipient of the prestigious Chrysler Award for Innovation in Design and the 1996 Publish Magazine Impact Award. Emigre is also the 1997 recipient of the AIGA Gold Medal Award and the 1998 Charles Nyples Award.

This electronic version of the Emigre product catalog includes full color images of all Emigre Magazine back issues and posters, as well as specimens of all Emigre Fonts.

gns rous awards;

n in 1996 Publish

On-Line Catalog / Site Contents 5 Ways to Order Latest Releases Special Offers Artist Index & Bibliography

leda e 1998 Charle

Location: HTTP://WWW.EMIGRE.COM

EMIGRE

■

Based in Sacramento, California, Emigre encompasses a number of operations including a type foundry, magazine, and graphic-design software division. Co-founded by the husband-and-wife team of Rudy VanderLans and Zuzana Licko, this studio has been around as long as the Mac itself (circa 1984). In fact, it's the main reason why Emigre got involved in type design: there weren't many typefaces available for use on the Mac when the couple established their magazine. Consequently, form followed function.

And although their first type designs were bitmap-fonts that could be output on a dot-matrix printer, Emigre became one of the first independent digital type foundries to establish itself. Their repertoire now includes styles ranging from revivals and traditionals to purely experimentals. At first, most of the typefaces were created exclusively for use in *Emigre* magazine. The foundry also represents the work of an international collection of type designers including VanderLans, Jonathan Barnbrook, the team of Eric Donelan and Bob Aufuldish, Frank Heine, Miles Newlyn, Claudio Piccinini, and Just van Rossum.

" Just like the ability to calculate the tangent with a calculator does not bring the user any closer to understanding the inner workings of geometry, the latest desktop publishing applications will not bring the lay person any closer to understanding the inner workings of design. But it gives the illusion of doing so. "

Licko's latest interests lean toward more traditional text faces: a direct result of *Emigre* magazine's need for appropriate fonts that can be applied to lengthy text blocks. In fact, Mrs. Eaves is her revival of Baskerville. Named after Sarah Eaves, the typeface pays homage to the woman who completed the printing of the unfinished volumes that her husband John Baskerville left upon his death.

To Licko, the most successful experimental type designs are often those that address new needs arising from new technology. "As we go forward with ever increasing speed to faster and more powerful computing," Licko comments, "it will offer us an ever growing number of choices, it will be crucial for designers to become ever more knowledgeable about selecting the most appropriate choices from an increasing availability."

e-mail: info@emigre.com

■ ■

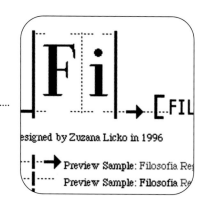

designed by Zuzana Licko in 1996

Preview Sample: Filosofia Re
Preview Sample: Filosofia Re

Emigre, Inc. is a digit
tributor of graphic design related software and printed materials based in F
4, coinciding with the birth of the Macintosh, Emigre was one of the first
ablish itself centered around personal computer technology. Emigre holds
ginal typeface designs created by a roster of contemporary designers. Emi
aments and illustrations is available in Type 1 PostScript and TrueType fo

igre's designs have won numerous awards; Emigre is the 1994 recipient o
Innovation in Design and the 1996 Publish Magazine Impact Award. Emi
GA Gold Medal Award and the 1998 Charles Nyples Award.

s electronic version of the Emigre product catalog includes full color imag
ues and posters, as well as specimens of all Emigre Fonts.

n-Line Catalog

Site Contents

ORDER

5 Ways to
Order

NEW

Latest Releases

$

Special Offe

EMIGRE MAGAZINE Emigre magazine was initially a vehicle fo
of its founders. Since then it has grown to become one of America's most controversial
design publications, featuring the work and writing of a new breed of designers and des
the world.

Subscriptions

Upcoming
Issue

Current
Issue

Back
Issues

Collectors
Issues

SINGLE
FONTS
$39

EMIGRE FONTS Emigre's original typeface designs, which were
exclusively for use in the magazine, and created specifically for digital typesetting, are c
Macintosh and PC users worldwide. Emigre's growing library of typefaces includes de
Andresen (USA), Jonathan Barnbrook (England), Barry Deck (USA), Eric Donelan &
John Downer (USA), Edward Fella (USA), Frank Heine (Germany), John Hersey (US
(USA), Zuzana Licko (USA), P. Scott Makela (USA), Conor Mangat (England), Nanc
Kelly (USA), Miles Newlyn (England), Claudio Piccinini (Italy), Just van Rossum (Ho
VanderLans (USA).

Licko knows the main reason designers come to
the Emigre site is to purchase specific fonts and
find information about the foundry. To make

finding the fonts and their families simple and
quick, a site map was created with links to all
available families, font volumes, and other
areas of interest within the site.

Rather than try and duplicate the well-known
magazine on the Web, the Emigre Web site

includes full-color images of *Emigre* magazine's current
issues, and a listing of all back copies, as well as text
describing what each issue is about.

we plan to expand this section to incl...

Choose
A - D
E - K
L - P
Q - Z

Artist
Index

LUST
PETER MAYBURY
JACK STAUFFACHER
LORRAINE WILD

migre]

TS:

e Catalog Main Page] [New Product Releases] [Special Offers]

[Bibliography] [Sample Articles]

Upcoming Issue] [Current Issue]
ollectors Issues] [Newsstands and Bookstores]

] [41] [40] [39] [38] [37] [36] [35] [34] [33] [32] [31] [30] [28] [26] [24] [23] [22] [21] [20] [19]

S : [3] [7] [8] [11] [14] [16] [17] [18] [25] [27] [42]

nation] [Volume Offers] [Formats & Licensing] [Character Sets]
nes] [View by Family] [Design Information] [Special Font Features]
[Frequently Asked Questions] [Custom Font Request] [Font Audit Form.]

[Arbitrary] [Backspacer] [Base 9&12] [Base Monospace] [Big Cheese] [Blockhead] [Citizen]
Democratica] [Dogma] [Elektrix] [Exocet] [FellaParts] [Filosofia] [Hypnopaedia] [Journal]
[Mason] [Matrix] [Missionary] [Modula] [Motion] [Mrs Eaves] [Narly] [NotCaslon]
at] [OutWest] [Platelet] [Quartet] [Remedy] [Sabbath Black] [Senator] [Soda Script] [Suburban]
plate Gothic] [Thingbat] [Totally Gothic] [Triplex] [Variex] [Whirligig] [ZeitGuys] ["Coarse

Single Fonts

S :

NEW Latest Releases from Emigre

[EMIGRE MAGAZINE.]

 Current Issue: Design as Content

Next Issue: (To be announced.)

[EMIGRE FONTS.] SINGLE FONTS $39

Hypnopaedia Patterns Designed by Zuzana Licko	Base Monospace Narrow Designed by Zuzana Licko	Base Monospace Wide Designed by Zuzana Licko	Filosofia Regular Designed by Zuzana Licko	Filosofia Grand Designed by Zuzana Licko
140	6	6	5	4

A basic color palette of red, blue, and black used through-out the Web site creates a clean and professional look and allows viewers to focus on the content of the pages, as well as offering extremely fast downloading of each page.

One of the problems with offering too much graphic imagery within the navigational structure of a Web site is making it clear where links are located, so Emigre's designers clarify this by color coding each link with blue HTML text, and implementing graphics only as headers and small graphic elements within each page.

citizen

emigre

exocet

font boy™

= baroque modernism for the new millennium =

fontBoy is a digital type foundry established in 1995. All fontBoy fonts feature the complete character set
and are available in Macintosh Type 1 format only.

In its short history, fontBoy fonts have been published by The Type Directors Club, in Graphis Digital Fonts 1,
and in "Faces on the Edge: Type in the Digital Age."
+++
The fontBoy interactive catalog has won awards from The Type Directors Club, Communication Arts
Interactive Design 2, ID Magazine's 42nd Annual Design Review, and was published in
"In Your Face: The Best of Interactive Interface Design."
+++
An older version of this site was published in Graphis Web Design Now.

CATALOG ORDER INFO NEW RELEASE

Location: HTTP://WWW.FONTBOY.COM

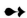
FONTBOY

■

" I try to focus on the exuberance of it all, rather than the back pain. **"**

FontBoy's founder, Bob Aufuldish, drew very few letterforms when he was in design school. And typography itself didn't make much sense to him until he learned how to print on a letterpress. The physical nature of the type-setting process opened his eyes. Then he started playing with photocopies of type which, as he puts it, "was a crazy, wacky tool like a Macintosh" in its day. It's been a few years, but now he truly appreciates the accomplishments of typographic giants such as Adrian Frutiger and Herman Zapf. "Not that I want to design type like theirs, but their craftsmanship is quite unbelievable." However, as he also admits, the learning curve is getting steeper for him as time goes on.

Based in San Anselmo, California, Aufuldish teaches design in San Francisco and does all sorts of work to please himself, taking photographs, making music, developing typefaces, and designing for clients (along with partner Kathy Warinner). With such a heavy work load, it's no wonder that he only releases two type families a year and has a backlog of about five years' worth of ideas. But he's not concerned about keeping up with prolific peers such as Emigre's Zuzana Licko. What he has learned in all this time is that he has become aware of his own past work and how a present project is or is not an improvement on the previous work.

Aufuldish offers a few words of wisdom for aspiring designers. The first is to follow your muse and not the prevailing trends. The second is not to sell your typefaces too cheaply. Even if it's a hobby, it's important that people don't think of type as a cheap, inexhaustible commodity. (Although, as he sadly admits, this has already happened.) And last of all, people will want to see a printed catalog of your typefaces even if you're selling and distributing them on the Web.

e-mail: bob@fontboy.com

. ■

ne a fisherman st
the shore and cast
into the ocean. I
he immensity of
and the inconseq
rame of a human be

a fisherman standing o
nd casting a line into the
the immensity of the Pacif
onsequential frame of a hun
at an astonishing act;
surd image. To expect to
hing under these

CATALOG

armature

m a t u r e : four font family: $95 = designed by Bob Aufuldish, 1992-97
{light} {regular} {bold} {extra bold} {text sample} {special characters}

baufy

b a u f y : five font family: $95 = designed by Bob Aufuldish, 1994
mal} {medium} {bold} {bulky} {chunky} {text sample} {special characters}

PUNCTUAL

n c t u a l : fourteen font family: $150 = designed by Bob Aufuldish, 1998
special pricing: punctual four : six font family: $95
{punctual} {punctual universal}

r o a r S h o c k = 1 2 0 dingbats: two font family: $60 = designed by Bob Aufuldish, 1997
special pricing: any two families for $110; all three families for $150
{roarShock 3} {roarShock 4}

r o a r S h o c k = 1 2 0 dingbats: two font family: $60 = designed by Bob Aufuldish, 1997
special pricing: any two families for $110; all three families for $150
{roarShock 5} {roarShock 6}

VISCOSITY

v i s c o s i t y : three font family: $75 = designed by Kathy Warinner and Bob Aufuldish, 1996
{regular} {inline} {interior} {text sample} {special characters} {swell feature}

Whiplash

w h i p l a s h : three font family: $75 = designed by Bob Aufuldish, 1994
{regular} {monospaced} {lineola} {text sample} {special characters}

Aufuldish uses HTML text for information content and graphic text for type samples and other imagery. He sees HTML text as neutral, providing a simple, unadorned frame to surround his typefaces. However, as he admits, "This is making a huge assumption on my part: that no one has spec'd anything too crazy as their default font."

Download time is a major consideration in the design of the fontBoy site. Aufuldish recognizes that he is selling a product on his site. Therefore, he caters to his visitors' patience level by keeping his download times short. The largest image in the site is 11K.

ine a fisherman standing on the
and casting a line into the ocean.
ine the immensity of the Pacific and
nconsequential frame of a human
. What an astonishing act; what
bsurd image. To expect to catch
thing under these conditions is
st pathological. The odds of
ess are apparently miniscule.
pursuit of meaning is an even
astonishing act as we cast into
stly greater ocean. It requires a

Imagine a fisherman standing on the shore and casting a line into the ocean. Imagine the immensity of the Pacific and the inconsequential frame of a human being. What an astonishing act; what an absurd image. To expect to catch something under these conditions is almost pathological. The odds of success are apparently miniscule. The pursuit of meaning is an even more astonishing act as we cast into a vastly greater

Aufuldish notes that many fonts lose their crispness when manipulated in Adobe Photoshop and converted into GIF format. He has become very critical about the fonts selected for use in the actual design of the Web site.

Aufuldish has decided that a typeface has to rasterize at a small size (especially bitmapped) to be used in fontBoy's Web pages. If the font is illegible or choppy in appearance in a 6-point setting size, then it cannot be used in a Web page design.

viscosity

whiplash

dingbats

WELCOME TO

FONTHEAD DESIGN

WORLD WIDE WEB

Click the illustration above to enter our site!

In business on the 'net since November 1994.
Serving over 40 countries.

Contents © 1998 Fonthead Design

Location: HTTP://WWW.FONTHEAD.COM

FONTHEAD DESIGN

" I think we have already seen the mediocrity that has resulted from the popularity of Grunge fonts and the ease of digital font creation. **"**

Ethan Dunham of Fonthead Design believes that the type design field is highly competitive. "There are hundreds of type foundries on the Web trying to establish themselves and gain 'mindshare' with graphic designers," Dunham comments. "We try to keep ahead of the game by tracking trends in the graphic design world. We review design annuals, competitors' type catalogs, Web sites, magazines, and books."

Releasing new typefaces twice a year, Dunham has always been strongly influenced by whimsical art and design, stemming from an interest in children's books. Dunham also has a Bauhaus streak which manifests itself in highly modular typefaces created on tight grid systems. Legibility is very important in Dunham's work since he believes in creating type that communicates to the general public rather than a specific, elitist audience. "I am trying to add to the vocabulary of graphic communicators," Dunham says. "Not to change the language they speak."

Located in Boca Raton, Florida, Dunham studied design at Rochester Institute of Technology in upstate New York, but didn't become interested in type design or Web development until after graduation. However, his father (a professional furniture designer) and mother (a professional potter) had a great impact on Dunham's approach to typeface development: they instilled a sense that a typeface is a functional piece of art created for a purpose.

Excited that people are exploring new ways to communicate with typography, Dunham encourages novice designers to make usable typefaces. "Be original and try to offer something unique," Dunham says and adds, "designers aren't looking for fonts that have been done before."

e-mail: info@fonthead.com

93

Blearex
AaBbCcDdEeFfGgHhIiJj

BROIGA
ABCDEFGHIJKLMNOPQ

Gritzpop
AaBbCcDdEeFfGgHhIiJjKk

TZPOP GRU
EFGHIJKLMNOPQRSTU

handskriptone
abcdefghijklmno

HolyCow
AaBbCcDdEeFfGgHhIiJjKk

WELCOME TO
FONTHEAD DESIGN
WORLD WIDE WEB

Click the illustration above to enter our site!

In business on the 'net since November 1994.
Serving over 40 countries.

Contents © 1998 Fonthead Design

FONTHEAD DESIGN
WORLD WIDE WEB

latest news

WONDERING ABOUT VOLUME 5?
▸We are hard at work on Volume 5. No promises can be made about the release date, but we will post samples as we prepare them. The fonts should be done sometime this summer!

FREE FONTHEAD TSHIRTS!
▸We had so much fun giving away tshirts recently, that we are extending our special. Buy any 4 volumes and get a free shirt! (We thought you needed something classy for your wardrobe

THE FONTS
Take a look at our huge collection of fonts with the online catalog.
Vol 4 | Vol 3 | Vol 2 | Vol 1 | Comic Fonts

HOW TO ORDER
Decided you need these fonts? Order securely online, by mail, or by fax.

FREE STUFF
Take home some goodies before you leave! Free fonts for Macintosh and Windows.

The Fonthead site incorporates HTML text for just about everything but the headlines and link images. This helps the site load quickly and makes it easy to read. It also sets up a strong graphical hierarchy throughout the site.

Dunham has received numerous comments about how fast his site is and what a pleasant experience it creates. His overall vision has been to keep non-essential graphics to a minimum. Fast loading sites do not have to be boring. On the contrary, Dunham welcomes the challenge to produce a site that's both simple and creative.

94 **WEBWORKS**

BECKETT
ABCDEFGHIJKLMNO

BlackBeard
AaBbCcDdEeFfGgHhIiJjKkLlM

BrownCow
AaBbCcDdEeFfGgHhIiJjkKkLl

ISEPIK
ABCDEFGHIJKLMNOPQ

JohnDoe
aBbCcDdEeFfGgHhIiJj

MatrixCiot
AaBbCcDdEeEfFgGhHiIjJkK

mekanek
abcdefghijklmnopqrs

SMITHPREMIER
ABCDEFGHIJKLMNOPQRSTUVWXYZ

TOUCAN GRUNGE
ABCDEFGHIJKLMNOPQRST

THE FONTS

Our font offerings now include over 60 fonts. Let these typefaces bring out your spicy creative side!

THEAD PRICES

me	$30
mes	$55
mes	$80
mes	$105
mes	$130
t	$15

LABLE FORMATS
intosh Postscript
intosh Truetype
dows Truetype
dows Postscript

VOLUME 1

VOLUME 2

VOLUME 3

VOLUME 4

COMIC BOOK FONTS

Home | **The Fonts** | How to Order | Free Stuff | About FHD | Feedback | Font Cookbook

VOLUME 1

Volume 1 | Volume 2 | Volume 3 | Volume 4 | Comic Fonts

$30

Allise
AaBbCcDdEeFfGgHhIiJjKk

BESSIE
ABCDEFGHIJKLM

Early on, the Fonthead site established a look and feel that involved three fonts. Allise is used on all titles and main headlines, while Samurai and Orion are used for subheads.

Dunham regularly checks the site's activity logs to track the number of hits and downloads: valuable data for future updates. The site also has a section that allows visitors to send feedback.

DOOMSDAY
ABCDEFGHIJKLMNOP

GOLIATH
ABCDEFGHIJKLMNOP

JOLLYJACK
ABCDEFGHIJKLMNOPQR

95

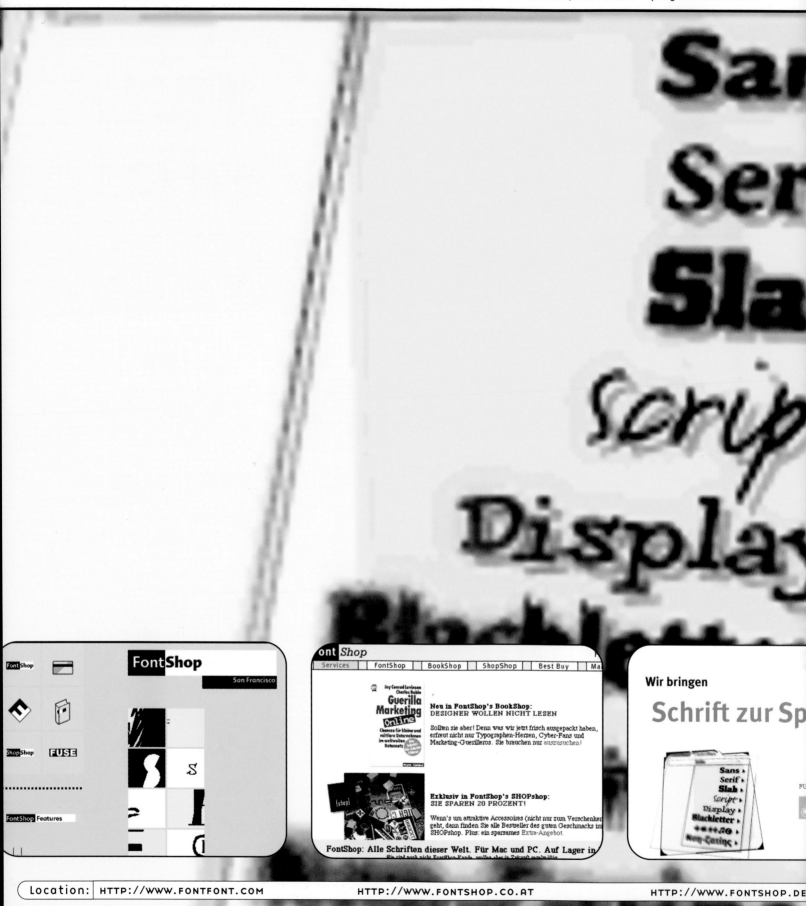

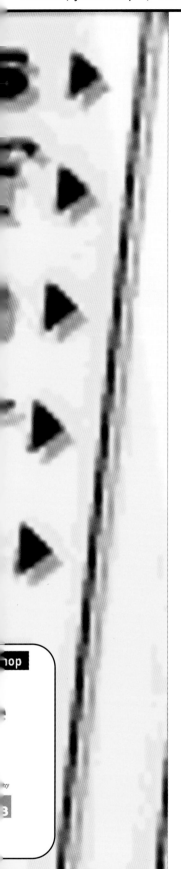

FONTSHOP

■

FontShop International publishes the Font-Font library of 1,100 typefaces which represents the work of ninety type designers from around the world, including members of the FontFont Type Board: Neville Brody, Erik Spiekermann, and Erik van Blokland. It maintains separate presences in the United States, Germany, and Austria, receiving 400 to 1,000 new type submissions every six months from individual type designers and smaller type foundries. Only 160 to 300 of those designs are chosen annually for inclusion in the FontFont library. Despite this huge volume of Internet traffic, the FontShop is a retail mail order company. Visitors can only download one free font off the Web site. Everything else is done via the post office.

> " Professional type users usually need good quality digital fonts with complete character sets which won't crash their systems. "

Ranging from crisp and classical to wacky and decorative, the FontFont Library has typefaces that suit just about every design style imaginable. No specific trend outweighs another in either inspiration or representation. As the San Francisco FontShop's Joan Spiekermann comments, "It is hard to say what influences the FontFont style other than the personalities and tastes of our Type Board. The criteria are originality and quality."

Spiekermann suggests that novices can pursue two options for getting published: "If someone is seriously looking to publish a font, submit it to one of the established companies such as Adobe, ITC, Agfa, or FontFont. If you want to publish under your own label, make sure you have an original collection: one that hasn't copied some of the many fonts available. Fonts are software, not shareware."

e-mail: sfo: info@fontfont.com • at: office@url.co.at

■ ■

fontshop sfo

fontshop at

fontshop at

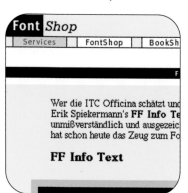

fontshop at

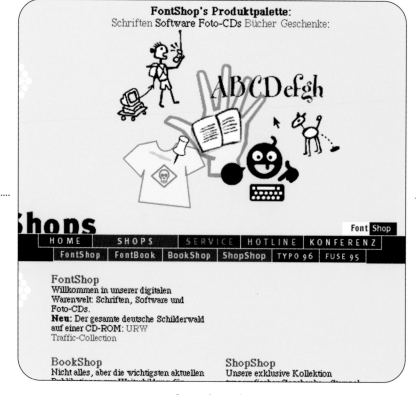

fontshop de

The FontShop sites employ a simple branding mechanism: the use of the corporation's logotype. Eric Spiekermann's FFMeta is employed in the sites' headline treatments which are executed in graphic text.

The FontShop's body text is executed as HTML text whenever possible. This allows search engines and Web crawlers such as Lycos, AltaVista, and Infoseek to index the appropriate content from every page in the site.

fontshop de

fontshop de

fontshop de

fontshop at

fontshop sfo

As Joan Spiekermann admits, "Most users are coming for a very specific reason and do not want to be burdened with long download times. These users are not coming for a 'site experience.'" Therefore, speedy downloads of each Web page are critical to the overall design of the site itself

The FontShop sites have big, bold colors and large areas of flat graphics, allowing for 3-bit or 4-bit optimization which reduces both download time and improves the visitor's view of each image.

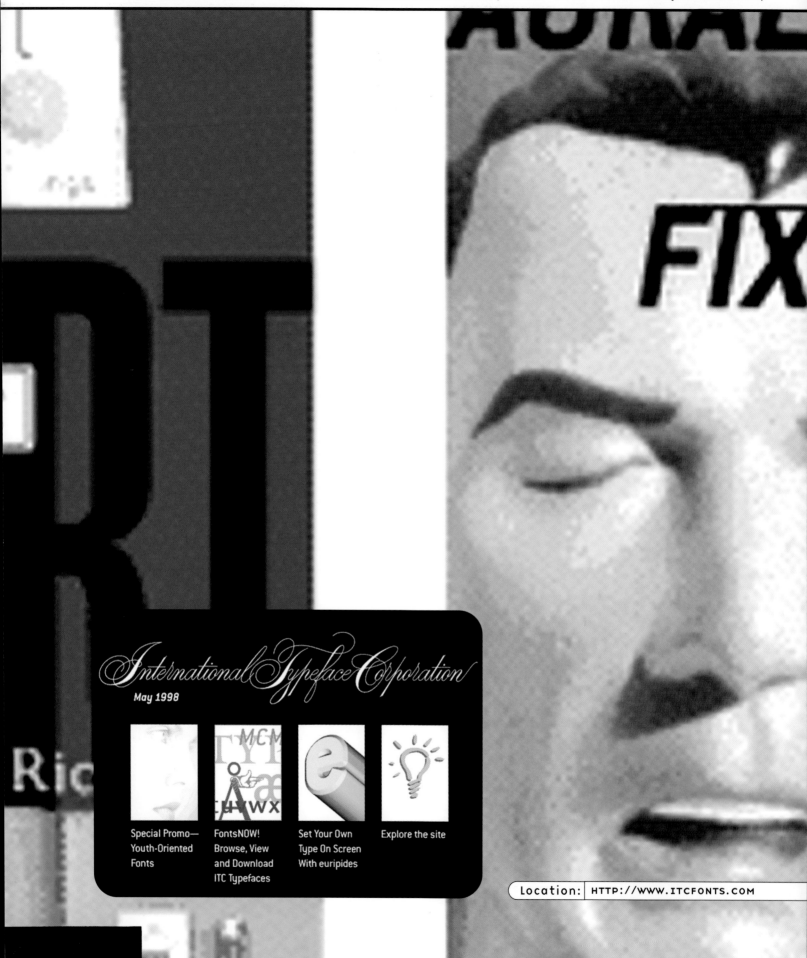

International Typeface Corporation

May 1998

Special Promo—
Youth-Oriented
Fonts

FontsNOW!
Browse, View
and Download
ITC Typefaces

Set Your Own
Type On Screen
With euripides

Explore the site

Location: HTTP://WWW.ITCFONTS.COM

INTERNATIONAL TYPEFACE CORPORATION
■■........

> ❝
> I admire Edward Benguiat who helped establish 'New York typography' in the 1960s and 1970s. Many of Ed's designs were for advertising and are not considered timeless. But I feel that history will prove him to be one of the giants in the history of type design. ❞

The script logo that appears on the opening page of the International Typeface Corporation (ITC) Web site was designed by one of ITC's founders—the late type designer and typographer Herb Lubalin. Located in New York City, this type foundry sells typefaces that can be found on almost every personal computer and in every typographic venue throughout the world.

The company was formed twenty-seven years ago to market the work of independent type designers, monitor sales of that work to both hardware and software manufacturers, and ensure that each designer receives royalties. The Web site is its latest marketing tool. Designed by Interactive Bureau, it is updated by ITC's in-house staff.

ITC's quarterly publication, *U&lc* (Upper and Lower Case), introduces the design community to new trends and typographic concepts. And ITC's Web site provides visitors to the foundry's vast font library as well as links to relevant information, sound files, animation, and a Web version of *U&lc*. ITC's director of development, Harold Grey, points out that, "We have found a few our of type designers on the Web. For instance, we found Brenda Walton who designed ITC Cancione while looking at calligraphy Web sites."

To Grey, architect Mies van der Rohe's quote, "God is in the details," means that one needs to pay attention to the details because that's where one finds the difference between enlightenment and disappointment. His advice to beginning type designers follows a similar path: "Know your type history. Know your tools. Know your customers. Know your goal."

e-mail: hgrey@itcfonts.com

...............■■■■■■■■■■■■■■■■■■■■■■■■■■■■■

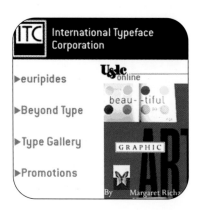

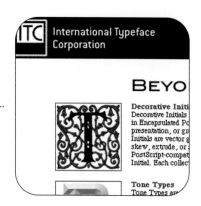

Grey and his ITC colleagues have learned that
body text cannot be created as graphic text.
When 10- or 12-point text is anti-aliased as an

Adobe Photoshop image, it's often fuzzy
and difficult to read.

Since the ITC site is used as a research tool by
many of its viewers, the body text (a font history

or an excerpt from a *U&lc* article) needs to be in
a format that can be copied as live text.

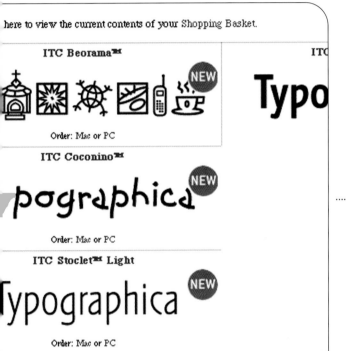

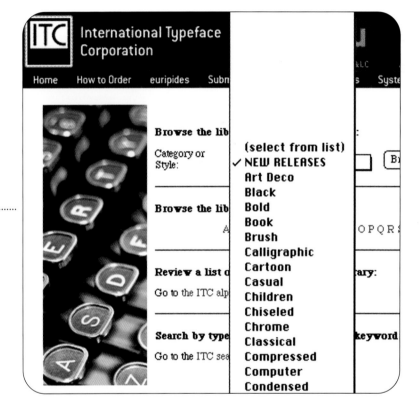

The ITC designers plan to use OpenType combined with Cascading Style Sheets (CSS) and font embedding, which will give them more control over Web typography even though it's in HTML text.

Consistent type usage adds a sense of structure to any Web site. ITC Conduit was selected as one of the site's branding elements because it is contemporary and suggests that the foundry provides contemporary typefaces. Even though ITC has a vast number of typefaces available, these are limited in the site design so visitors don't get confused as they surf.

impakt

cult

itc juice

INTERNATIONAL TYPEFACE CORP.

[T-26]

a NEW Digital Type Foundry

US toll-free 888.T26.FONT, tel 773.862.1201,
or fax 773.862.1214

e-mail t26font@aol.com

Location: HTTP://WWW.T-26FONT.COM

T-26

■

Representing over 1,000 typefaces, the T-26 type foundry in Chicago, Illinois, receives a new type submission from an aspiring designer nearly every day. But the process of font selection, Web and print promotion, and actual product release takes longer than that. "We need to have everyone in our facility approve a new font before we carry it," adds lead designer, Jim Marcus, "so you can imagine that it's a reasonably grueling process."

Marcus believes that type has a very special place on the Web. He doesn't accept that type will be completely replaced by images. Once a word is converted to a graphic, it can no longer be searched as text which defeats the Web's purpose. "I believe that Web Embedding Font Technology (WEFT) and Cascading Style Sheets (CSS) are going in the right direction," he says. "Once we can solve the problem of properly indexing and searching type which is ornate, functional, and graphical, the real integration [between text and image] will occur."

" I'm finished predicting the future. I do believe that the public's perception of type will force them to treat typography as more than an afterthought in the design equation, but I have no numbers as to when this might happen. **"**

As far as Marcus is concerned, most new design interns don't understand what a lucky break they actually have. He thinks that looking over someone's shoulders and doing things for yourself are the best ways to learn just about anything, including type design and typography. He realizes that his own learning curve was a lot steeper in retrospect than it seemed when he executed his first typefaces. "I look at a lot of the first things that I did and they seem very poorly done," he admits. "Since then, I've developed a much keener sieve through which to filter my work as it appears to the public. I know now which typefaces to use personally and which to make available for use."

e-mail: t26font@aol.com ■

The T-26 site employs graphic text for headers and images that incorporate text. But, for the sake of bandwidth, HTML text is still used for the bulk of the text. Marcus believes it's important to provide HTML text versions of data that needs to be copied or saved for later use such as database pages.

Marcus cares deeply about bandwidth and download times but he won't pander to the lowest common denominator. He concentrates on using a relatively small, consistent color palette to establish continuity and also to shrink file sizes.

Frames enable certain images and information to remain constantly on-screen while the viewer surfs through other segments of the site. This simple technique is used by T-26 to cut down on the number of downloads needed per page.

With a roster of over 1,000 typefaces, Marcus believes in showcasing a few typefaces in the site's design without stacking too many fonts in one design. He believes that when working with type embedded in graphics, it's a good idea to treat the project as though it contained invisible style sheets rather than overloading the image with conflicting letter styles.

kaixo variator 1 wave

E-Commerce on the Web

by Katherine Tasheff Carlton

The customer is king. The rule my great-grandfather upheld while operating a corner grocery store in the early 1900s still applies in the world of electronic commerce. Customers want to have their needs met as quickly and conveniently as possible. With an estimated 304 million people online worldwide and the average duration of a page view less than one minute, e-commerce customers are increasingly interested in the expedience the technology offers, not the technology itself. Most of the novelty of online transactions has worn off; people want to get online, make their purchases, and get on with other activities. Sites must immediately grab attention. If users are not intrigued or satisfied, they move on—quickly.

Repeatedly, the conversations I've had with site designers have boiled down to this: Simplicity is the key to e-commerce design. As most developers know, a design that appears simple is often the most complicated to create. With nearly one out of every three Internet users making online purchases, e-commerce site developers must tread a delicate line between utility and aesthetics. Beyond the retail-oriented sites, the corporate world has almost universally made the leap to online transactions. Pull-down menus, heavy back-end databases, secure servers, limited bandwidth, and brand marketing all must be taken into account while creating a visually pleasing, easy-to-use environment.

What does simplicity in design really mean? More often than not, ease of use is the bottom line. This means that the most important aspect of e-commerce design is understanding the company's business model and knowing how customers will access the site and what they will demand when they do.

Many designers try to do too much, loading sites with too many bells and whistles or presenting so much information on the home page that users are immediately lost. Occasionally, the original model was a good starting point, but through the rapid expansion possible in the interactive age, sites outgrow their systems, navigation, and basic design.

Sometimes simplicity in design means not changing the site around to accommodate every new advance in technology. As Rhonda Wells, director of e-commerce for Payless ShoeSource, says, "How do you feel in this scenario? You're in the middle of cooking dinner for guests that evening when you realize you're out of an ingredient. Time is of the essence, so you drive to the grocery store you frequent once a week and double-park knowing you'll only be five minutes maximum. Once inside, you run to the middle of the aisle on the left-hand side where the ingredient is always stocked, but it's not there—in fact, nothing that belongs there is there. The store has changed and you're not happy—you're frustrated. Then you're even more frustrated when the store manager explains that the change was made to enhance your shopping experience." Customers must be able to appreciate the improvement in the site; otherwise, you may lose their business.

No hard-and-fast rules exist on the Internet; things change too quickly for rules. But over the past few months, I've been able to identify guide-lines that every e-commerce designer should take into consideration:

- Know what technology you need in order to deliver what your customers want. If you're fulfilling customers' orders via e-mail, you don't need a comprehensive e-commerce environment. But if you have 20,000 items in inventory, spend the time to develop a system and interface that really work. Skimping will mean slow site operation and customers who can't find what they're looking for.
- Do the research. The coolest Flash introduction in the world is a complete waste of time, energy, and money if most of your customers are connecting through their local libraries or around the world at significantly slower rates than in the United States. Even high-speed customers may not want to wait.
- Balance navigation and information carefully. This is a tough one. People want their information as quickly as possible, but too much content at once leaves the customer feeling confused and stranded. Even FAO Schwarz doesn't display all their merchandise at one time.
- Don't try to do too much. When we work with this technology all day long, there's a tendency, almost a driving need, to utilize new technologies to make a site more interesting. Unfortunately, most customers aren't impressed and often are actually turned off. The technology should be transparent; the user experience should be seamless.

Electronic commerce is more than buying widgets online. In fact, some people define e-commerce broadly enough to include the use of fax machines to place orders. For the purposes of this publication, I've defined electronic commerce as the use of the Internet for initiating, conducting, or fulfilling the requirements of a business transaction. I've tried to cover an extremely broad range of e-commerce businesses, from the big online retailers like bluefly.com and Nordstrom to subscription sites like *The Wall Street Journal*. By the time this book is published, I'm sure many new technologies will enable still more types of e-commerce sites. But in the spectrum of enterprises included here, I hope that designers and entrepreneurs will find design approaches, innovative uses of technology, and navigational concepts that will help them in building their own sites.

Consumer and Retail Sites

>> **Consumer and Retail Sites**
>> **Finance, Banking, and Business-to-Business Sites**

Most people would be hard-pressed to think of a single product or service that can't be purchased on the Web: flowers, clothes, music, prescriptions, shoes, groceries, office supplies, and even cars can be ordered online and delivered to your door. New consumer-oriented dot.coms appear on the Web every day, flooding the marketplace with product offerings. The most successful online retailers have one thing in common: They make it fun and easy to find the right merchandise and even easier to purchase. Some people complain that the shipping charges levied by the online merchants negate the value of shopping online. As long as customers can access a Web site, find the perfect gift for their sister's new baby, and have it wrapped and delivered overnight, they're going to be willing to pay a little extra for the service.

As Sean Wechter, director of electronic commerce development for chipshot.com, says, "The basics of e-commerce involve making the site clean, with as slippery a slope as possible to the checkout." Making it easy for customers to find the product they want and speeding them along to entering their credit card number means a successful site. If customers had trouble finding the potato chips at a convenience store and then had to stand in line for 15 minutes to purchase them, they wouldn't be back. Where's the convenience? The whole concept behind shopping online is the same.

>> The chipshot.com home page allows users to search, find the category they're most interested in, or jump right into one of the featured specials.

Golf's New Address

- Don't make the customer wait for anything.
- Minimize the number of clicks to the checkout.
- Customers want all the information in one place.

site: chipshot.com

chipshot.com

About the Site

Chipshot.com caters to the notoriously conservative golfing crowd—not what you might expect from a hot Silicon Valley operation. So how do they merge cutting-edge high tech with a conservative, college-educated, affluent, mostly male clientele? Understand the audience. Focus on the product. Make the site clean, with as slippery a slope as possible to the checkout.

About the Customer

Some people who come to the chipshot.com website know exactly what they want; some don't. Some are Internet experts; some are novices. "The site must create as wide a net as possible to catch all the potential customers," says Tom Loretan, VP of production and design. "As a result, there's no point in using the kinds of features and technology that will eat up bandwidth. Each second someone waits means increasing the possibility that they won't make a purchase."

Site Design

Every product on chipshot.com has an accompanying detailed photo. For the chipshot.com clubs, customers can see three-dimensional rotating views of the head and close-ups of the shaft and grip. All of the images provide a sense of the texture and metals used in the products. There's also some editorial copy comparing similar products to further educate the shopper.

White and shades of green throughout the site not only contribute to the clean feeling but also help ad banners and specials pop out. Especially user-friendly features include a complete navigation bar at the top of every screen, so the customer can jump to another section at any time, and a printable gift certificate for those inevitable last-minute gifts.

"E-commerce is a constantly moving target," says Sean Wechter, director of e-commerce development for chipshot.com. "Once we get the style down, we have to stay with it to preserve the brand. If our customers can't identify our site, we're lost. E-commerce is our only source of revenue.

chipshot.com: 1452 Kifer Road, Sunnyvale, CA 94086, (408) 746-0600

Executives: Sean Wechter, Director of E-Commerce Development; Tom Loretan, Vice President of Production and Design Design Team: Jan Kennedy, Managing Graphic Designer; Caryn Fukui, Web Team Manager Toolbox: HTML (no JavaScript at this point), High-quality digital camera (with experienced photographer), Animated gifs

The world's
biggest
shoe store

NORDSTROM shoes.com

summer
basics

Great Summer
Basics

sale

Save up to 75%
in our sale
section.

Our Catalogs:
- Catalog Quick Order
- View Catalogs Online
- Request a Catalog

Nordstrom Credit Cards
Apply Now!

Power Browse

Sign In

Beauty Hotline

Easy Returns, Free Exchanges

Employment Opportunities

Register for E-mail Updates:
Your E-mail Address GO

color crazy

Color explodes just in time for spring. Beach Vacation

REinvent
THE GIRL
NEXT DOOR

Reinvent Yourself

THE WEDDING LIST

NORDSTROM partners with
The Wedding List. See Details

your account | e-mail updates | about us | our stores | site map | contact us

© 2000 Nordstrom Inc. about your privacy

>> A simple and bright home page welcomes the user to the Nordstrom.com site.

The Best in Quality Fashion Goods and Services Online

- Focus on navigation.
- Always ask, "How will this affect the customer?"
- Don't lose the brand in the technology.

site: Nordstrom, Nordstrom shoes

Nordstrom

With hundreds of thousands of SKUs and an additional offering of more than 20 million pairs of shoes, Nordstrom.com and Nordstromshoes.com rely on transparent navigation to help customers find the items they're looking for. Instead of superimposing a single architecture on the site, Nordstrom allows customers to choose the way they want to shop. Multiple options for searching and sorting make an otherwise mind-boggling site easy to surf and shop.

How They Do It

All the merchandise on the Nordstrom.com site is divided into tabs: women, men, shoes, jewelry, gifts, sale, and featured items. Within each tab are more directional cues that connect customers with merchandise to fit their shopping objective, such as "trends" or "your style." In addition, for focused shoppers, Nordstrom has Power Browse, an incredible search engine that selects merchandise based on the customer's preferences. This feature allows users to pinpoint exactly the right merchandise without clicking through lots of pages.

At Nordstomshoes.com, customers may browse men, women, kids, trends, and brand stores or search for a particular size, color, brand, or width. All of these options make sorting through millions of shoes a breeze; users don't have to look at anything they aren't interested in. Innovative use of a frame at the bottom of the screen lets users search, view their picks, shopping bag and account information, or contact customer service, all without leaving the item currently selected.

The Catalogs

The integration of Nordstrom's catalogs into the website offers another customer-friendly feature in this already extensive operation. Customers may order items featured in a catalog, request a catalog, or actually view a number of catalogs online.

Visual Design

It's not just the amazing navigation options that make Nordstrom.com so strong; the essential graphic design makes the merchandise stand out. Muted, natural colors, maximized white space, and small fonts all bring the focus to the products, not the site itself.

Nordstrom, Inc.: 1617 Sixth Avenue, Seattle, WA 98101-1742, (888) 282-6060

Executives: Paul Onnen, Executive Vice President and Chief Technology Officer; Kathryn Olson, Executive Vice President, Marketing; Bob Schwartz, Executive Vice President and General Manager, E-Commerce **Design Team:** Chris Dressler, Group Program Manager; Pamela Perret, Managing Director, Internet **Toolbox:** Microsoft Windows 2000, Photoshop, Illustrator, Streamline

NORDSTROM

checkout | search | help

women | men | shoes | gifts | jewelry | sale | featured

>> Neutral and very small, the navigation bar can take users anywhere on the site.

▼ How do you want to shop?

category

Our entire collection of women's clothing and accessories is organized into easy-to-browse categories.

Shop by Category

trends

Check out the latest fashion trends and the must-have items of the season.

Shop by Trends

your style

Shop your way—whether you're in a beach vacation mood or a business casual mode.

Shop by Your Style

brands

Brand collections including Callaway Golf Apparel by Nordstrom®, Façonnable, David Dart and more.

Shop by Brands

special sizes

Petites, Plus Sizes, Talls and Maternity— because one size doesn't fit all.

Shop by Special Sizes

>> Nordstrom allows customers to choose how they want to shop the site.

PRODUCT INDEX: POWER BROWSE

To browse quickly through our product selection, click on a category below.

or Click here for a keyword product search.

CATEGORY
- Dresses
- Easy Shapes
- Knit Outfits
- Work Redefined
- Pants
- Skirts & Shorts
- Shirts & Jackets
- Sweaters
- Sweatshirts & Tees
- Outerwear
- Lingerie
- Swimwear
- Accessories
- Fragrance
- Bath & Body
- Best Sellers

Work Redefined
- Outfits
- Jackets & Tops
- Pants & Skirts

Outfits
- Four-Piece Wardrober
- Three-Piece Suiting Separates
- Three-Piece Wardrober with Tank Dress
- Rayon/Acetate Pants Set
- Linen Pinstripe Suit
- Three Piece Wardrober

Three-Piece Wardrober with Tank Dress

>> The Power Browse feature cuts down on surfing for customers who know what they want.

- **Website Objective:** To provide the best possible online shopping experience for customers.
- **Creative Strategy:** Create a compelling and engaging environment that helps customers quickly find the right item.
- **Target Audience:** Women and men who love shoes, fashion, accessories, and apparel.

>> The Nordstromshoes.com interface allows users to view product and search for other footwear at the same time.

our catalogs

place a catalog order

❶ Enter Source Code
Type in the Source Code found in the blue shaded area in the white address box on the back of your catalog.

❷ Enter Item Number
The item number can be found in bold at the end of the item description, just before the price. Please type in all characters, including letters.
Example: E6606

❸ Once you have submitted your item (by clicking the "continue" button below), you'll be asked to choose your size and color. Then proceed to Checkout (by clicking the red "checkout" button at the top of your screen) or select your next item.

`continue`

※ **Please note** that our Online Store features many items not offered in our catalogs including men's shoes, apparel and furnishings. Click here to shop online.

📖 Request a Catalog

view our catalogs online

View Life/Style
Summer 2000

View Life/Style
Spring 2000

>> Customers can purchase catalog items online, request a catalog, or view current catalogs.

beauty hotline

beauty requires a personal touch

You can **order** any beauty product here — our Beauty Specialists will personally handle, promptly fill and quickly ship any order to you from a nearby Nordstrom store. It's just like having your very own personal beauty shopper.

place an order

Need to refill your foundation? Want to try something new? Simply place an order and our store's Beauty Specialists will promptly fill and then quickly ship your order directly from a Nordstrom store near you. Or call 1-800-7-BEAUTY.

Place an Order

beauty trends and must-haves

Don't miss the latest looks and must-haves. Check back every other week for updates.

Beauty Trends

fragrance trends and must-haves

Just like everything else, fragrance not only follows trends, but it constantly evolves. Find out what's hot and discover the newest expressions of scent.

Fragrance Trends

spa nordstrom

We invite you to experience Spa N
of services and products that have
promote your natural state of well
Spa Nordstrom

>> The beauty hotline links customers to articles on beauty trends and personal beauty shoppers.

beauty hotline: fragrance trends and must-haves

▶ PLACE AN ORDER

▶ BEAUTY TRENDS AND MUST-HAVES

▼ FRAGRANCE TRENDS AND MUST-HAVES

▶ BEAUTY GLOSSARY

indulge your senses

introducing Façonnable
pour elle

Façonnable pour elle.
Eau de toilette spray:
100ml, $69.00; 50ml, $49.00.
Eau de parfum spray:
50ml, $59.00.

Façonnable pour homme.
Eau de toilette spray:
100ml, $59.00; 50ml, $42.00.

exclusively ours

Place an Order

>> Exclusive Nordstrom products, such as fragrances, warrant special features.

featured

▸ REINVENT THE
 POWER SUIT

▸ REINVENT THE
 GIRL NEXT DOOR

▸ REINVENT
 SOCCER MOM

▸ REINVENT
 THERAPY

▸ REINVENT
 THE HEIRLOOM

▸ REINVENT
 PAJAMAS

reinvent yourself

REinvent
THE POWER SUIT
▸ Loosen Your Tie

>> Featured products are grouped
 by theme with intriguing text
 and images.

REinvent
THE GIRL NEXT DOOR
Walk on the Wild Side ▸

REinvent THE HEIRL[OOM]
◂ Raid Our Jewelry Box

REinvent THERAPY
Session Starts Here ▸

REinvent PAJAMAS

REinvent PAJAMAS

Indulge yourself.

6mm Faux Pearl
Strands
$19.00 - $35.00

Pearl Cross
Necklace
$55.00

Pearl Bracelet
$125.00

Cultured Pearl
Earrings, 7mm
$150.00

Tahitian Pearl &
Pave Diamond
Ring
$2,960.00

Scott Kay
Platinum & Pearl
Earrings
$920.00

Freshwater Pearl &
Silver Bracelet
$68.00

Freshwater Pearl
Ring
$28.00

8mm Faux Pearl
Strands
$20.00 - $36.00

Carolee Curly
Chain Necklace
$40.00

Carolee Drop
Earring
$25.00

Carolee Illusion
Necklace
$40.00

Cultured Pearl
Earrings, 6mm
$110.00

>> Close-up images of products and prices are linked to detailed product pages.

" Muted, natural colors, maximized white space, and small fonts all bring the focus to the products. "

>> A beauty glossary helps the cosmetically challenged understand what all those terms mean.

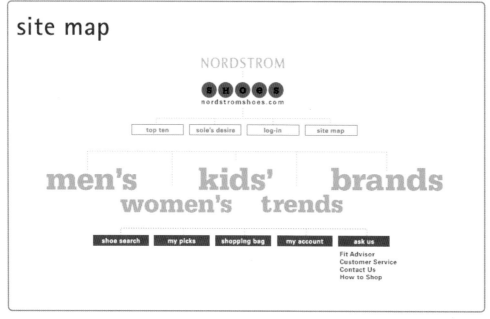

>> The bright, easy-to-understand site map helps customers navigate the site.

trends

ANIMAL PRINTS

In their own quirky way, animal prints are both trendy and classic; either way, they're here today and here to stay. Try a touch of python, leopard or pony print to update your wardrobe.

top 10 shoes

Men's Top 10
Women's Top 10
Kids' Top 10

embellished footwear

This season, embellishment doesn't stop with your clothes; it goes down to your toes with tapestry, ribbons and fanciful trims.

sporty accents

Athletic shoes are not just for the gym anymore. Rarely has a trend been so comfortable and so versatile (think school to workout without even changing). We've got all the cool shoes, whether you're looking to make a sporty fashion statement or you're simply wanting to wear some comfy shoes for once.

sandal shop

Our Sandal Shop features hundreds of tantalizing sandals. Whether your thing is thongs, comfortable classics or style on a higher platform, shop here to fulfill your desires.

bright is right

This season's footwear is strappy and happy, in colors sure to lift your spirits —and boost your style.

>> Fun text and colors highlight the latest trends in footwear.

top 10 shoes :

Our top picks. Here's our take on this week's top ten styles. Click on a shoe to find out more about it.

⋯→ women's top ten → men's top ten → kids' top ten

1 Delight 3-Strap Sandal by ECCO

2 Hera by Munro

3 Main Stretch by Aerosoles

4 Clatter by ModaSpana

5 Clarks Sanibel by Clarks England

6 Ultimate by Naturalizer

7 Anni by Hush Puppies

8 Champion Oxford Canvas by Keds

9 Born Wish by Born

10 Paradigm by Rockport

>> Nordstrom's top ten picks for women's shoes change weekly.

Fun is the keyword for bluefly.com.

>> The home page sets the tone for a fun online shopping experience.

Discount Shopping Made Fun

- Customers want to enjoy the shopping experience.
- Give users different ways to sort through merchandise.
- Customers should be able to develop an accurate sense of the products through text and images.

site: bluefly.com

bluefly.com

The Idea

A couple of years ago, bluefly.com CEO Ken Seiff spent a frustrating day outlet shopping, rummaging through disorganized bins of out-of-season designer clothing. He knew there must be a better way. Within a few months, he developed bluefly.com's core concept: an Internet-based lifestyle brand offering consumers top designer labels in a fun, friendly, smart, and stylish way.

Making It Fun

Fun is the keyword for bluefly.com. The site is filled with fun colors, icons, and eye candy features that go the extra mile to enhance users' shopping experience. The entire site maintains an attitude of amusement and accessibility, making it enjoyable to browse the content. A prime example is the top navigation bar, which brightens with a single added color when users roll over the menu with their cursor.

Because merchandise changes routinely in a discount shopping environment, the fun atmosphere of the site is balanced by a strong organizational architecture and an accurate search engine that allows users to search by product category, favorite designer, or price. Bluefly also offers the mycatalog feature, which creates an online personalized catalog based on the user's preferences and sizes.

Adding Value

Additional editorial content flows smoothly throughout the site in the form of helpful product and designer descriptions. Co-branded articles from fashion magazines about creating a designer wardrobe on a budget and a monthly online newsletter called *Flypaper* bring a smart, casual voice to the site and forge a feeling of trust with the customer.

The actual shopping experience at bluefly is a breeze. Large, clear images of the merchandise enable users to develop a sense of the product. The shopping bag details every aspect of the transaction, including a smaller image of the selected item, in a concise and simple format.

bluefly.com: 42 W. 39th Street, 9th Floor, New York, NY 10018, (212) 944-8000

Executives: Ken Seiff, CEO/Founder; Marty Keane, Vice President of Product Development **Design Team**: <kpe>, Kervin Ligasan – Art Director, Rik Catlow – Graphic Designer **Toolbox**: Adobe Illustrator, Photoshop and GoLive.

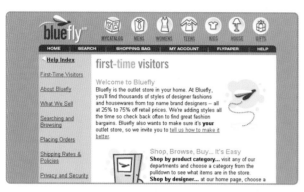

>> Cartoonlike icons enhance the copy and guide users through the site.

>> Use of a single bright color enhances the rollover feature on the navigation bar.

>> The *Flypaper* newsletter adds helpful fashion advice tailored to the current product selection.

- **Website Objective:** To develop an Internet-based lifestyle brand offering consumers top designer brands in a fun, friendly, smart, and stylish way.
- **Creative Strategy:** To create and promote a fun attitude and style through innovative, high-quality products and services. Create a brand that easily meshes with multiple co-branding opportunities.
- **Target Audience:** 25–35-year-old women shopping online, perhaps for the first time.

>> When setting up the mycatalog feature, customers can select a range of sizes.

>> The shopping bag details every aspect of the selected items.

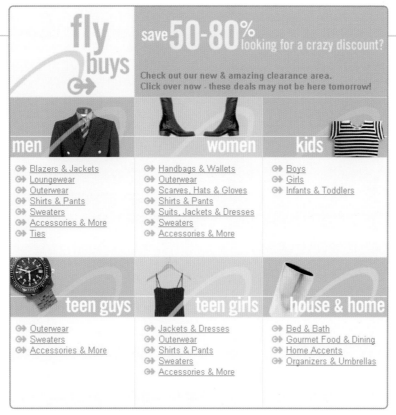

>> Fast-moving specials are featured on the fly buys page.

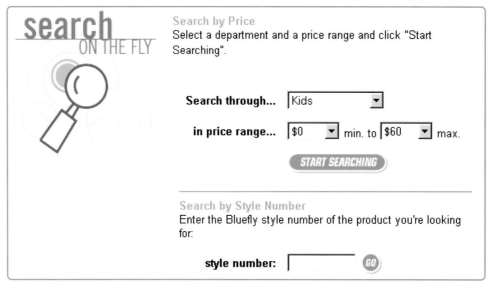

>> A simple search engine interface allows users to search by category, price, or style number.

gifts / cosmetics accessories

cosmetics accessories (all designers)

sorted by what's new | re-sort by price

page 1 2 ❯

SHOP BY:

price
color

designer ▼
browse cosmetics
accessories by designer...

all designers
Donna Karan /
DKNY
Fina Firenze
Kerri Kahn
Laura Madrigano
Maria Turgeon
Mike + Ally
Temma Dahan

BROWSE...

gifts
- all designers
- all categories
- style buzz

TRENDS...

Father's Day Gift
Guide
Flybuys!

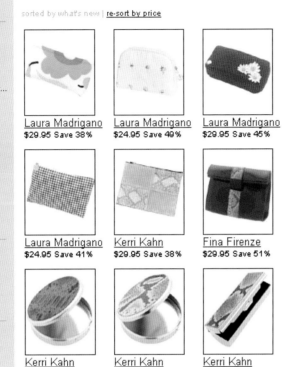

Laura Madrigano
$29.95 Save 38%

Laura Madrigano
$24.95 Save 49%

Laura Madrigano
$29.95 Save 45%

Fina Firenze
$29.95 Save 51%

Laura Madrigano
$24.95 Save 41%

Kerri Kahn
$29.95 Save 38%

Fina Firenze
$29.95 Save 51%

Kerri Kahn
$19.95 Save 59%

Kerri Kahn
$14.95 Save 65%

Kerri Kahn
$14.95 Save 65%

Kerri Kahn
$19.95 Save 61%

Donna Karan /
DKNY
$12.95 Save 54%

Donna Karan /
DKNY
$12.95 Save 54%

Temma Dahan
$24.95 Save 59%

>> Small, clear product images help customers make quick decisions.

Wilke-Rodriguez ties

⊕ SEE LARGER PHOTO

◐ ◑ browse ties

Save 56% Off Retail $45.00
Bluefly Price: $19.95
Select: [one size ▾] Qty: 1

ADD TO SHOPPING BAG

color: Navy/Bronze

description: Triangle pattern tie.
Wilke-Rodriguez creates clothing for
today's modern
lifestyle...uncomplicated, comfortable
and versatile. Tie features a pattern of
navy and bronze triangles, a perfect
compliment to a business look. 100%
Silk. Navy/Bronze. Professionally
clean only. Made in the USA.
Style #0043533.

ⓘ view size chart
⊕ see more about Wilke-Rodriguez

>> Helpful copy, pricing, and detailed text inform the customer about the product.

Finance, Banking, and Business-to-Business Sites

>> Consumer and Retail Sites

>> Finance, Banking, and Business-to-Business Sites

Just as the business section of the newspaper portrays a different atmosphere than the lifestyle section, business-oriented Web sites

look and feel different from their cyber-relatives in the consumer world. Most notably, business customers are in an even bigger rush than

average consumers. For these people, time means money and time spent waiting for inaccurate information or out-of-date products is a

complete waste. Many of the sites in this section don't bother with a fancy home page or video introduction. Technology like that is

reserved for demos or additional features that can be accessed at users' convenience. As Vince Bohner, director of customer experience

for NextCard, says, "Speed is of the essence."

Customers should enjoy using finance and business sites, though. A welcoming environment appeals to everyone, everywhere. Sites that utilize bright colors and lighthearted copy to create a comfortable world in which investors can find the information they need are more likely to thrive. Mirroring the "work casual" corporate dress code that is becoming the norm, business-related websites may operate in a less formal environment, but they've still got to deliver the goods.

"The easier the site is to use and the more helpful feedback and information our customers can find, the higher our rate of retention. They have to find us valuable as well as easy to work with. We're creating an atmosphere of cooperation and collaboration," says Paul Smith, CEO of bSource.com.

>> A bright, friendly home page clearly defines the information and options available to the user.

The First True Internet Visa

- Keep the approach as simple as possible.
- Manage when and how the customer receives information.
- Focus on the brand.

NextCard

If the basic concept behind the Internet is to make things easier, faster, and generally more convenient, the NextCard site wraps up all of those advantages and adds a few to boot. Every aspect of the site is well designed and easy for the customer to use, from the application process through the add-on features.

Making Decisions for the Customer

"Speed is of the essence," says Vince Bohner, director of customer experience for NextCard. "When we were designing the application process, we had to make decisions about what information we wanted customers to have and when. One of the things we decided to do was streamline the application process as much as possible. Once customers were approved, then we presented them with different rates and options."

The same judicious flow of information applies to the customer update interface. The basics of the statement are presented in a compact format, and more detailed information is no more than a click away. "We have to make it easy for users to know what to do once they get to a page. Too many options can be overwhelming," adds Bohner.

Keeping the Brand Intact

Since the NextCard site launched in December 1997, the scope of the site has changed tremendously. New credit card products have been added, functionality has been enhanced, and the content and company vision have evolved. In order to maintain ease of use, NextCard has focused on maintaining the brand image. All of the pieces of the site work together, thanks to the simple palette, trademark blue whorl, and NextCard logo. Amazingly, co-branded products still dovetail with the NextCard brand to create a unified presentation for users.

What's Next

As the company continues to grow, Bohner works hard to stay abreast of the latest technology, ensuring that his customers have access to the best the Internet has to offer. "I'm looking forward to a time when we have universal broadband Internet access and WYSIWYG tools that give business owners and designers more control over dynamic content," he says.

NextCard, Inc.: 595 Market Street, Suite 1800, San Francisco, CA 94105, (415) 836-9700

Executives: Jeremy Lent, President; Dan Springer, Chief Marketing Officer; Sue deLeeuw, Vice President, Brand **Design Team:** Vince Bohner, Deborah Harkins, Andrew Hargreaves, Zachary Lazare, Marci Singer **Toolbox:** Photoshop, Illustrator, GoLive, Image Ready, Macromedia Fireworks, Flash, DreamWeaver, BBEdit, HomeSite, QuarkXpress, Microsoft Office, ColdFusion, IView, HTML, ASP, JSP, ATC Dynamo

Congratulations! You're approved!

You're approved for the Standard NextCard Visa. Your excellent credit means you
qualify for personalized upgrade packages. Click a card to choose your upgrade p

Your personalized upgrade packages

Click a card to continue ▶

		CLASSIC	PLATINUM Upgrade	PLATINUM Upgrade
		benefits	benefits	benefits
Rates:	Fixed APR (not an intro rate)	15.9%	12.9%	**9.9%**
	Credit Limit	$5,000	$7,000	**$9,000**
Features:	PictureCard (optional)	see below*	FREE!	**FREE!**
	Rew@rds Points	No Points	Single Points	**Single Points!**
Savings:	Required Balance Transfer	$0	$3,500	**$6,000**
	Your Savings**	$0	$160	**$425**
	Annual Fee	$0	$0	**$0**
	Upgrade package terms and condi			

>> Simple presentation of credit card
options helps potential customers
make decisions.

>> A standard navigation bar with brand
colors and design reinforces the
NextCard image.

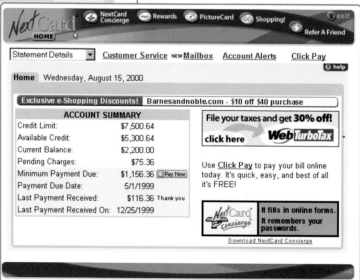

>> Account statement basics are combined with other offers without overwhelming the customer.

- **Website Objective:** Actually, NextCard has three: acquisition of new customers, creation of easy application experience, excellent customer management and retention.
- **Creative Strategy:** Make the NextCard experience as fast as possible.
- **Target Audience:** Internet users in general.

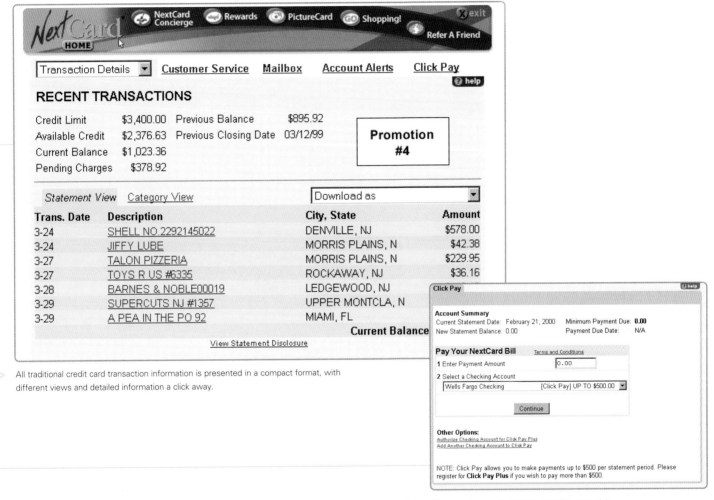

>> All traditional credit card transaction information is presented in a compact format, with different views and detailed information a click away.

>> All transactions are boiled down to the essentials, making them easy to understand and conduct.

NextCard Rewards℠
Rewards Points! Earn FREE flights and merchandise just for using your NextCard.

GoShopping!℠
Find the lowest prices anywhere on the Web.

Concierge℠
Make purchases online with just 1 click!

>> NextCard features several different bonus programs for users.

Details

NextCard Rewards
Earn FREE flights and merchandise just for using your NextCard to make purchases. Open an account with a qualifying balance transfer, and every $1 spend with your NextCard Visa can earn you Rewards Points to use for travel the airline of your choice, or for clothes, music, dining, books, and more! Visit Rewards Page to learn more.

GoShopping!
GoShopping! puts the latest in online shopping technology at your fingertips. Simply type in the company or product you're looking for and GoShopping! does all the work. It will search the Web to find the lowest prices and the highest consumer-rated online merchants for FREE. You can even get personalized digital coupons from brand name stores delivered directly to you

Try GoShopping! for free right now.

Concierge
Ready to buy? Your NextCard Concierge makes shopping online a cinc Your FREE Concierge remembers all of your passwords, logs you into website and automatically fills in online purchase forms with your shipping address an your NextCard Visa account number with just 1 click. NextCard Concierge work with all of the Top 100 online merchants and thousands more.

Download your free Concierge now.

Home | Guaranteed Safe Online Shopping | Contro
As low as 2.9% Intro or 9.9% Fixed APR | FREE N
About Us | Contact Us | Security & Privacy | Press

Details

NextCard Rewards
Earn FREE flights and merchandise just for using your NextCard to make purchases. Open an account with a qualifying balance transfer, and every $1 you spend with your NextCard Visa can earn you Rewards Points to use for travel on the airline of your choice, or for clothes, music, dining, books, and more! Visit our Rewards Page to learn more.

GoShopping!
GoShopping! puts the latest in online shopping technology at your fingertips. Simply type in the company or product you're looking for and GoShopping! does all the work. It will search the Web to find the lowest prices and the highest consumer-rated online merchants for FREE. You can even get personalized digital coupons from brand name stores delivered directly to you.

Try GoShopping! for free right now.

Concierge
Ready to buy? Your NextCard Concierge makes shopping online a cinch. Your FREE Concierge remembers all of your passwords, logs you into websites, and automatically fills in online purchase forms with your shipping address and your NextCard Visa account number with just 1 click. NextCard Concierge works with all of the Top 100 online merchants and thousands more.

Download your free Concierge now.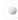

Top

>> Customers can personalize their
NextCard with different images.

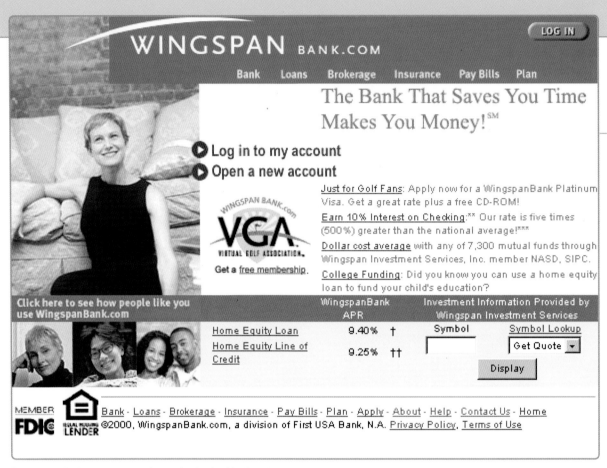

>> The WingspanBank home page sets the tone for the site: friendly technology.

The Original Online Bank and Financial Services Site

- Place the brand image foremost in the mind of the customer and designer.
- Account information doesn't need to be dressed up.
- Make important navigation options stand out visually.

site: **WingspanBank.com**

WingspanBank.com

The Short Road to Success

Given the relatively short period of time online banking has been around, it's remarkable how quickly WingspanBank has established itself as the leader in online banking and financial services. Founded in 1999 to solve the frustrations many people experience when dealing with money issues, Wingspan enables customers to manage almost every aspect of their finances on one easy-to-use website.

The successful balance of technology and customer service as well as a direct appeal to a younger audience separates Wingspan from other online financial organizations. From the home page to account information, Wingspan delivers the advantages of high-technology banking with a personal approach.

Comprehensive Services, Consolidated Site

Perhaps the biggest challenge facing the Wingspan design team is trying to make such a wide variety of services feel personalized to the user. Customers have access to checking accounts, credit cards, insurance quotes, certificates of deposit, investment information, brokerage services, online bill payment, and financial planning tools, not to mention customer service. Still, throughout the site, the Wingspan brand remains strong, and navigation is a snap.

The Look

On the home page, black and white images of potential customers combined with the muted blue and white logo provide a contemporary look and feel. Important navigational points, like logging in and applying for an account, are highlighted in brighter shades of red and green. Deeper into the site, the logo/navigational bar maintains the brand image while stylized icons highlight product offerings. Account information and applications are pared to the bare minimum of graphic features, utilizing color bars and text only where they enhance the organization of the information presented on the screen.

> **Black and white images of potential customers combined with the muted blue and white logo provide a contemporary look and feel.**

WingspanBank.com: 201 North Walnut Street, Wilmington, DE 19801

Executives: Michael Cleary, CEO; Bill Wallace, CIO; Kevin Waters, Senior Vice President, Marketing; Chris Sulpizio, Senior Vice President, Operations; Chip Weldon, Senior Vice President, Interface Engineering **Design Team:** Mike Young, Information Architect; Patty Kingery, Vice President, Production **Toolbox:** Frames, HTML, Adobe Photoshop, Checkfree servers, Pershing servers

Throughout the site, the Wingspan brand remains strong and navigation is a snap.

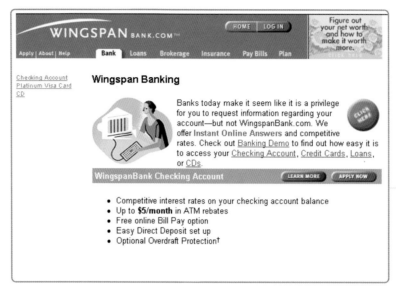

>> Detailed information about services is presented in a user-friendly format.

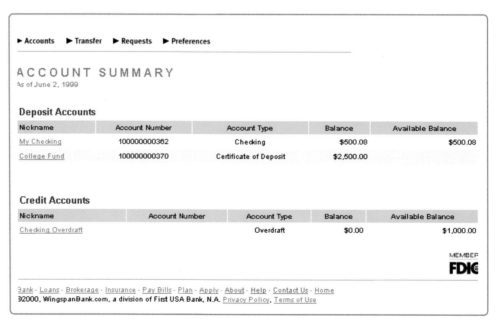

>> Account balances and related data are clearly organized.

- **Website Objective:** To help individuals maximize their financial potential on the web.
- **Creative Strategy:** Make Wingspan simpler and easier to use than the majority of financial websites currently available.
- **Target Audience:** Women, 25–45, in charge of family finances.

>> Financial planning tools support Wingspan's offerings.

>> A simple initial application filter customizes the application form to users' requests.

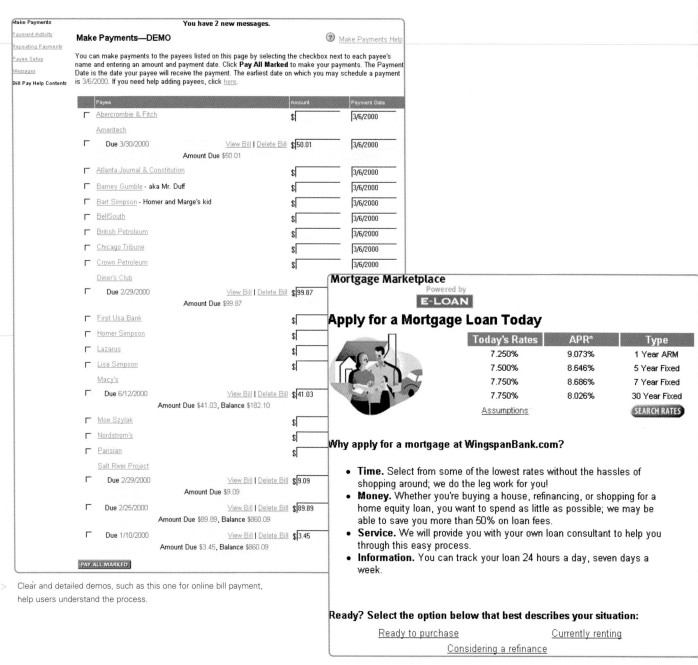

Make Payments

Payment Activity

Repeating Payments

Payee Setup

Messages

Bill Pay Help Contents

You have 2 new messages.

Make Payments—DEMO (?) Make Payments Help

You can make payments to the payees listed on this page by selecting the checkbox next to each payee's name and entering an amount and payment date. Click **Pay All Marked** to make your payments. The Payment Date is the date your payee will receive the payment. The earliest date on which you may schedule a payment is 3/6/2000. If you need help adding payees, click here.

Payee	Amount	Payment Date
☐ Abercrombie & Fitch	$	3/6/2000
Ameritech		
☐ Due 3/30/2000 View Bill \| Delete Bill	$50.01	3/6/2000
Amount Due $50.01		
☐ Atlanta Journal & Constitution	$	3/6/2000
☐ Barney Gumble - aka Mr. Duff	$	3/6/2000
☐ Bart Simpson - Homer and Marge's kid	$	3/6/2000
☐ BellSouth	$	3/6/2000
☐ British Petroleum	$	3/6/2000
☐ Chicago Tribune	$	3/6/2000
☐ Crown Petroleum	$	3/6/2000
Diner's Club		
☐ Due 2/29/2000 View Bill \| Delete Bill	$99.87	
Amount Due $99.87		
☐ First Usa Bank	$	
☐ Homer Simpson	$	
☐ Lazarus	$	
☐ Lisa Simpson	$	
Macy's		
☐ Due 6/12/2000 View Bill \| Delete Bill	$41.03	
Amount Due $41.03, Balance $182.10		
☐ Moe Szylak	$	
☐ Nordstrom's	$	
☐ Parisian	$	
Salt River Project		
☐ Due 2/29/2000 View Bill \| Delete Bill	$9.09	
Amount Due $9.09		
☐ Due 2/25/2000 View Bill \| Delete Bill	$89.89	
Amount Due $89.89, Balance $860.09		
☐ Due 1/10/2000 View Bill \| Delete Bill	$3.45	
Amount Due $3.45, Balance $860.09		

[PAY ALL MARKED]

>> Clear and detailed demos, such as this one for online bill payment, help users understand the process.

Mortgage Marketplace

Powered by
E-LOAN

Apply for a Mortgage Loan Today

Today's Rates	APR*	Type
7.250%	9.073%	1 Year ARM
7.500%	8.646%	5 Year Fixed
7.750%	8.686%	7 Year Fixed
7.750%	8.026%	30 Year Fixed

Assumptions [SEARCH RATES]

Why apply for a mortgage at WingspanBank.com?

- **Time.** Select from some of the lowest rates without the hassles of shopping around; we do the leg work for you!
- **Money.** Whether you're buying a house, refinancing, or shopping for a home equity loan, you want to spend as little as possible; we may be able to save you more than 50% on loan fees.
- **Service.** We will provide you with your own loan consultant to help you through this easy process.
- **Information.** You can track your loan 24 hours a day, seven days a week.

Ready? Select the option below that best describes your situation:

Ready to purchase Currently renting

Considering a refinance

>> Daily updates on mortgage rates and easy-to-understand text encourage users to utilize the Mortgage Marketplace.

Insurance Center

Welcome to The Wingspan Insurance Center.
Here you can compare free, no obligation quotes from some of the most trusted names in insurance. Simply fill out a profile—compare quotes—and choose the quote that's best for you.

Auto Insurance
Think you're paying too much for car insurance? Compare free quotes and see if you can save.

Homeowners Insurance
Owning or planning to buy a home? Get home insurance quotes right from your computer.

Renters Insurance
Need to protect your valuables? Get fast and free renters insurance quotes now.

Life Insurance
Thinking of getting life insurance? Get life insurance quotes with one easy-to-use form.

Health Insurance
Compare individual health insurance quotes f

Important Customer Information: Insuran
underwritten by Wingspan Bank, or any of its affiliat
FDIC insured, and are not a condition to an
INSURANCE PRODUCTS ARE NOT AVAIL

>> Customers can compare insurance quotes on anything from renters insurance to health coverage.

>> Wingspan Investment Services provide the key elements for simple and convenient online investing.

>> The English-language home page immediately provides a wide variety of information to the user.

Communicating a Global Brand to Two Different Culture:

- Understand the cultural and technological differences in your audience segments.
- Adopt corporate guidelines that do not limit creativity.
- Pace the environment to the customer.

site: Citibank Hong Kong

Citibank Hong Kong

The Citibank Approach

Around the world, Citibank websites look very similar. Corporate image standards are issued to every country and business organization outlining fonts, colors, required text and links, and other brand-related provisions. Locally, country organizations and business groups develop and create their own sites within these corporate guidelines. Once refined, sites are transferred to a central staging location, where a technical and visual evaluation takes place. When the inevitable bugs and tweaks are taken care of, the sites are hosted and updated via a central location.

The Hong Kong Challenge

Three years ago, Hong Kong was a primarily English-speaking global business center. Since the Chinese government took over, the island has retained its prestige as an international commerce hub, while also representing an entire Chinese-speaking region. Creating a banking site to address these changes and the associated diverse audience provides an unusual challenge.

How Citibank Does It

Customers accessing the primary site at citibank.com.hk see the English-language site first. Packed with financial information, promotions for Internet-based services, credit card applications, and Citibank Hong Kong news, the home page provides a complete picture of the services available to Citibank customers.

When users access the Chinese-language site at citibank.com.hk/chinese, a much simpler interface is displayed. Instead of high volumes of information stuffed into a 640 x 480 screen, a more formal image offers a welcoming statement and links to various services. When investigating the credit card application process, users view three pages of text before being linked to an online application in English— the same one accessed through the English site.

The two Citibank Hong Kong sites reflect the differences in the two cultures of the customer base as well as the relative novelty of the Internet to most of the Chinese population. The English site furnishes as much information as possible as quickly as possible. The Chinese site follows a methodical protocol, carefully educating and directing the user through the sites.

Citibank Hong Kong: Global Consumer Banking, 9/F Dorset House, 979 Kings Road, Quarry Bay, Hong Kong , 852 2860 0333

Executives: Internal Internet Steering Committee **Design Team:** In house **Toolbox:** Netscape Enterprise Server

- **Website Objective:** To accurately convey the offerings of Citibank Hong Kong to both English- and Chinese-speaking audiences.
- **Creative Strategy:** Develop two sister sites that address the different needs and cultures of Citibank Hong Kong customers.
- **Target Audience:** Internet-savvy users in Hong Kong.

>> A welcoming statement and links to other areas of the site are the only content on the Chinese-language home page.

>> The top-level navigation bar on the Chinese site closely mirrors its English counterpart.

香港

環球個人銀行服務

連接 Citibank 網上
理財服務

連接 Citibank 網上
證券服務

網上申請銀行服務

Citibank「萬分回享」
積分計劃

「大來積分享精萃」目錄

理財服務

½Đ §Y ¥î 10 ¤À ÄÁ ®É ¶¡ ¡A ¤F ¸Ñ §Ú Ì ³º »È ¦æ ª A °È ¦p ¦ó ¥i °¡ ¬ ±z ³º Ó ¤H
²z °¡ n ¨D ¡A Ó ÅU ±z ¤H ¥î ¤ ¨C Ó ¤£ ¦P ¥Ø ¼Đ ¡A ¨Ã ¥O ±z ³º °¡ ˇI ¥R °¡ ¬¡
¤O ¡A ¤£ Â_ ¼W ª ¡C

- ¡y ³Ì ˇf ±z ¡z »È ¦æ ª A °È ¡ § ©À
- CitiGold ¶Q »« »È ¦æ ª A °È
- ¤¡ ±M ¥î Åv ¯q - Citibank Student Banking Services

¡¹ ¥~ ¡A n §Ö °H ¤@ ¨B ´x °² { ¥N Ó °H ²z °¡ ¤ ¤ ¤¡ Ù ¤D ¡A ˇN n ²v ¥ý ¨ ¤î ¸U °ê Ä_
³q »È ¦æ ¥p ´a °³Đ ³º °°ˇô ¤W ²z °¡ ª A °È ¡I ¶Q ¬ §Ú Ì ³º »È ¤á ¡A ±z ¤ ¶¡ ¡· ˇì ²z ¥ô
¡ó ¤â Äô ¡A ¥u n ³s ±u ¤¡ Ãô ¤º °¡ ¤W ±z ³º ¨v U ³ ¤î ¤z ¡½ X ¤î ¡q ¤ Ü ²z

>> Few promotional images are found on the
Chinese site, which is mostly text-driven.

>> Credit card applications are still in English, but users may request responses in Chinese.

**When users access the Chinese-language site at citibank.com.hk/chinese,
a much simpler interface is displayed.**

Extranets and Subscription-Based Sites

What is an extranet? An extranet is a secure area of a Web site used to exchange information with business partners or customers. An extranet affords companies the ability to supply important information on a timely basis to the right people.

Dell's support site provides valuable information to Dell computer owners, including software updates, tutorials, and order status. For Dell, the support site means deploying fewer human resources in the customer support area while providing the best customer support in the industry. For Dell customers, the support site means not having to wait on hold for the next available customer service agent.

Subscription-based sites form an interesting area of extranet development. While subscribers do not necessarily view proprietary company information, they do receive valuable services. These can range from technical support to editorial content to order status infor-

Intranet and Extranet Sites

>> Intranet and Extranet Sites >> Other e-commerce Sites

mation. To retain that value, the company providing the subscription must ensure that only people or companies who have paid for the service can access it.

For 111 years *The Wall Street Journal* (p. 154) has provided highly respected business news. Now the *Journal's* Web site offers subscribers the same editorial content, plus additional online features. The success of the online version relies not only on its content but also on the communication of the *Journal's* reputation for excellence through the design of the site. As Jennifer Edson, executive director of design and product development, says, "Our design captures the essence of *The Wall Street Journal,* which brings with the brand the authority and reputation of the paper and the integrity of the journalism *The Wall Street Journal* is known for."

edfinder.com

Your guidance team.

Welcome to the EdFinder.com. We assist professionals and families in making the best educational choices for children with special needs. The site contains a comprehensive database of private schools and special programs. If you are a current subscriber, login at right.

LOGIN:

[]

[]

Login

For Parents

Search Edfinder.com Database
Our database contains hundreds Of programs that may be right for Your child. Use our special search Wizard to find the best program.

Find an Expert
Once you find the program, let Edfinder.com connect you with an Expert to help you interpret the Results of the search, and to add Value to your decision making Process.

For Professionals

Search Edfinder.com Database
Our database contains hundreds Of programs that may be right for Your client. Use our special search Wizard to find the best program.

Professional Resources
Edfinder.com has assembled a wealth Of special resources specifically for educational consulting professionals.

>> The home page allows users to log in immediately or find out more about the site.

Helping Parents and Educators
Make the Best Decisions for Children

- Keep the interface simple.
- Provide only relevant options on the top level.
- Make the commerce component almost transparent.

site: EdFinder.com

EdFinder.com

The Concept

Today's parents find themselves overwhelmed with information about educational options for their children. EdFinder provides a portal for parents to easily filter information from literally hundreds of thousands of schools, colleges, summer camps, medical and therapeutic providers, and educational consultants and resources. Beyond offering this access to information, EdFinder also matches parents with experts who can help them make informed choices according to their child's specific needs.

Making It Work

The almost-Spartan graphic interface for EdFinder belies an incredibly complex multidimensional database, and in this lies its beauty. Rather than being overwhelmed by options right off the bat, parents or educators input a set of criteria specific to a particular child's needs. The result is a list of relevant programs for that child.

The E-Commerce Components

For a small fee, parents are matched with an expert who walks them through the identified options and assists them in making the best choice among them. Users can choose either short- or long-term commitments with the expert. Users and experts are connected through a central telephone system that tracks each individual call and stores it in a transaction database for billing purposes.

Professional users, like guidance counselors and librarians, pay an annual subscription fee for access to the database. Schools, camps, and other providers also are charged a fee to self-maintain their individual records in the database.

"This state-of-the-art application is completely Internet-based." says Damon Myers, president of xalient.com, the design firm responsible for pulling the project together. "EdFinder takes an intimidating if not completely overwhelming marketplace and makes it manageable for both parents and experts." This manageability, conveyed through an incredibly simple interface, makes EdFinder successful.

This state-of-the-art application is completely Internet-based.

EdFinder.com: 337 Summer Street, Boston, MA 02210, (800) 252-7910

Executives: Ben Mason, President and CEO; William Cole, Vice President and COO Design Team: xalient.com Toolbox: E-Business Application: Oracle8l, Java PL-SQL, CyberCash Digital Telephony Switch: MS- SQL 7.0, VisualBasic, VisualBasic Script

- **Website Objective:** To supply highly specific educational consulting information to parents in a central information database.
- **Creative Strategy:** Create an interface that reaches out to three distinct audiences without confusing any of them.
- **Target Audience:** Parents with annual income in excess of $85,000, education consultants, and guidance counselors.

edfinder.com

Your guidance team.

Thank You!

Your registration has been accepted. Now, enter the additional informat requested below. Once you submit this information, a list of experts will provided online and via email.

These experts will contact you within the next 24 hours, or you may ca directly using the 800 number and extensions provided.

Our child is a: ○ Boy ○ Girl

Our child's age is: []

Our primary concern is our child's: (check all that apply)

☐ Change in peer group
☐ Declining academic performance
☐ Defiance, rebellion against authority
☐ Drug and alcohol involvement
☐ Self-destructuive tendencies

>> The find-an-expert page starts with the most basic information and the most often requested categories.

>> As users drill deeper into the database, more specific information can be accessed.

Search Results

Your search resulted in **12** programs that matched the criteria you submitted. You have two choices for accessing this data.

EXPERT HELP	SHOW ME THE RESULTS
$39.95	$9.95
With this option, you will be matched to up to 3 experts with specific experience in the areas corresponding to your program matches. The expert will guide you through an	With this option, you will be shown the results of your search. The results will also be emailed to you. No expert help will be supplied You will contact each program directly

>> The results page gives the users a list of relevant experts based on the input criteria.

The almost-Spartan graphic interface for EdFinder belies an incredibly complex multidimensional database.

The home page brings all of *The Wall Street Journal's* best features to the forefront.

The World's Leading Source of Business and Financial News and Information

- Keep the user in mind at all times.
- Don't compromise the quality of the information.
- Integrate new technology judiciously.

The Wall Street Journal
Interactive Edition

Bringing a Legend Online

The interactive edition of *The Wall Street Journal* brings the reputation and integrity of one of the world's most respected newspapers online: a daunting task at best. In typical *Journal* style, the interactive edition clears the hurdle with room to spare, actually improving on the usability of the paper and leveraging the brand to include channels on careers, personal technology, startups, and more.

Easing the Transition

Logging on to wsj.com leads to a familiar experience. The format is essentially in black and white and retains the hallmarks of the print newspaper, such as the dot drawings, the logo, and the typeface in the sections.

"When we first designed The Wall Street Journal Interactive Edition, very few commercial sites were on the web. We needed to educate the world on what an electronic newspaper could be, how one from *The Wall Street Journal* would function and what it would look like," says Jennifer Edson, executive director of design and product development. "The visual identity is a clean, elegant, refined, and newsworthy design that reflects an unparalleled level of trustworthiness that readers expect from *The Wall Street Journal.*"

Making It Work

The advantages to subscribing to *The Wall Street Journal* online are readily apparent: immediate access to the European and Asian editions, complete search capabilities, and customization features deliver the best of the paper to users' fingertips. Headlines and links to the day's top stories and navigation to other areas of the site are packed onto the screen, but without appearing distracting or overwhelming. The site is continually updated, more often than once an hour, keeping the news fresh.

Keeping Pace with the Interactive World

"We are constantly challenged by the rapidly developing pace of the web environment," adds Edson. Future enhancements under consideration include adding a fourth column to utilize the additional space made available by high-resolution monitors, distributing content to personal digital assistants such as Palm Pilots, and integrating video, sound, and moving imagery.

The advantages to subscribing to *The Wall Street Journal* online are readily apparent.

The Wall Street Journal **Interactive Edition**: Dow Jones & Company, 200 Liberty Street, New York, NY 10281, (212) 416-2900

Executives: Neil Budde, Editor and Publisher, WSJ.com; Gordon Crovitz, Senior Vice President, Electronic Publishing, Dow Jones & Company **Design Team:** Jennifer Edson, Executive Director of Design and Product Development; Andrew Gianelli, Design Director **Toolbox:** Photoshop, Illustrator, Microsoft Excel, Deltagraph, DreamWeaver, Flash, Shockwave

17 18 **19** 20 21 22 23 24 25 26 27 28 29 30

- **Website Objective:** To be online what *The Wall Street Journal* is in print: the leading source of business and financial news and information.
- **Creative Strategy:** To capture a classic tone that appears timeless and preserves the integrity of *The Wall Street Journal*.
- **Target Audience:** High-end educated business professionals.

The page you requested is available only to subscribers.

If you're a subscriber...

Please enter:

User Name: _____

Password: _____

[Sign On]

Forgot your User Name or Password?

☐ Save my User Name and Password
More information about this feature

If you're new...

- Learn more about subscribing to The Wall Street Journal Interactive Edition and Barron's Online.

- Register now as a NEW subscriber.

- Read our Privacy Policy.

>> The login page is free of extraneous graphics and features, speeding the user to more information.

>> Careful use of color enhances the signature black-and-white color scheme, helping appropriate sections stand out.

>> The top-level banner features date, time, up-to-date market information, and search capabilities.

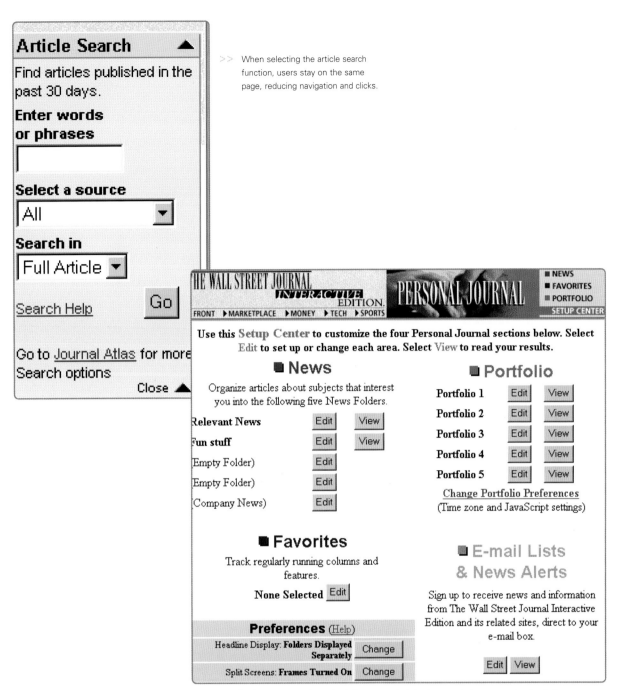

Article Search ▲

Find articles published in the past 30 days.

Enter words or phrases

Select a source

All ▼

Search in

Full Article ▼

Search Help Go

Go to Journal Atlas for more
Search options

Close ▲

>> When selecting the article search function, users stay on the same page, reducing navigation and clicks.

THE WALL STREET JOURNAL *INTERACTIVE* EDITION. PERSONAL JOURNAL ■ NEWS ■ FAVORITES ■ PORTFOLIO
FRONT ▸MARKETPLACE ▸MONEY ▸TECH ▸SPORTS SETUP CENTER

Use this **Setup Center** to customize the four Personal Journal sections below. Select Edit to set up or change each area. Select View to read your results.

■ News

Organize articles about subjects that interest you into the following five News Folders.

Relevant News	Edit View
Fun stuff	Edit View
(Empty Folder)	Edit
(Empty Folder)	Edit
(Company News)	Edit

■ Portfolio

Portfolio 1	Edit	View
Portfolio 2	Edit	View
Portfolio 3	Edit	View
Portfolio 4	Edit	View
Portfolio 5	Edit	View

Change Portfolio Preferences
(Time zone and JavaScript settings)

■ Favorites

Track regularly running columns and features.

None Selected Edit

■ E-mail Lists & News Alerts

Sign up to receive news and information from The Wall Street Journal Interactive Edition and its related sites, direct to your e-mail box.

Edit View

Preferences (Help)

Headline Display: **Folders Displayed Separately**	Change
Split Screens: **Frames Turned On**	Change

>> The personalization center employs simple buttons and minimal copy to help users customize their *Wall Street Journal* experience quickly and efficiently.

We are constantly challenged by the rapidly developing pace of the web environment.

Insider Trading Spotlight

A look at buying and selling by company insiders. Statistics, provided by First Call / Thomson Financial of Rockville, Md., are updated daily.

▶ **Intent to Sell:** A list of companies with the highest number of insiders filing Form144 with the Securities and Exchange Commission, disclosing their intention to sell restricted stock. *Updated on Mondays.*

▶ **Industry Leaders:** Lists of the industries where insiders have been the most active buyers and sellers of stock. *Updated on Tuesdays.*

▶ **Spotlight:** Lists, as published in The Wall Street Journal, of the biggest individual insider trades of the past week and a rundown of companies with the largest net change in insider ownership. *Updated on Wednesdays.*

▶ **Insider Buying:** A rundown of the 40 companies in the Standard & Poor's 500 with the highest number of insider purchases during the past three months. *Updated on Thursdays.*

▶ **Insider Selling:** A rundown of the 40 companies in the Standard & Poor's 500 with the highest number of insider sales during the past three months. *Updated on Fridays.*

>> Features such as the Insider Trading Spotlight are updated throughout the week.

>> The Spanish-language *Wall Street Journal* follows a similar but more colorful format.

The site is continually updated, more often than once an hour, keeping the news fresh.

>> The career area of *The Wall Street Journal* online provides timely information for both management and prospective employees.

>> Some areas of the site focus on issues outside the office like the home.

E-Zines on the Web

by Martha.Gill

The title of this section, *E-zines Publishing Online,* may be misleading. True 'zines were a phenomenon in the early '90s, underground self-published (sometimes Xeroxed) publications distributed through the mail, friends, and local resources. Many were filled with alternative views and visuals rarely seen in the mainstream media. With the fruition of the Internet, the 'zine publisher could now compete with the larger traditional magazines; the cost of publication and distribution was no longer a factor. In this section you will find a sampling of e-zines (the electronic version of a 'zine), online-only electronic magazines, and print magazines that have launched electronic counterparts.

Some print magazines with e-counterparts have launched what are called "subscriber sites" with little content, with only securing an order for the print edition as the goal of the site. Other publishers, like Time Warner and Condé Nast, embrace the new medium, not only offering content from print magazines "for free" but expanding the definition of what we consider a magazine to a virtual and complete experience.

The intent of this section is to provide a sampling of the best and most interesting publication-related material on the Web, to give readers a taste of the wide variety of design, content, and technologies that now globally compete on an equal footing, whether formatted as e-zines or as "super-sites" based on the brand of longstanding publications. Here you will find a soccer fanzine in the U.K. that has evolved into a protest site for activists, typographers building publications that teach the basics of type design, designers located on rural routes in Maine and the mountains of Norway who are reaching out to the world, digital artists, cartoonists and, yes, Web designers, programmers, and editors.

The majority of designers interviewed on these pages share several traits: enthusiasm and wonder for the media, the belief that content is critical, and a desire to interact with and learn more about the audience for whom they design and program in a real-time environment. Today, not only do they enjoy the ability to be designers/programmers/journalists, but they are also happily surprised to be trailblazing communicators working within a dynamic and ever-changing new medium. The constant call from some to keep things simple and focused on the most primitive browser software is balanced by a smaller number of technicians and designers determined to push the envelope of what is possible, no matter how many they baffle, perplex, or crash online.

A new style of designer is emerging, one who blurs all boundaries, a cyber-Renaissance person who is at once a journalist, art director, self-publisher, and entrepreneur. Elegantly designed online publications such as Salon prove that the art of design as communication has not been completely swal-

Our little systems have their day.

—Lord Alfred Tennyson (1809–1892)

lowed up in the excitement of a new technology. Well-planned and brilliantly conceived sites continue to set high standards for site architecture, navigation, prioritization, and organization. The Onion, with roots in the 'zine culture, proves the far-reaching effects of the Internet on distribution and communication. Sites initially posted as counterparts to print magazines are quickly losing their stepchild status, becoming an integral part of the mix by creating a live extension of the publication's culture.

A new chapter in publication design is being written by designers and computer technicians who ten years ago could never have imagined the partnership they now forge. A new role for both—and for the printed word—has emerged through the expansion and growth of the Web. Online designers and programmers daily confront the challenges of a technology that is rapidly changing, simultaneously frustrated by the speed of change and by their feeling that change is not happening rapidly enough. What is happening to the world of publication? Not even the truly seasoned who work within the eye of the storm know for sure. Everyone agrees anything is possible. Designers are learning how to think in a different way, how to design for a real-time audience that selects what it views, has limited patience and varied resources, and reacts to design and programming changes with instantaneous feedback. The closed door of the ancient order of the publication designer has swung wide open, allowing T-shirt designers, paste-up artists, underground digital developers, activists, and more to converge upon publication design traditionalists, creating an environment that is unprecedented and in its infancy.

Is online publication design a degradation of the field of design? One may rightly argue that the world of the Web is rife with the diminishment of design, but before succumbing to this belief, consider the entry of desktop publishing and birth of digital type. A severe jolt to the professional designer, both of these innovations ultimately allowed unprecedented channels of communication to flow. Eventually, the awareness of classical and contemporary style was heightened due to the sheer lack of design abilities as practiced by the masses. The onslaught of so much "bad design" clarified what makes a design "good" and what many proclaimed "bad" design eventually became revered as breakthrough design. The vast majority of participants interviewed for this book felt that design and technology, while important, needed to support compelling content and not exist in a vacuum. The vastness of the Web and the possibilities it holds for the world of publication design are overwhelming, but consider this enduring quotation from Louis Henri Sullivan, who wrote in 1896 about the arrival of the tall office building, "Form ever follows function." The same appears to be true for this courageous and exciting new medium.

Business

e-zines

>> **Entertainment** >> **Lifestyle** >> **Self-Published**

One of the fastest growing categories on the Web is financial and business information for investors and others. Information gathering and data retrieval on the Internet by professionals during the work day has quickly become part of the up-to-date job description. Electronic publications catering to business needs to provide inspiration and indispensable tools for the modern business person. Wide access to the Web and a working knowledge of what is occurring are critical for success in today's competitive markets. From advice geared toward a new breed of investor who wants to be amused and educated to the ability to quickly check on Asia's daily news events, business information on the Web is prevalent and rapidly increasing.

FAST COMPANY

FCtoday | community | careers | partners | archives | subscribe | HOM

life&work in the new economy

conflict resolution

2 - 8 august

How to Disagree (Without Being Disagreeable)
Business is a contact sport, and conflict is a given. Here's a collection of new ideas and hands on tools to make your disagreements not only easier to handle, but lots more productive. More...

now online

FAST COMPANY
Design Life Works

core themes
archives
about us
search

hmstore.com

But who helps the world connect to Cabletron.com?

Put yourself in good company. Click here.

ERNST & YOUNG
FROM THOUGHT TO FINISH™

click here to visit the fastco store

Company of Friends
Sign in here

community
career center
RealTime
education

hotOffice™
Anytime Anywhere Officing™
Web-Based Intranet Service for Small Business
30 DAY FREE TRIAL

Win cash for your business!
FAST COMPANY EZVENTURE
Click Here!

Work! @ FAST COMPANY

CLICK HERE
WE WANT YOU

Online Feature:

Stop, Look & Listen
In this new world of work, expectations, priorities, and egos clash with a certain regularity. Yet the show must go on, and conflicts simply must not clog the flow of business.

Here, Fast Company has collected conflict resolution doctrines, methods, and survival techniques from four leaders in four diverse fields: environmental protection, education, psychology, and community dispute mediation. Read on to learn how they facilitate peace, love, and understanding. More...

From the archives:

Zen and the Art of Managerial Maintenance
All that number crunching, that theoretical stuff they are feeding to MBAs isn't business! Business is inherent conflict! Business is yin and yang! Business is Zen! More...

Staff Favorites:

- Resolution Works
- Conflict Resolution Questionaire
- Workplace Conflict Resource Center

FC Advice:

Community:

Would your company benefit from establishing formal procedures for intra-office conflict resolution? - **vote**
Yes
No
(comments)
See Previous Polls

Let anger be your best friend
Next time you feel a spot of anger coming, first identify the reason why you feel angry and then see if it can be used as "fuel" in your drive rather than just let it be "exhaust" through your pipe.

...sign on here
then join the Creativity and Innovation conference.

site: fastcompany.com

Fast Company

"KEEP IT SIMPLE. KEEP IT FAST. BUILD SLOW." This expert advice comes from David Searson, Fast Company's electronic magazine Internet strategist, who believes in keeping navigation as consistent and simple as possible across the site. "With several thousand pages of content, site architecture has always been the leading issue. We focus on the simplicity of content presentation."

While the print and electronic versions of Fast Company have followed separate development since the beginning, they do overlap. The electronic version borrows heavily from the magazine, but often the print product cannot be easily translated into the low-bandwidth style required for a Web site. And recently, "Web-only" content has been finding its way into the print magazine. The site is updated using what they call the "reflex publishing system": monthly for the magazine content, weekly for the online homepage features, and daily for monitoring of online discussions and polls. Since the whole site works from templates, sitewide updates can be done at any time. Redesigns are usually done every six months. *Fast Company* also builds a new "cybercafe" environment for live events every six months and the Web site provides extranet support services for sales and marketing, editorial staff, and corporate public-relations efforts.

To hold a reader's attention online, Fast Company's Web team presents a new theme each week—and keeps readers informed of the themes through its "Fast Take newsletter" by e-mail. Searson explains, "When they visit, we like to keep them around by providing as few obstacles as possible—the pages load relatively quickly, no Java or plug-ins, no special type, very few images. . . . In general the approach is that it makes more sense to *keep* a visitor online than try to entice new visitors to make up the same traffic. We have ended up with a loyal repeat-visitor base. No cheap tricks, just current, common-sense content and attention to the requests and complaints to keep the site developing to the customer needs."

A business 'zine about work and life in the new economy, *Fast Company* is leading the cutting edge. Its Web team creates an interactive space that allows magazine readers to interact with editors, writers, the company, and each other. As Searson says, the idea is "to enable zero barrier to access, to give the content freely to people who want to read online. There is no practical barrier to enter the *Fast Company* experience."

As the resident netizen within Fast Company, my job is fairly clear—to make Fast Company available to the whole world, using all the possible technologies of the net in balance with the reality of global access speeds.

David Searson // Internet Strategist

12 13 14 15 16 17 18 19 20 21

>> Work and life in the new economy, business performance combined with "sane human values," and the people who are leading the business revolution all shape the content of Fast Company articles.

Keep it simple. Keep it fast. Build slow.

David Searson // Internet Strategist

>> The Company of Friends is an interactive space designed around 150 regional groups who meet online and also in real life to discuss magazine stories.

>> A "cybercafe" new environment for live events is created every six months.

> > Brand yourself, find your calling, search for a job, make a choice, and
move on at Fast Company's career guide page.

The job of Webmaster is kinda like being the Wizard, hidden behind the curtain, pulling the strings that make everything work like magic. HTML, Perl, CGI, UNIX, databases, Mac, layers, frames, NT, channels, XML . . . all the tools of the modern-day wizard.

David Searson // Internet Strategist

> > Web readers can get a free issue of the print product.

FAST COMPANY

FCtoday community careers partners archives subscribe H

Click here for a FREE trial issue!

COMMUNITY CENTRAL | Forums | Newsletter | Company of Friends | Live Events

Fast Company Community Central

Welcome to Community Central, where you'll find ways to interact with other readers on and offline, the Fast Company team, and the writers and people featured in the magazine.

The Company of Friends
Join our readers' network to connect with readers who live in your area or share your interests.

Fast Take
Subscribe to Fast Take, FC's twice-monthly electronic newsletter.

Fast Talk Forums
Join other Fast Company readers in online discussions.

>> Access the Fast Company community with a click.

Fast Company's site is more than a "version" of a print magazine online, and though the e-zine is central to the business, it is only one part of a whole picture. You need to view the Web space in context of long-term vision and wider applications.

David Searson // Internet Strategist

TIME

TIME.com Home
TIME Daily
From TIME Magazine
TIME.com Newsfiles
Web Features
Photo Essays
TIME Digital
TIME For Kids
LIFE Homepage
Latest CNN News
Boards & Chat
Magazine Archives

Search TIME.com
[_____] Go

Subscribe to TIME
Subscriber Services
Write to TIME.com

marketplace

LIFE
LIMITED OFFER
TO THE MOON
AND BACK

TIME Selections
TIME 100 Bookstore
TIME Almanac 1999
TIME.com Book Deals
Free Product Information
JFK Jr. Commemorative

Quick Links
Find books
Find videos
Find music
Find SI Swimsuit Calendar

OTHER NEWS
Market Tumbles,
Intel Stumbles
FORTUNE.com

timedaily
What the News Means Today

Web-only news
Tuesday, Oct. 12, 1999

In Pakistan, Army Shows Who's the Real Boss

Pakistani prime minister Sharif, left, meets with Chinese president Jiang Zemin

A coup in the newly nuclear state signals military's lingering anger over Kashmir retreat. FULL STORY >>

Pakistan: A Q&A Primer
TIME Daily's Tony Karon takes you through the fundamentals

Faith of Our Fathers
A special TIME.com essay takes the long view on the Red Sox's World Series prospects

Phew! Al Gore Gets the Nod From Big Labor
It's not the numbers of an AFL-CIO endorsement that count, it's the campaign muscle — and the fact that it didn't go to Bill Bradley

Bradley: It's Not 'Bill Who?' Anymore
New poll shows big strides for Dollar Bill. Chalk it up to exposure

Lamaze, Shlamaze — Load Up That Epidural
More and more women are having spinal anesthesia during labor. Whatever happened to natural childbirth?

Clinton Faces Nuclear Test Ban Defeat
Postponing a Senate vote means abandoning a key foreign policy goal — and sends the wrong message to the world

Now, That's What You'd Call a Good Buzz
An implant that sends mild shocks to the brain is shown to reduce depression. It could also be a cure for obesity

Return of an Endangered Species — Nurses
A new California law requires hospitals to have a quota of qualified

magazine

Cover
With a New Toy Story and a Cool iMac, Steve Jobs Is at the Top of His Game

Interview
Jobs Talks with TIME

The Unabomber Speaks
From Prison, Ted Kaczynski Talks About His New Book and His Future

Campaign 2000
George W.'s Triangulation Wins Points but Annoys the GOP

Science
A New Book Examines the Mystery of Consciousness

web features

Closer Look
Why Big Business

>> A navigation bar on the home page of time.com features the printed publication's current cover and top stories.

Time

According to Web Art Director Melanie McLaughlin, **ONE OF TIME.COM'S SECRETS IS TO LINK DAILY STORIES TO RELATED WEEKLY MAGAZINE STORIES** to archived stories to special features on the subject and then to related sites across the Web, resulting in a much richer experience for readers than simply accessing the e-zine or daily story. Images and creative design are used to keep the site graphically interesting, and time.com believes in the power of linking. When designing site architecture, McLaughlin always looks for a clear path and another option for the reader to click on, giving someone with a short attention span somewhere else to go.

First brought in to work on the redesign of time.com one year ago, McLaughlin's role is to update the navigation of the site and create a design with a quick download time. "I think after the redesign, the biggest challenge has been to keep working to find ways to introduce the new technologies to an audience that may not all be up to speed with the latest browsers and plug-ins. We're beginning to get to the point where we have to move ahead, and let those with browsers earlier than 4.0, and some Mac users, fend for themselves."

McLaughlin adds that "we give away the cover story each week and a couple of other stories; we put the full contents up a week later. I would say we're a composite site: part mag shovelware, part original publication. Certainly, it's a site you can come to daily for an interesting take on the day's headlines, as well as a variety of other features that the time.com team develops—from Shockwave games to photo essays to chats."

Editor Dick Duncan oversees all aspects of the site. A team of writers, photo editors, HTML production specialists, and programmers form the community that fulfill the technical and content aspects of both the daily and magazine features of the site. Daily updates are supervised by Deputy Editor Matt Diebeland, while archives and news file reference areas are handled by News Editor Mark Coatney.

Currently the Web team is experimenting more and more with animation, still slide shows, and audio. In the future, the team foresees greater use of animation, visual, and audio effects, although they certainly aren't waiting breathlessly for the very newest technology. For the next year or so time.com plans on mastering the technologies they have used only sparingly to date: Flash, DHTML, and Shockwave—learning how to use them deftly, with reasonable file sizes, and always with expedient downloading.

The best Web design is not derived from magazines or television; it's a thing of its own. Do your best to stay abreast of new technologies and have an understanding of what they can do, what the limits are, even if you don't have to program DHTML or XML. It's vital to be able to understand how to solve problems.

Melanie McLaughlin // Art Director

12 13 14 15 16 17 18 19 20 21

> > We like to keep ad banners down to 12K count. We are beginning to experiment with pop-up interstitials, which seem to cause less user annoyance than we had feared. If used right, they get a lot more response than banners.

> > Clean, fresh layouts facilitate a quick download throughout the e-zine.

> > The e-zine's table of contents features the cover and related stories, breaking additional articles into a two-column format.

> > Sidebars display articles related to the main story, archived information, and Web resources that are of interest.

TIME.com

photo essay

Around the World in 20 Days

...d and Jones quickly rose
...s on the morning of
...It was pilot Bertrand

TIME.com

photo essay

Around the World in 20 Days

The night before launch, February 28, was bitterly cold. At the launch site in Chateau d'Oex, Switzerland, final preparations for the historic flight were made and supplies stowed aboard as the Breitling Orbiter 3 lay tethered to the ice.

AP Photo: FABRICE COFFRINI

Next > >

>> Photos from around the world are used to create visual essays.

> When designing site architecture, McLaughlin always looks for a clear path and another option for the reader to click on, giving someone with a short attention span somewhere else to go. >

>> The full content of each printed magazine is archived after one week online. Readers can view by date or cover.

>> The Time 100 feature is a user favorite. Time's ability to involve users in a sense of history is a real asset—leaders, revolutionaries, artists, entertainers, scientists, heroes, and icons are profiled.

ASIAWEEK asianow

TIME asianow

SEARCH [] GO

ASIA NOW

east asia

southeast asia

south asia

central asia

australasia

TIME ASIA

current issue

asia buzz

market q&a

magazine archive

web features

time money

customer service

subscribe to time

ASIAWEEK

BIZ ASIA

SPORTS ASIA

SHOWBIZ ASIA

ASIA WEATHER

TRAVEL ASIA

OTHER NEWS

From TIME Asia

Asia Buzz:
What, No Coffee?: Why I love to hate Japanese inns

Market Q&A:
Hong Kong Sheds 1.8% on Fears of Over Supply

Q&A: Sylvia Chang
Exclusive, online-only excerpts of the TIME

BREAKING NEWS: Pakistan in crisis

Chain Reaction

Japanese authorities admit that a recent nuclear accident was worse than previously realized, and the finger-pointing begins
[full story]

ALSO IN TIME:
How Japan's Accident Stacks Up Next to Chernobyl

CNN:
Breaking news from East Asia
Asiaweek:
'We're Scared for Our Baby'

Kyodo News
Japanese PM Keizo Obuchi samples a slice of melon cultivated near the site of the country's worst nuclear accident.

COVER STORY
BUSINESS: The Big Apple
Maverick Steve Jobs has done the seemingly impossible, fueling the rise of two cutting-edge companies—Apple and Pixar—and making the personal computer cool once more

ASIA

Asia Buzz: What, No Coffee?
Why I love to hate Japanese inns

Market Q&A: Hong Kong Sheds 1.8% on Fears of Over Supply
With Scott Blanchard, head of sales trading, ABN Amro

THIS WEEK'S ISSUE

Steve's Jobs

Cover
Archives
Subscribe

QUICK VOTE

Malaysia's PM Mahathir must schedul an election by next April, when do yo think he will do it?

By the end of this year. ○

Sometime next year. ○

View Results

[vote]

TRAVEL WATCH

Love Me Tender, Love Me Suite—Asian Style
Many love hotels offer clean, well-maintained and well-appointed rooms. Choose carefully and you, the budget traveler, have unearthed a bargain

>> An international version of the e-zine and an Asian edition are online; all incorporate the strong red, black, and white graphics that brand time.com.

E-zines on the Web

>> Business >> Computing/Design >> Counter Culture >> Popular Culture

Computing/Des

>> **Entertainment** >> **Lifestyle** >> **Self-Published**

While information about computing is given freely, unfortunately the leaders in the design industry continue to post limited—or

worse yet, subscription-only—sites. In time, perhaps leading communication magazines such as *Graphis* and *Communication Arts*

will realize the vast potential of a loyal reader base and the opportunity to attract new readers through the medium of the Internet

and develop their sites beyond the obligatory URL. The sites listed here comprise a wide variety, from renegade Web designers

giving advice (such as the creator of Eclipse) to Japanese cartoonists (manga artists) to the designers of Metropolis—one of the

leaders in the design industry that dares to post substantial information, free of charge, for a computer-savvy audience.

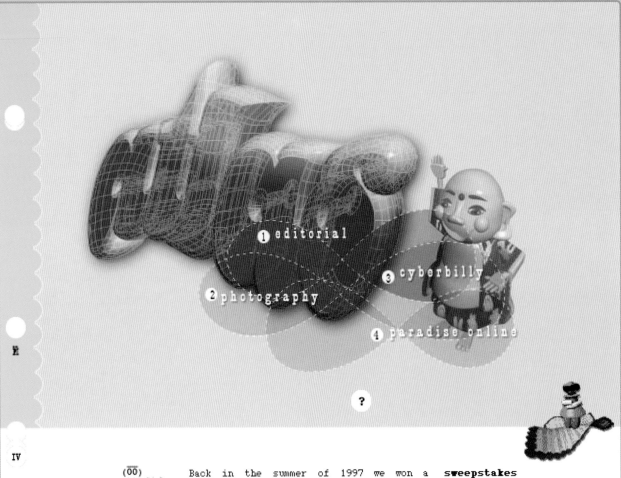

1 editorial

2 photography

3 cyberbilly

4 paradise online

?

Back in the summer of 1997 we won a **sweepstakes vacation** to a dude ranch. The clean mountain air, the high plateaus and the **freshly mowed alfalfa** were a welcome respite from the fast-paced life of cellular phones and the low-pixel world of the Web. **In fact,** we felt so invigorated and close to nature that we **almost forgot** to come home. But a **strong sense of duty,** not to mention **Dynamic HTML,** lured us back to our screens. Of course, we shall never forget those **wonderful months** of pastoral idleness, punctuated only by preparing cattle for market.

So without further ado ...

@tlas magazine

A E-ZINE-GALLERY SITE THAT SIMULTANEOUSLY SPOTLIGHTS BREATHTAKING PHOTOGRAPHY, ETHEREAL ILLUSTRATION, AND MULTIMEDIA DESIGN, @TLAS IS ONE OF THE FIRST THREE WEB SITES TO BE INCLUDED IN THE PERMANENT COLLECTION OF THE SAN FRANCISCO MUSEUM OF MODERN ART. In 1994 Creative Director Olivier Laude decided that the Internet would be an interesting way to publish without relying on media conglomerates. He wanted to develop something aesthetic and interesting, not just a design site. Today, Laude describes @tlas as "*foie gras* for your bandwidth." A long list of awards and honors follows the site, including highest honors from Magellan and Excite, features in *The New York Times, USA Today,* c|net, and a consistent placement in the top fifty sites as ranked by 100hot.

@tlas is divided into four major sections: Editorial, Cyberbilly (multimedia), Photography, and Paradise Online. Name Droppings is a "phenomenally popular" in-box where readers recommend URLs. And the @tlas gallery features soothing MIDI renditions of the Webmaster's musical works. The editorial section includes Pulitzer Prize-winner Stanley Karnow explaining how he found himself in Paris in the '50s, an online multimedia novel, and a review of the most recent American Institute of Graphic Artists (AIGA) Conference, Design of Culture, titled "Culture Shock." Photography is prevalent throughout @tlas with features from Cuba to a look at China's countryside and rural architecture.

@tlas is filled with edgy graphics and is "super-enhanced" with the latest Netscape or Internet Explorer features plus Shockwave and QuickTime VR plug-ins. Filled with moving parts, vivid photos, flying celestial illustrations, and experimental multimedia, @tlas is a visual adventure that explores the latest technologies. The amazing e-zine-gallery is a group effort produced by a core team of three: Olivier Laude, Amy Franceschini (Senior Designer), and Michael Macrone (Implementation). An array of eclectic contributors graces the screen with interactive displays, journalistic photos, and creative inspiration.

@tlas is a mix of multimedia for anyone who wants to learn.

Olivier Laude // Creative Director

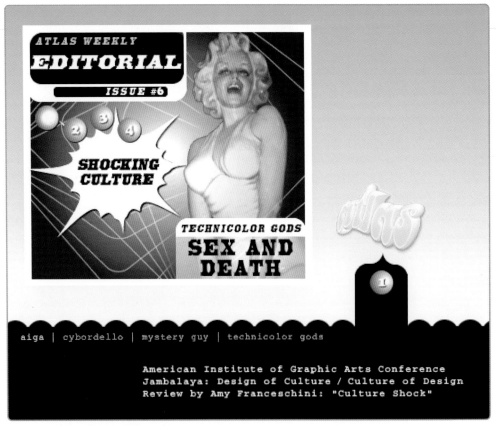

>> The editorial section of @tlas includes a semi-regular feature, Cybordello, reviews, and eccentric intellectual musings.

>> Cyberbilly is the latest in experimental multimedia. Here you will find a digi-cam view of the @tlas office by day.

>> Journalistic photography is an ongoing component of the @tlas mix. Take a visual trip "under" New York or to a bazaar in Bombay.

>> A narrative by Adam Kufeld accompanies a gallery of photos shot on a trip to Cuba.

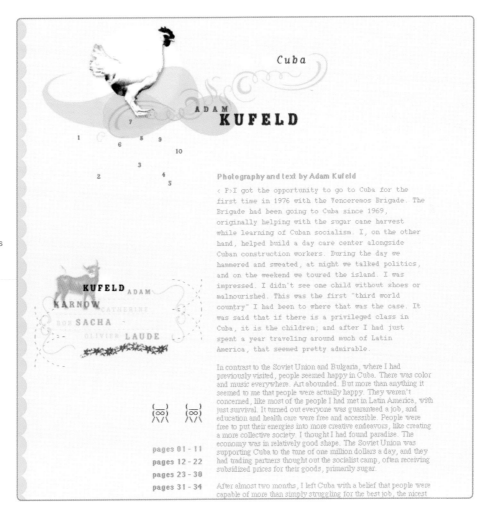

Photography and text by Adam Kufeld

< P>I got the opportunity to go to Cuba for the first time in 1976 with the Venceremos Brigade. The Brigade had been going to Cuba since 1969, originally helping with the sugar cane harvest while learning of Cuban socialism. I, on the other hand, helped build a day care center alongside Cuban construction workers. During the day we hammered and sweated, at night we talked politics, and on the weekend we toured the island. I was impressed. I didn't see one child without shoes or malnourished. This was the first "third world country" I had been to where that was the case. It was said that if there is a privileged class in Cuba, it is the children; and after I had just spent a year traveling around much of Latin America, that seemed pretty admirable.

In contrast to the Soviet Union and Bulgaria, where I had previously visited, people seemed happy in Cuba. There was color and music everywhere. Art abounded. But more than anything it seemed to me that people were actually happy. They weren't concerned, like most of the people I had met in Latin America, with just survival. It turned out everyone was guaranteed a job, and education and health care were free and accessible. People were free to put their energies into more creative endeavors, like creating a more collective society. I thought I had found paradise. The economy was in relatively good shape. The Soviet Union was supporting Cuba to the tune of one million dollars a day, and they had trading partners thought out the socialist camp, often receiving subsidized prices for their goods, primarily sugar.

After almost two months, I left Cuba with a belief that people were capable of more than simply struggling for the best job, the nicest

pages 01 - 11
pages 12 - 22
pages 23 - 30
pages 31 - 34

>> Photo images are presented gallery style; they
 are grouped in sets and can be enlarged for
 identification and viewing with a click.

>> The @tlas site map features a digital
 illustration of a man on a flying carpet
 who zooms in and out of the finely
 illustrated directional grid.

>> An earlier edition of @tlas highlights fanciful illustration, fantastic photography, and a heartfelt message from Olivier Laude.

>> An editorial, "Technicolor Gods" by Julie Winokor, talks about the three faces of the goddess Devi, a.k.a. Parvati, and "mood swings."

METROPOLIS online

architecture, design, and a changing world

special subscription offer! click here!

october 1999

events + exhibitions
designmart®
web picks
archives
conferences

search
subscribe

international contemporary furniture fair
for advertisers
who we are

NEW AND IMPROVED! **www.bnind.com**

Metropolis

"From saltshaker to skyscraper, our magazine looks at all aspects of design. Our beat is one of the most complex designed environments in the world: the metropolis." According to Metropolis Editor Susan Szenasy the print magazine *Metropolis*—conceived by Publisher Horace Havemeyer III in 1981—began life with a vision to expand the dialogue about design and architecture to a wider audience than "just the professions": identifying the cultural, social, economic, and political connections between design and society and how together they shape our physical world.

Metropolis Online is essentially the paper magazine on the Web, and the site as it appears today was designed by J.P. Frenza with Earth Pledge Foundation in New York. Szenasy explains, "When we first went on the Web, we were part of the Electronic Newsstand; no pictures, just text. In an effort to reach a new audience for the magazine, we decided to create our own site."

Each issue of Metropolis Online is posted by a freelance Web designer every month. The content includes the cover image, newsworthy stories, archives, a subscriber page, and a conference area with information about the International Contemporary Furniture Fair that Metropolis has sponsored since its inception in 1989. Susan talks about one of the popular interactive features of the online magazine: "We select Web links [Web Picks] to help promote traffic to the site and expand our universe way beyond issues of architecture and design. The concept of linking is in keeping with the contextual, multi-disciplinary approach we take to covering design and architecture." Susan and the team at Metropolis are currently evaluating what the next phase of Metropolis Online should be. . . . "How do we create a real Web product, not just a magazine on the Web? **WE ARE DISCUSSING THE WAYS AND MEANS OF MORE INTERACTIVE INFORMATION SHARING IN HOPES OF UNDERSTANDING THE EVOLVING NATURE OF THE WEB AND HOW IT WILL BE USED IN THE EARLY YEARS OF THE NEXT MILLENNIUM."**

> **The online format was devised for easy navigation. The lozenge-shaped buttons serve as quick entry points to each segment of the site. They're colorful to reflect the back-lit, TV-screen-like Technicolor nature of our computer screens. The rounded square box frames simply repeat the rounded square box of the computer screen. They tend to be small, so that computers of all capacities can get at them easily.**
>
> **Susan Szenasy // Editor**

12 13 14 15 16 17 18 19 20 21

hmstore.com

| home | current issue | subscribe | talk to us |

METROPOLIS contents

october 1999

"Apocalyptic forecasts flourished. The subcontractors, it was rumored, were refusing to work because of the pay, working conditions, and lack of quality control. Local realtors were telling clients not to buy here because of the poor construction, and town house residents had stopped paying their maintenance fees in protest."

see article 'Mousetrapped" in the print edition of *Metropolis*

features

the British empire
Graduates of the Royal College of Art dominate the design of everything from Calvins to convertibles to chairs — not bad for a place with only 800 students. **Caroline Roux** tells tales out of the school that's quietly colonizing the world.

all's fair
The best seats — and laminates and lighting and more — at this year's ICFF.

the architecture of madness
Philip Nobel investigates the therapeutic — and debilitating — power of buildings.

More in the print edition of *Metropolis*

best western?
A prestigious competition inspired five high-profile architects to imagine a future for Manhattan's last undeveloped frontier. **Valerie Gladstone** reports on how the west was won by Peter Eisenman.

the collector
Photographer **Ezra Stoller's** pristine specimens of postwar buildings.

mousetrapped
An excerpt from The Celebration Chronicles, the new book by **Andrew Ross**, about the "house-rich and cash-poor" home-owners who want to get off Disney's ride.

see article "the British empire"

contributors

Valerie Gladstone, Colin Moynihan, David Pescovitz, Andrew Ross, Jimmy Cohrssen, Ben Katchor

departments

the metropolis observed
Philip Johnson gets jiggy with P.S.1; Grand Central Terminal's paradoxical furniture; two swell new Swatches; Londoners cozy up to cubicles; Yale almost cons itself out of a Kahn; the Willy Wonka of restaurateurs reopens the Russian Tea Room.

enterprise
Smart Design hopes to push all the right buttons — and eclipse 3Com's Palm market share — with its Thumbscript keypad language. **David Pescovitz** examines the Graffiti on the wall.

see article "metropolis observed."

what goes up
As a young architect, Colin St. John Wilson got the commission of a lifetime — and 36 years later, it's now complete. **Michael Sorkin** finds his British Library both overdue and fine.

in review
Paula Deitz on "The Un-Private House" at MoMA; Joseph Giovannini on "Carlo Scarpa, Architect: Intervening with History" at the Canadian Centre for Architecture; D.T. Max on Samuel R. Delany's Times Square Red, Times Square Blue; Anson Rabinbach on Eve Blau's The Architecture of Red Vienna 1919–1934.

up and coming
A preview of October's exhibitions, events, and conferences.

ben katchor
Who knows what darkness lurks in the hearts of household appliances?

More in the print edition of *Metropolis*

>> The contents of online Metropolis include features, regular departments, a list of contributors, and previews of exhibitions, events, and conferences.

| home | current issue | subscribe | talk to us |

METROPOLIS feature

october 1999

the british empire

The Main Event is a portable boxing ring that swings out of one of 25 multiuse trailers designed by RCA architecture student John Senior for an existing housing project.

(photo: John Senior, courtesy: Royal College of Art)

click here to see the photos and captions for this article

how a small London art school quietly colonized the world.

by Caroline Roux

There is no such thing as a normal fashion show, but it still feels seriously out of the ordinary when several portly men in early middle age suddenly appear on the runway among the willow-thin girls and the foxy-faced boys. One, holding a camera, wears a strangely turned up hat; another models a campily cropped jacket and a pair of billowing trousers; a third in a slick piece of tailoring smirks slightly, like a college professor who went through the wrong door and suddenly found himself in the world of Comme des Garçons (although the clothes are all wrong). In fact, he is a professor — they all are — and he has found his way into the only fashion show on Earth where he can cut as captivating a figure as the young models around him. Welcome to the Royal College of Art at the turn of the century.

In the best tradition of art schools everywhere, the RCA is on a continual mission to declare itself present. It hasn't done so badly over the years. The *Phantom*

>> A Metropolis feature, The British Empire, follows the graduates of the Royal College of Art and their diverse careers.

| home | current issue | subscribe | talk to us |

METROPOLIS the metropolis observed

may 1998

the zine-ing of architecture

Zines devoted to architecture and urbanism explore the life of cities (Photo: MacDuff Everton/@Corbis)

Little magazines bring a breath of fresh, democratic, and sometimes visionary air to the architecture dialogue.

>> A recent article about the 'zine revolution in the early '90s finds the genre has brought a breath of fresh air and new vision to the dialogue of architecture.

186 WEBWORKS

the british empire

This past year's student projects in Industrial Design and Furniture include a shelving unit by Herbert Gasthaus. (courtesy: Royal College of Art)

GinGin, a mold for making a lemon squeezer, by Andrew Woolnough. (courtesy: Royal College of Art)

Architecture student Charlotte Boyen's Climb Collage is part of an "Alternative Lesiure Landscape." (courtesy: Royal College of Art)

Size Matters, a seating project for the Tate Gallery by Rainer Spehl. (courtesy: Royal College of Art)

Above, opposite left to right: Architecture head Nigel Coates. (photo: Ed Reeve)

Womenswear by fashion Student Leanne Jones. (courtesy: Royal College of Art)

Menswear by Jose Rodriguez. (courtesy: Royal College of Art)

>> A photographic collection of student projects from the Royal College of Art is framed in rounded, thickly ruled boxes designed to echo the shape of a viewer's computer screen.

>> In addition to the standard divisions, the Metropolis Archives include categories for places, preservation, and sustainability.

>> Events and exhibitions are updated monthly and divided into four categories: Eastern, Central, Pacific/Mountain, and International.

the architecture of madness

(photo: Ophelia Chong)

click here to see the photos and captions for this article

Buildings can drive you crazy, but can they help restore mental health?

by Philip Nobel

The Boston Government Service Center (BGSC) looks like the last place one would want to go for help. Designed by Paul Rudolph immediately after he completed the Art and Architecture Building at Yale in 1963, the BGSC incorporates all of that earlier building's cave-dwelling mystery and brave experimentation with the abrasive qualities of concrete. But it was designed on a much grander scale — the BGSC occupies a superblock on the lowest slope of Beacon Hill, consolidated in what might be the nation's most infamous act of postwar urban renewal, the destruction of Boston's West End — and with more harrowing possibilities for unhinging the minds of those unfortunates inside.

The Art and Architecture Building has often been singled out as an example of unnecessarily belabored and disorienting space; in the catalogue for an exhibition to celebrate its opening, Vincent Scully famously warned that the building "puts demands upon the individual user that not every psyche will be able to meet." In the BGSC, and particularly the Lindemann Mental Health Center, which shares the spiraling megastructure with several civic bureaucracies, Rudolph would expand on Art and Architecture's dark palette of labyrinthian spaces, and the result in human terms would be infinitely worse.

Erich Lindemann, for whom the center was named, was a respected Boston psychiatrist and a professor at Harvard in the 1960s. There is considerable irony in his being honored with this dedication. Among his then-recent works was a well-publicized study that recorded the deleterious side effects of urban renewal, focusing on the experiences of residents in the West End. He would later help lead a movement that brought psychiatrists, designers, and urbanists together to study the influence of man-made environments on mental health. The building that still bears his name would go on to be a notorious example of architecture's power to confuse, agitate, and sometimes fatally overwhelm.

>> A basic "Swiss-style" grid is used for articles and features throughout the site for visual consistency, clarity, and easy scanning.

| home | current issue | subscribe | talk to us |

METROPOLIS furniture fair

International Contemporary
Furniture Fair® 2000

Saturday, May 20 – Tuesday, May 23
New York City's Jacob K. Javits Convention Center

Exhibit Organizer:
George Little Management

Sponsored by:
Metropolis® Magazine

Internationally sponsored by:
Abitare, Interni, Intramuros, Wallpaper*

Address & Telephone:
Ten Bank Street
White Plains, NY 10606-1954
p: (914) 421-3200;
f: (914) 948-6180
1-800-272-SHOW (7469)
(Attendee Registration)

Internet:
http://www.glmshows.com

Official Exposition Title:
INTERNATIONAL CONTEMPORARY
FURNITURE FAIR®

Markets Represented:
Designers, Manufacturers and representatives of
contemporary furniture, lighting, floor coverings,
textiles and decorative accessories for the
residential, home/office and contract markets.

Profile of Attendees:
Architects, residential and contract interior
designers, retailers, store designers, facility
managers, wholesalers and manufacturers.

Anticipated International Participation:
Belgium, Brazil, Canada, France, Germany, Israel,
Italy, Japan, Kenya, Mexico, Netherlands,
Norway, Singapore, Sweden, Switzerland,
Venezuela, United Kingdom

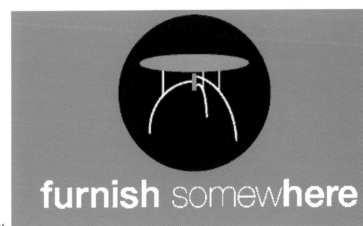

furnish somewhere

>> A sponsor of ICFF (International Contemporary Furniture Fair), the Metropolis Web presence allows the company to give
up-to-the-minute information to attendees.

Being a magazine on the Web is no longer enough. The medium is much more dynamic than the two-dimensional world of print. So, let the magazine be a magazine—which, by the way, is a great medium that continues to appeal to our tactile, visual, and olfactory senses—and let the Web be the Web . . . whatever that will be.

Susan Szenasy // Editor

>> Business >> Computing/Design >> Counter Culture >> Popular Culture

Counter C

e-zines

e-zines

>> **Entertainment** >> **Lifestyle** >> **Self-Published**

From edgy programming to alternative content, the culture of the Net embraces freedom. A tour of the outer fringe reveals

creative experimentation within a cyberworld. Distribution of information to a mass audience—such as The Smoking Gun's postings

of sensitive legal documents and La Spirale's interviews with underground filmmakers and avant garde digital artists—underscores

one of the primary goals of the counterculture: information sharing. The far-reaching effects of information sharing by groups such

as these is evident in looking at the numbers of activists and protesters who are able to meet, connect, and organize themselves at

a multitude of politically motivated sites such as U.K.-based e-zine urban75.

ture

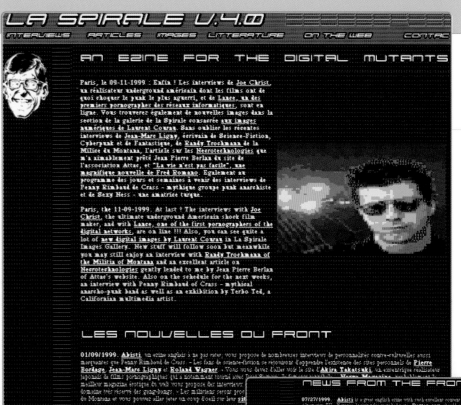

>> Links to La Spirale's interviews, a gallery of
images, offbeat literature, and news from the
front line of alternative culture are presented
against a black dotted background with
Space Age typography and flashing digital art.

site: laspirale.org

La Spirale

Video director and digital artist Laurent Courau began La Spirale in 1993 as an alternative Xerox paper 'zine, moving to the Web in 1996. Going digital cut out printing costs and distribution worries and offered La Spirale worldwide readership. Courau observes, "It's amazing every morning to go through the statistics of the Web site and note that people from Africa, Asia, or an exotic Pacific island have visited me the day before. That really makes me feel that something global is at last on its way and that I'm a part of it."

Courau calls La Spirale a one-man e-zine. She handles every aspect of the e-zine, from design and technical production to editorial content and translation. Based in Paris, France, Courau is committed to keeping the e-zine bilingual (English and French versions) because it allows global access to the site. Courau says, "There is a new form of English nowadays that is quite like the low Latin that was in use at the time of the Roman Empire, a language common to a great number of people in today's world that enables a French e-zine publisher like me to communicate with my Brazilian or Japanese readers."

The editorial content of La Spirale embraces counterculture. **INTERVIEWS INCLUDE CYBERPUNK WRITERS, MEMBERS OF AMERICAN MILITIA GROUPS, ONLINE SATANISTS, DIGITAL SWINGERS, MEDIA HACKERS, WEB PORNOGRAPHERS, MULTIMEDIA ARTISTS, AND MIND CONTROL SPECIALISTS.** Other features of La Spirale include articles on the darker side of our societies, a digital image and film gallery, links to the weirdest of the weird on the Web, and reviews of books and fanzines.

While dedicated to offering new and different content from what is available in mainstream media, Laurent does not recommend using experimental programming for a content-oriented site like La Spirale. She explains: "I have to admit that I am not very eccentric when it comes to software. Like most graphic and Web designers, I use [Adobe] Photoshop and Illustrator to do the design as well as Front Page or DreamWeaver to build the actual pages. I see programs as shortcuts between my mind and the published result. Just like any good tools, they have to be efficient and allow sustained productivity." In the graphic design of La Spirale, Laurent often uses black backgrounds, flashing digital art, and asymmetrical layouts to reflect the content of the site. "It is dark but laughs at itself, clean but with a twisted edge."

"La Spirale is a weird e-zine, made by weirdos, for the weirdos."

Laurent Courau // Digital Artist/Video Director

12 13 14 15 16 17 18 19 20 21

> > A fashion series created by Laurent Courau for CODa magazine is featured in the Digital Gallery.

I love experimental Web sites that are a challenge to explore, but it isn't necessarily a good thing when it comes to an e-zine based on content.

Laurent Courau // Digital Artist/Video Director

> > Edgy interviews ranging from cyberpunk fantasy writers to underground shock filmmakers are offered in both French and English to attract a global audience.

>> Viewers can click on a specific photo, video clip, graphic design, digital artwork, or animation to enlarge.

>> Recommended reading and book reviews are a popular page on La Spirale.

>> An enlargement of the introductory animation from the French television show *L'Oeil Cyclone.*

>> Images from a Yann Minh short movie.

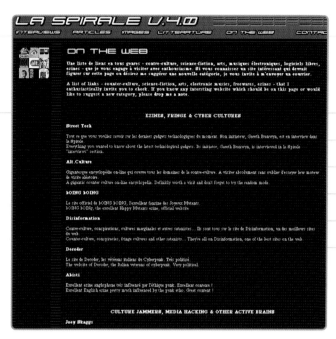

>> A listing of weird links to counterculture, science fiction, arts, electronic music, freeware, and other e-zines that Laurent Courau, La Spirale's publisher, enthusiastically recommends.

Unless you're aiming to build some kind of weird experimental prototype of a site—an e-zine should be easy to read and surf through. Overloading your pages with heavy graphics and multiple framesets will only make visitors run away.

Laurent Courau //
Digital Artist/Video Director

>> A digital illustration for a short story by Fred Romano in *CyberZone* magazine.

>> Business >> Computing/Design >> Counter Culture >> Popular Culture

Popul

e-zines

Admittedly the first stop for people "who don't want to be at work," electronic magazines that explore popular culture are sought

after and widespread on the Web. The Onion employs self-deprecating humor and daily content changes to elicit loyal fans who

spread the word and hit the site habitually. Sites like Salon.com offer the fun and intellectual adventure of a small dinner party,

while FEED takes the approach of commentary and opinion as seen and heard from far above the earth's surface. These e-zines

provide a thorough examination of popular and cyberculture as we enter the Interactive Age.

r Culture

SEARCH ARCHIVES SITE GUIDE CONTACT US TABLE TALK NEWSLETTER AD INFO MEMBERSHIP SHOP

salon.com

SITES
Arts & Entertainment
Books
Comics
Health & Body
Media
Mothers Who Think
News
People
Technology
Travel

Columnists

Search Salon

[Search]
Advanced Search | Help

Salon is hiring

Table Talk
[Salon's freewheeling discussion area]

The career you can leave at the end of the week Is temping the rat race an alternative?

Hankie-panky Why we love movies that make us cry.

History repeats The dirtiest presidential campaigns ever.

+ Table Talk
+ Posts of the week

TODAY IN SALON

Weekend, August 21-22, 1999

▶ Arts & Entertainment

GEFILTE PHISH
A small band of Orthodox Jews found God amid noodling guitar jams and psychedelic drugs. But can they lead Phish's camp followers into the promised land?
By Felix Yikhman - 08/21/99

+ Investor Relations
+ Salon.com Inks Distribution Deal With Lycos

The Preferred Card of Salon.com

Salon's Network Sponsors:

Get Salon News and Technology articles on your Palm Pilot and other handhelds from AvantGo

Salon dot com, the Web site for hair care and beauty professionals, is now at www.salon.net

Salon and CultureFinder
Click here to check out our new performing arts ticketing and information service

 CEOExpress — Think of it as the executive assistant you've always wanted. Get right on it Click here.

In e-business every second counts 00:07

Search Archives Contact Us Table Talk Newsletter Ad Info Investors

 salon.com **Mothers Who Think**

E-mail this story
Print this story

Arts & Entertainment
Books
Comics
Health & Body
Media
▶ Mothers Who Think
News
People
Politics2000
Technology
+ Free Software Project
Travel & Food

Columnists

Current Wire Stories

Click here to read the latest stories from the wires.

Win a Dream Vacation
click here

Also Today

For a full list of today's Salon Mothers Who Think stories, go to the Mothers Who Think home page.

Search Salon

[Search]
Advanced Search | Help

Recently in Salon Mothers

POO RULES!
For some seemingly inexplicable reason, No. 2 is No. 1 with Japanese kids.

By Brennan Conaway

Dec. 13, 1999 | A recent cartoon on Japanese TV features a hero who makes a sidekick out of his own feces. Meanwhile, at the local temple, visitors buy plastic poop trinkets to bring them good luck. And at the corner store, a vast array of poop-shaped candy is on sale -- a veritable coprophagous feast

The turd -- presented in Japan as a prettified swirl resembling soft ice cream -- has become a recurring motif in Japanese pop culture. There's there's even a term for it -- maki guso -- which roughly translates as "cuticue poo."

The recent poop-centric "Gakkyu-o Yamazaki" (Classroom King) cartoon on TV is a video version of the comic book with the same name. It features the adventures of a schoolboy locked in battle with his bowel movements. Unique as that may sound, Gakkyu-o Yamazaki is not the first popularization of poo in a kid's cartoon. "Ugo Ugo Ruuga" ("Go Go Girl," jumbled up), an infamously hallucinogenic kid's show of the early '90s, featured a pointy-headed excretum that emerged from the toilet and spouted Western philosophy.

And the poop apparently cannot be confined to television and comics. School kids who need good fortune and fortitude during the tribulations of exam time can buy key

>> Mothers Who Think is one of ten consolidated areas of interest.

Salon—the brainchild of David Talbot—was conceived while he was working with the *San Francisco Examiner* as the style editor. Salon's vision in David's words: **"I WANTED TO BUILD A WEB SITE THAT HAD THE HIGH SPIRITS AND PASSIONATE ENGAGEMENT OF A GREAT DINNER PARTY—THE KIND THAT LEAVES YOUR HEAD BUZZING FROM ALL THE FASCINATING PEOPLE YOU'VE MET AND THE CONVERSATIONS YOU'VE HAD."**

Talbot approached several of the editors he worked with at the *Examiner,* and Mignon Khargie (a page designer and illustrator)—then sold Richard Gringas of Apple Computer on the idea and received enough funding for a team of four to leave their jobs at the *Examiner* and begin work on the Salon prototype. A few months later the first "issue" of Salon was published.

Khargie followed the textbook approach to building a website, and the textbook was *Teach Yourself Web Publishing With HTML 4 in a Week* by Laura Lemay. "I counted every K[ilobyte] and did not waver from the recommended file sizes. I wanted a strong, uncluttered look, which coincidentally worked very well with what David had in mind. On the first day of work, he brought in a bunch of books and tearsheets, all pulling from an art deco influence. I was excited: flat fields of color, bold geometric shapes, imagery which was tailor-made for the Web. Then, as now, it was a collaborative effort, some of which was probably due to the close quarters in which we worked (we could all see what the others were working on), but more because that's how we do things."

A second designer, Elizabeth Kairys, was hired, and over time the art department expanded and the design vocabulary of Salon grew. In 1995 Salon, published articles every two weeks; in 2000, articles are published daily as well as round the clock. Salon's growth has paralleled that of the Web: More and more users are going online to get their news, and there is no need to wait for a designated news hour or publishing time. The approach is to make stories available as soon as they are ready to be published, an "anytime" publishing environment in which it is possible to get articles from anywhere.

Web designer Khargie talks about the challenges of real-time design: "I think that when you work at our pace, sometimes even the best designers falter. It would be nice to have more time to work on some carefully constructed solutions, but then again we've done some of our best work on deadline. The Web presents a special level of difficulty, in the amount of testing we need to do and the available solutions versus what the audience will bear. It's probably a common enough scenario: having a love-hate relationship with the very demanding and also intensely rewarding medium of the Web."

Know your audience and your technology. We build Salon for the people looking at it, we know the hardware they use and the software, we know their average length of visits, their areas of interest, what ticks them off and what they like. For instance, I also provide onsite classes for the art department: Designers should be aware of the latest technologies and what is possible.

Mignon Khargie // Web Designer

12 13 14 **15** 16 17 18 19 20 21

>> Salon makes it easy for readers to find what they want. The Books section offers smart reviews of the latest published material, usually with a link to purchase.

>> Graphics, photos, and illustration tend to be placed front and center on Salon's page layouts. A good example is this e-collage illustrating an innocent encounter between two travelers and a heartbroken, gun-toting Mexican sheriff.

>> Mothers Who Think is packed with information and resources from roundtable discussions to articles geared toward the "intelligent" parent.

>> Salon often leads the pack with in-depth, insightful reporting. Viewers can click on HTML type for story links; the result is added depth to most articles.

>> An example of "Salon style"—conceptual illustration often precedes content.

>> Excepts from books and legions of columnists from homey Garrison Keillor to edgy Camille Paglia vie for attention on the digital literary pages of Salon.

Technology

Weekend, August 21-22, 1999

► **Girl talk** Are frank online discussions of blow jobs and masturbation empowering teen girls -- or turning them into Lolitas?
By Janelle Brown [08/21/99]

► **Silicon Follies** Chapter 46: Green tea and red ink -- Barry loses millions over breakfast
By Thomas Scoville [08/21/99]

Editor's Pick

► **Caveat poster** Online anonymity is under siege by a barrage of court orders -- and no one is fighting them.
By Kaitlin Quistgaard [04/20/99]

Recently in Salon Technology

► Six-packs, macaroni and software Does stuff you like make for stocks you should hold? And why do companies offer "affinity groups" cheap stock when they go public?
By Mark Gimein [08/20/99]

>> The latest wire stories and top headlines of the day are always online—paired with a brief one- to two-sentence description for scanning.

Online design can only get better. There was the inevitable explosion of graphic experiments, which are now settling nicely into intelligent design discourse. Available software seems to be on an upward curve both in terms of upgrades to existing software and development of new technologies.

Mignon Khargie // Web Designer

>> Each "site" cover page offers links to Table Talk (billed as Salon's freewheeling discussion area), CultureFinder (performing arts ticketing and information service), Salon.com Shopping, and Membership.

>> Using a cell phone in Spain? Or just looking for a beach to "bare it all"? Salon's Travel section gives expert advice and offers travel services.

Search Archives Contact Us Table Talk Newsletter Ad Info Investors Membership Shop

 salon.com | # Health & Body

Arts & Entertainment
Books
Comics
▶ Health & Body
Media
Mothers Who Think
News
People
Technology
Travel

Columnists

Search Salon

Search

Advanced Search | Help

Recently in Salon Health & Body

The pelvic
A Harvard med student must
separate sex from science
when she does her first
pelvic and prostate exams.
By Ellen Lerner Rothman,
M.D.
[04/14/99]

Heal thyself.com
As wired patients go online
for medical help, the question
is: Can a little knowledge be
a dangerous thing?
By Arthur Allen
[04/13/99]

Falling apart may have been just what this overachiever needed

BY STEVEN SCOTT SMITH

April 15, 1999 | I can laugh at it now because comedy equals tragedy
plus time. A nervous breakdown is highly underrated, and while I don't
recommend it for everyone, it can be the antidote and wake-up call that
you needed to set your life in order.

I am 41 and what most people would call an overachiever: obsessive,
intellectual and part of the dreaded cultural elite. I am strong-willed,
determined, opinionated and extremely headstrong. I would never
consider asking anyone for help. And yet, it happened to me. As Zelda
Fitzgerald wrote to F. Scott, "It is ghastly losing your mind" -- but
sometimes that is your only option.

If you're going to do it, you might as well do it the right way. And you
should know that you are in good company. Susan Sarandon recently

>> At the Health & Body section of Salon.com, readers find a large collection of current and archived articles about
 topical health issues, e-mail questions to Dr. Bob (a neurologist and novelist) and uncover links to health-related
 articles "elsewhere on the Web" via sites such as the *Village Voice* and *The New York Times*.

**This is a medium populated by pioneers. We should stop holding it up to the standards of
the print world. Thinking about a print version of Salon is exhausting: How on earth do you
match a publishing schedule such as ours to the lead time needed for print?**

Mignon Khargie // Web Designer

>> Business >> Computing/Design >> Counter Culture >> Popular Culture

Entertainment on the Web is another growing industry, from electronic magazines that provide links to gaming sites—like Eon's

sci-fi e-zine—to Time Out, a complete guide to what to do in more than twenty-six cities around the world from Tokyo to Prague.

Interactive features allowing viewers to select where they go next create a real-time environment uniquely suited to entertainment.

The active medium of the Web allows readers to seek out movie reviews and entertainment information related to their specific

interests and to find communities around them. Music and games continue to be two of the most popular keywords with which to

begin a surf session.

e-zines

>> Entertainment >> Lifestyle >> Self-Published

Entertainment

Don't Click Here!

If you think laughter is overrated.

TimeOut.com

The World's Living Guide

The world's greatest cities, bars, clubs, hotels, restaurants, shops, galleries, museums and music venues are all here.

Amsterdam
Barcelona
Berlin
Boston
Brussels
Budapest
Chicago
Dublin
Edinburgh
Florence
Glasgow
Hong Kong
Johannesburg
Las Vegas
London
Los Angeles
Madrid
Miami
New Orleans
New York
Paris
Philadelphia
Prague
Rome
San Francisco
Shanghai
Sydney
Tokyo
Washington DC

Interviews

30 years of Time Out interviews from Yoko Ono to Zo' Ball

24 HOUR LONDON

@ E-mail survey

Good Chemistry

Barcelona: Chemical Brothers

Dublin: Dolly West's Kitchen
The much-anticipated new play by Frank McGuinness opens at the Abbey Theatre

Prague: Triffid
Head downtown to discover this dark and trendy new nightspot

London: Yan Dyck
The Royal Academy's Autumn blockbuster is a glittering feast for the senses

Tokyo: Divas Live 1999
Top female vocalists in two days of tonsil-wobbling at this showcase concert

Shanghai Film Festival
Over 200 movies compete for the Golden Cup Award

Finger-lickin' good

London: American Pie

New York: Elvis Costello
Costello's concerts always hold the potential for surprises

Boston: International Festival
Celebrate world cultures at the Expo Center

Amsterdam: C*zanne to Yan Gogh
A new collection of Impressionist works goes on show this week

Brussels: Miss
Don't miss this hilarious supermodel farce, running until Oct 30

Sydney: Comedy Festival
Comedy heaven with the best line up ever

Global Millennium

● ● LONDON LISTINGS

People.Finder
People Finder
People Finder

Webmaster vacancy
Timeout.com seeks a Webmaster

Editorial Yacancy
Timeout.com seeks an Assistant Editor

Travel magazine
Turtle watching in Turkey

Multimedia
Online art, plus top music biz sites

London Student Guide
From getting a First, to sleeping with your tutor first

Net Books
Time Out's online literary guide

Amsterdam
Barcelona
Berlin
Boston
Brussels
Budapest
Chicago
Dublin
Edinburgh
Florence
Glasgow
Hong Kong
Johannesburg
Las Vegas
London
Los Angeles
Madrid
Miami
New Orleans
New York
Paris
Philadelphia
Prague
Rome
San Francisco
Shanghai
Sydney
Tokyo
Washington DC

Interviews

30 years of Time Out interviews from Yoko Ono to Zoë Ball

24 HOUR LONDON

@ E-mail survey

TimeOut.com

The World's Living Guide

The world's greatest cities, bars, clubs, hotels, restaurants, shops, galleries, museums and music venues are all here.

>>

01 02 03 04 05 06 07 08 09 10

Time Out

FEATURING THIRTY CORRESPONDENTS BASED IN CITIES THROUGHOUT THE WORLD—FROM AMSTERDAM TO TOKYO—THE ELECTRONIC VERSION OF TIME OUT IS A ONE-STOP SUPER E-ZINE FOR ENTERTAINMENT LISTINGS AND TRAVEL INFORMATION FROM AROUND THE GLOBE. Aimed at the young, hip traveler, Time Out also publishes "handheld" weekly city magazines, travel guides, and eating and drinking guides that are distributed worldwide. Early adopters on the Internet, Time Out's staff began building a Web presence in early 1995. Redesigned by London-based new media consultancy Arehaus Ltd. in 1998, Time Out was relaunched with more content, functionality, and style. Now with twenty-eight city guides (and plans to add many more), Time Out offers each guide as a separate e-zine under the Time Out "umbrella." Each city guide is divided into ten sections: The Living Guide, Accommodation, Sightseeing, Essential Info, Entertainment, Eating & Drinking, Shopping, Kids, Gay & Lesbian, and City Links. Hubs for the Time Out site, like Net Books, Travel Magazine, and the London Student Guide were created to target niche audiences and ultimately further the Time Out brand.

Sarah Dallas, the managing editor of the London office, offers this advice—"Avoid frames. Frames are terrible! Also, user-generated content can be a handy way of keeping the site feeling fresh without having to produce new content yourself. Feedback forms that ask 'What do you think?' after a book review can produce great material and add an interactive feel to the site, turning it into a community." According to Dallas, placing content online increases offline sales. "After all, we are dealing with two very different consumer experiences. Very few people will print out an entire magazine or travel guide from the Web. But they may visit your site and then pick up your product in a store a day later. Our Web site complements our offline publications and, we believe, strengthens our position in the marketplace."

> **Design will become more tele-visual, with faster downloading and more personalization features. I see content management becoming more sophisticated, responding to individual user preferences—the Web needs to feel more personal, even emotional, in order to be a satisfying experience for users.**
>
> **Sarah Dallas // Managing Editor**

12 13 14 15 16 17 18 19 20 **21**

>> The first page of each listed city is the Living Guide page. This page serves as a portal to a selection of the most interesting features of each city, such as up-to-the-minute listings of concerts, exhibitions, clubs, and events happening that week.

>> The navigation bar for each city appears on the Living Guide page; links take viewers to essential information for worldwide travel.

>> Time Out Amsterdam's home page.

>> Entertainment listings are posted monthly by a correspondent in Amsterdam.

That's a **LAUGH!**

People Finder

Welcome to TimeOut.com's people finder service

Remember that girl you met in Barcelona five years ago? Wonder where she is now? Want to get in touch with the Los Angeles clubbing scene? Hook up with old mates in New York? Or maybe just find yourself an electronic pen pal?

Whoever you're looking for, you can **leave a message** on the Peoplefinder bulletin board.

Don't forget that someone might be looking for you. Why not **have a browse**? You might be surprised.

>> Bold, blocky color identifies the People Finder, where you can get in touch with the Barcelona clubbing scene, hook up with friends in New York, or maybe just find an international electronic pen pal.

>> The Living Guide home page for Prague.

>> An e-zine within an e-zine—the London Student Guide divides student life into night and day; click on the type and time to find your way around

Time Out is updated by a dedicated staff: working on different sections each day; inserting new features, articles, and images; using database applications that expire outdated copy automatically.

Sarah Dallas // Managing Editor

>> An article about Divine Time, a pop group that is hovering around the fringes of the charts, is featured within the London Student Guide.

>> The edgy design of the London Student Guide graphically presents study hints.

Web-only news from

Entertainment
WEEKLY
ONLINE

Find what you want:
Search EW

[] Go

Sweepstakes: WIN $5000!

REVIEWS

Movies
Tonight's TV
Music
Books
Video
Web Guide

Subscribe to EW Magazine

Get our entertainment news e-mail

MARKETPLACE

EW Selections

Great Books From The Publishers of Your Favorite Magazines

Find a Gift

Pokemon merchandise
E.Holiday Shopping Edition
Warner Bros. Stuff

e-business Click here

Quick Links

Find books
Find music
Find videos

SERVICES

Make EW Online your homepage

Online Help

Site Overview

Magazine Subscriber Services

Subscribers Only: Sign up for the magazine bonus section EW Internet

Moviefone: Tickets & Showtimes

Today's News:

December 17, 1999

How "Magnolia" became one of the year's longest movies Julianne Moore, William H. Macy, and director Paul Thomas Anderson make no apologies for their epic

 An animated Drew Barrymore tries to save Christmas Matt Groening talks about his new holiday special and other seasonal hits from years past

 "Deuce Bigalow"'s success could spawn new lingo Catchprase king Rob Schneider tells how "man whore" could be the next "Steve-meister"

Movie Review "The Cider House Rules" With his tart adaptation, John Irving gets to the root of his fanciful novel

A peek behind the scenes of "The Green Mile" Two of the movie's stars reveal the film within the film

News Summary Garth Brooks thinks about retiring Plus, Chris Tucker, WWF, Christina Aguilera, Jay-Z, and more

Tonight's Best TV: "Olive, the Other Reindeer" and more

 Daily Pop Quiz: Which of Tom Cruise's relations worked on "Magnolia"?

Reuters Entertainment Wire Get today's news summary

Previous EW News Items >

CHARTS

Top Albums
1. THE NOTORIOUS B.I.G. Born Again,
2. CELINE DION All the Way...A Decade of Song,
3. BACKSTREET BOYS Millennium,
 more

Top films
Top TV shows
Top videos
Top books

EW MAGAZINE

Search every back issue of EW magazine

Want to subscribe to Entertainment Weekly?
Take a FREE TRIAL

THIS WEEK

Holiday Movie Guide
Get the latest on Hollywood's holiday fare

VH1 Vogue Fashion Awards
See stylin' photos of Jennifer Lopez, Lil' Kim, and others at the ceremony

All-Time Greatest Movies
Post your opinion of EW's Top 10, and you could win a free book

One-Stop Shopping
Link to the best sites for buying every gift on your holiday list.

Movie Openings Dec. 17: Jodie Foster, Chow Yun Fat in "Anna and the King"; Robin Williams in "Bicentennial Man"; Tom Cruise, Julianne Moore in "Magnolia"; Michael J. Fox in "Stuart Little"; and Jeff Bridges, Nick Nolte in "Simpatico."

See more features

OPINIONS

 Critical Mass EW readers gave an A-to "Toy Story 2" Grade this movie and others, and see critics' grades

Weekly Poll Hanks for the Memories Which is your favorite Tom Hanks character?

Jim Mullen's Pie Chart The week's pop culture in a graph: What Are the Worst Christmas Presents This Year?

Message Boards Talk about movies, TV and more

Online Staff

Entertainment Weekly

Launched in fall 1994, Entertainment Weekly was one of the initial sites on Time Inc.'s Pathfinder network. The print magazine was first published in 1990. According to online Executive Editor Michael Small, in the early years the site was extremely small and consisted mostly of magazine articles that were repurposed for the Web in flat HTML. "When I started working on the site in January 1997, there were only three full-time staffers producing the entire site; now we have about fourteen full-time staff members and will probably expand," says Small, who oversees the editorial, technical, and design aspects of the site and is also the main liaison to the business side.

The Entertainment Weekly online team works closely with the print magazine staff. "We have a representative of the Web site at almost all of the magazine's meetings. We work off of the magazine's editorial calendar, planning ahead with the magazine staff to create the online features that will supplement what's in the magazine. One major challenge is when the magazine changes its course at the last minute before the weekly closing. Then we need to be able to adjust our online content to reflect those changes. For instance, the magazine's Holiday Movie Preview was in a different format from the Fall Movie Preview. So we had to figure out how to adapt the content to fit into the standard template we had created for the Fall Movie Preview."

Unlike many online magazines with print counterparts, Entertainment Weekly offers lots of content that is Web-only. Small goes down the list: "The Hot Topic, The Quiz, The Pie Chart, Critical Mass Interactive Poll, and almost all of our daily news items—because the magazine is weekly, we need to generate our own daily news—are Web-only. Even when we take text from the magazine, it may be edited to make it fit better into a Web format. **ONE IMPORTANT POINT: EVEN THOUGH WE HAVE ONLINE-ONLY CONTENT, WE ALWAYS MAKE SURE THAT IN SOME WAY IT MATCHES THE TONE AND STYLE OF THE MAGAZINE."**

Interactivity is an integral part of the Entertainment Weekly online mix. "Critical Mass Movie Polls, Hot Topic, and the Message Board," Small says, "demonstrate the potential for creating an interactive online supplement to a print magazine. For instance, the Critical Mass Movie Poll lets viewers grade movies—and the results are reported every week in the Critical Mass chart in the magazine." Small is convinced that interactive features on the Web site enhance the magazine by giving readers a chance to participate. "Hot Topic is another major accomplishment—the critics that readers recognize from the magazine write original, online-only pieces in a slightly looser format than you see in the magazine," Small says. "Because we've added a scribble board where readers can talk back, it reinforces the bond between the critics and the readers. Sometimes the readers' level of entertainment knowledge is just amazing. . . . I think it shows how connected they are to Entertainment Weekly and the way we cover entertainment."

Interactivity, of course, is a smart way to keep readers involved with the site. And we acknowledge that a magazine story is different from a Web feature. For instance, we tend to put less text on a page. If people want to read a lengthy article, we either send them to the magazine to read it, or we send them to our text-only archive of magazine content. In other words, people who want lengthy text can find it easily at the lower levels, but we give it a lot of promotional hoopla at the top level of the site.

Michael Small // Executive Editor

> The greatest challenge has been to constantly update and adapt the site to take advantage of new technology while simultaneously generating fresh content every day. Those two parallel tasks have to be kept in balance.
>
> Michael Small // Executive Editor

>> EW Daily is a feature that is Web-only on the electronic counterpart of the print magazine.

>> Each Friday, Entertainment Weekly graphs and lists the top movies, music, videos, books, and television shows.

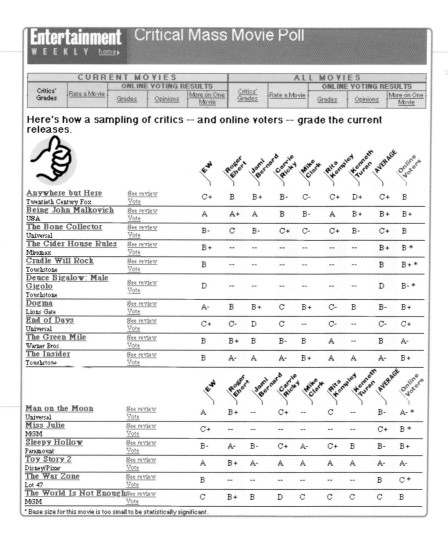

Critical Mass Movie Poll

CURRENT MOVIES | **ALL MOVIES**

		ONLINE VOTING RESULTS				ONLINE VOTING RESULTS			
Critics' Grades	Rate a Movie	Grades	Opinions	More on One Movie	Critics' Grades	Rate a Movie	Grades	Opinions	More on One Movie

Here's how a sampling of critics -- and online voters -- grade the current releases.

		EW	Roger Ebert	Jami Bernard	Carrie Rickey	Mike Clark	Rita Kempley	Kenneth Turan	AVERAGE	Online Voters
Anywhere but Here Twentieth Century Fox	See review / Vote	C+	B	B+	B-	C-	C+	D+	C+	B
Being John Malkovich USA	See review / Vote	A	A+	A	B	B-	A	B+	B+	B+
The Bone Collector Universal	See review / Vote	B-	C	B-	C+	C-	C+	B-	C+	B
The Cider House Rules Miramax	See review / Vote	B+	--	--	--	--	--	--	B+	B *
Cradle Will Rock Touchstone	See review / Vote	B	--	--	--	--	--	--	B	B+ *
Deuce Bigalow: Male Gigolo Touchstone	See review / Vote	D	--	--	--	--	--	--	D	B- *
Dogma Lions Gate	See review / Vote	A-	B	B+	C	B+	C-	B	B-	B+
End of Days Universal	See review / Vote	C+	C-	D	C	--	C-	--	C-	C+
The Green Mile Warner Bros.	See review / Vote	B	B+	B	B-	B	A	--	B	A-
The Insider Touchstone	See review / Vote	B	A-	A	A-	B+	A	A	A-	B+
Man on the Moon Universal	See review / Vote	A	B+	--	C+	--	C	--	B-	A- *
Miss Julie MGM	See review / Vote	C+	--	--	--	--	--	--	C+	B *
Sleepy Hollow Paramount	See review / Vote	B-	A-	B-	C+	A-	C+	B	B-	B+
Toy Story 2 Disney/Pixar	See review / Vote	A	B+	A-	A	A	A	A	A-	A-
The War Zone Lot 47	See review / Vote	B	--	--	--	--	--	--	B	C *
The World Is Not Enough MGM	See review / Vote	C	B+	B	D	C	C	C	C	B

* Base size for this movie is too small to be statistically significant.

>> The Critical Mass Movie Poll samples critics and online voters who grade current movies. The chart also links to movie reviews.

>> Interactive features proliferate on the EW Online site. The Weekly Poll asks a question, then viewers click for an instant visual tally.

>> The Entertainment Weekly Message Boards offer a forum for Web surfers to debate and discuss hundreds of entertainment topics.

>> An example of Jim Mullen's popular pie chart. Here is a graphic representation of things you might see on an Antiques Roadshow episode in the year 2099.

>> The Fab 400 is full of the best of pop culture. An asymmetrical layout with color bars, photos, and text make a ton of information appealing on screen.

>> Entertainment enthusiasts can sign up for a quick update each week via e-mail that briefly highlights current news, reviews, games, and trivia.

Advertising on the Web
by Thom Forbes

>> Creative tension probably dates back to when our ancestors were hunting woolly mammoths. I imagine a hunter scratching on the wall of the communal cave a representation of the beast he has just slain. A primordial creative director sidles up and suggests that he move the pictograph down six finger lengths, make the outline a little bolder, and smudge it all with some indigo. And guess what? Sometimes—not always, but often—the creative director's carping would actually improve the artist/hunter's work.

Creative tension permeates advertising. Art director and copywriter thrash out a concept, leaving blood on the floor. The executive creative director picks apart the resulting execution and puts it back together again, tauter and clearer. A few accommodations are made at the behest of Nervous Nellie, the account supervisor whose mortgage payments depend on knowing just how far the client can be pushed. Finally, there's the do-or-die struggle to get the tamer but still clutter-busting work past the Guardians of the Hallowed Brand at corporate headquarters. Less often than is desirable (but immediately recognizable when it happens), a brilliant piece of informative, entertaining, and effective advertising emerges from all this turmoil. Advertising that informs. That evokes laughter, tears, or nods of empathy. That sells.

Interactivity has introduced a new player into the drama of creating advertising and she's stealing the show. She's the consumer. The interactive consumer is the embodiment of creative tension, a mixture of experience and passion ferociously expressed. She knows what she likes—whether intuitively or rationally—and will not hesitate to act on her desires. The interactive consumer will also fail to act on her desires; indeed, that is what she does most often. The click rate on most banner advertising is less than one percent and steadily declining. But in the pages that follow, you'll find Web advertising that has been remarkably successful, whether the measure is click rates, branding, or sales. Because Web advertising is interactive and measurable, creatives know almost immediately which executions are effective, and which are not. Color can be changed immediately. Typefaces altered. Elements shifted on the page. Ineffective copy lines tweaked, or dropped.

Although consumers have had a say in how ads are crafted—through copy testing and focus groups—for decades, those are artificial environments. There is nothing artificial about e-commerce through the Internet. And advertising in forms that will undoubtedly evolve from the fin de millennium sampler you find here, will surely play a major role in making the Web the domina

01 02 03 04 05 06 07 08 09 10 11 12 13 14

source for marketing information and transactions in the 21st century. If you readers of this book are who I think you are, you'll be firmly at the reins of the evolution—harnessed to the driving force of the consumer.

The creators of interactive advertising in this book represent a wide array of styles and philosophies. They range from techno-boutiques thrown together by self-described geeks to divisions of the most august mainstream advertising agencies. All share the understanding that "the user is in control on the Web," as Erwin Jansen, interactive managing director of LDV BATES points out. On the Web, it's much easier to determine exactly what the user likes and dislikes—what makes her accept or reject a sales proposition, read more about a product or click to a competitor's site. "You can't put a camera behind somebody's eyes and know how they really read an ad, or know how they really look at a television commercial," says iDeutsch's Adam Levine. "But the click of a mouse tells you a shitload."

Many verities of design remain true on the Web, but some new rules are being written, too. They're not like the old saws of print, handed down by geniuses like Ogilvy and Bernbach, who ruled their agencies through intuitive points of view. The new rules are being served up by the consumer.

The folks at sinner+schrader interactive marketing will tell you that the funnier a banner is, the shorter its life should be. That's because they've quantified that funny banners generate high click rates, but only for a short time. Because users laugh at a joke only once, sinner+schrader changes some very effective banners after a mere week's run on the Web.

Historian Daniel J. Boorstin points out that people in democratic societies talk to each other in the language of persuasion. It's how we try to convince each other that our ideas—and products—are better than the other guy's. Many persuasive ideas are expressed in this book. Freestyle Interactive tells us that the GIF banner is dead and that rich media is the future of interactive advertising; Brand Dialogue cleverly makes the point with some mock porn banners that you need to aim for the heart, not the eye. There's no right and wrong here. The whole industry is learning. This book offers a smorgasbord of approaches to a craft that's taking its first baby steps. Great advertising sells, no matter what form it takes. And what sells—from a design and copy standpoint—will become clearer and clearer as you creatives delve deeper into the interactive magic of this medium.

>> Advertising on the Web

>> **LDV Bates**—This banner for Studio Brussel, the top youth radio station in Belgium, ran only on the launch date of its Web site and was downloaded thousands of times as a collector's item.

>> **iDeutsch**—This three-frame animated GIF banner for IKEA promotes a free brochure for businesses and home-office workers in need of furnishings.

>> **sinner+schrader**—Promising fun and entertainment in an effort to make the brand likeable, a series of banners feature a broad variety of smiling faces that ask questions such as, "Online auctions, what's that?"

>> In and of itself, a banner advertisement may never sell the likes of an automobile. Nonetheless, you'll find a lot of advertising for automobiles here. Mercedes, BMW, Peugeot, and all the other automakers have extensive Web presences through which they brand and build relationships.

"Interactive provides something you can't buy in any other medium, and that's the ability to interact with, and around, the brand," says Tom Beeby, creative director at Modem Media. Poppe Tyson. "You can demonstrate for yourself the relevance of that brand in your life." Banner advertising clearly has its place in this mix. Sprinkled around the Web in appropriate spots, banners for automakers are like the calling cards that ladies and gentlemen left behind them when they called at finer residences of the last century. "Here's how to get in touch with us, if you'd like," they say.

If that analogy sounds a bit highfalutin, let's not forget that the Internet itself is highfalutin. To marketers, the Net represents a virtual gold mine of educated, affluent consumers who not only have the ability to talk back but are extremely articulate when they do so. Globally, they are the crème de la crème of sophisticated consumers. That's why it's so critical to respect their time and intelligence. "Design should not try so hard, and not say too much," says Peter Jin Hong, creative director at Palmer Jarvis DDB Interactive. "We

are given a privilege of being in the audience's personal space. Hence, we should be brief, entertaining, natural, and say it with sincerity."

I just asserted that banner ads can't sell automobiles. But I can envision a banner where you type in a particular make and model and get back price quotes from a dozen dealers almost instantaneously, similar to the way that the John Hancock Portrait Planning Tool offers financial information. If such an ad existed a few weeks ago, I might have leased my new van from a different dealer. If a banner existed that analyzed several makes and models and made a recommendation, I might have purchased instead of leased, or gone to a different nameplate entirely. Just thinking about the schemes and possibilities that Web advertisers are no doubt developing fires up the inclination to begin typing my credit card number in a shopping-cart form. But first we need to establish a relationship. Please let me know what you're creating by e-mailing me at tforbes@tforbes.com.

>> **Brand Dialogue**—Users follow the footsteps of a polar bear from the Langnese ice cream print campaign through the banner and onto the Web site.

>>**Modem Media . Poppe Tyson**—Designers felt that to be effective, they could only use two fields to gather data. They worked with John Hancock to limit the required data-entry points accordingly.

>> **Palmer Jarvis DDB**—From frame to frame, there is a purposeful, rhythmic coordination to the flow and order of information, much like a strong bass beat keeps other instruments synchronized.

Building Brands and Driving Traffic

> *People remember what they interact with.*

> *Less is more.*

> *You can only determine the value of your creative work by the results you've gained for your clients.*

 >>

>> Banners for MediaOne Express appeal to gamers.

Beyond Interactive

CEO Jonn Behrman of Beyond Interactive launched Wolverine Web Productions from his apartment in 1995 while attending the University of Michigan. The company has grown to more than 60 associates in three U.S. offices and acquired a new name. It offers full-service online advertising solutions, from strategic planning to media planning and buying, banner design, third-party ad serving, and campaign management and optimization.

Beyond Interactive believes that an online advertising campaign is like a jigsaw puzzle with three pieces:
- Strategy, which is the overall plan for accomplishing goals on the Web;
- Media, which is the placement strategy come to life;
- Design, which represents the physical and visual aspect of the strategy.

All three elements must be in place for the puzzle to be complete. As important as media placement is to success, users don't stop to admire an excellent media buy. What they do notice, and click on, is the physical aspect of the strategy—the design. Beyond Interactive believes that design is as crucial to successful online advertising campaigns as the media plan.

"Good design is imperative, because it bridges the gap between the advertiser and the customer," says Behrman. "If a visitor doesn't notice the ad, the ad has not accomplished anything. Good design gets attention and interaction, and indicates that the campaign's strategy is effective."

Although campaigns achieve success through different means, some key elements remain constant. Banners must grab attention with attractive design combined with a clear, simple message that is communicated quickly, often with a specific call to action. Beyond Interactive's creative team always keeps the goal of the campaign in mind—whether it's branding benefits or direct marketing—to determine how the design and copy can best achieve results.

As Web marketing strategies evolve, elements such as interactivity and permission marketing have come into play. This has led to new advertising techniques like rich media banners using HTML, Flash, and JavaScript. "When the design and copy on a banner is presented in such a way that users are compelled to enter their e-mail address," says Behrman, "they are in effect saying 'Yes, I want to find out more, I'm willing to receive more messages about this product or service, and here's the place to send it.' "

Banners now offer creative and powerful incentives to click, like scratch-off cards that can lead to instant prizes. In these cases, the design has more to do with reinforcing functionality and activity than with aesthetics. Beyond Interactive is also integrating more creative types of design, such as Flash animation and promotional tie-ins, into campaigns. The methods of design may change as the Web advertising industry evolves, Behrman says, but the principles that make it effective will not.

>> A straightforward call to action for Ford Rent-A-Car.

>> A simple, clear enticement for AutoNation USA.

Address.5075 Venture Drive, Suite B, Ann Arbor MI 48108 / **Voice.**734 747 8619 / **Web Site.**www.gobeyond.com / **E-mail.**manager@gobeyond.com /
Executives.Jonn Behrman.Chief Executive Officer

>> This banner (one of the first that ran in the campaign) serves to brand the Giftpoint name and logo, as well as the little "nametag" icon.

>> The design of this banner—"opening" like a real gift certificate envelope—proves that you can breathe new life into an older, more established form of banner, the GIF.

>> This button reminds visitors of the sophisticated, name-brand retailers featured on Giftpoint.com and appears on an e-greetings site to provide a convenient shopping solution for someone who hasn't yet sent a card and/or gift to friends and loved ones.

>> Again, another large "button" that brands the logo and nametag, featuring some of the high-end, national retailers available on Giftpoint.

Graphic Designer.Jeremy Dybash / **Graphic Designer.**Kellie Fradette / **Graphic Designer.**Brad Lutz / **Graphic Designer.**Shirley McGrath
Tools Used.Adobe Photoshop / Ulead Gif Animator / Allaire HomeSite.

| 01 | 02 | 03 | 04 | 05 | 06 | 07 | 08 | 09 | 10 | 11 | 12 | 13 | 14 |

Marketing Objective:

Drive traffic to the Giftpoint.com site and generate purchases of gift certificates.

Creative Strategy:

Increase awareness of the Giftpoint.com brand and site and demonstrate that Giftpoint.com features a large selection of local and nationwide retailers.

Media Placement:

Search engines, e-commerce sites, greeting card services and communities, as well as targeting to human resources employees.

>> Stresses the point that gift certificates from Giftpoint are a convenient, thoughtful gift solution for anybody on any occasion.

>> The Scratch It Rich e-lottery ticket promotion is echoed in the design of this banner, which scratches itself off to reveal the "prize" of a free gift certificate just for participating.

>> You can select the occasion for which you wanted to purchase the gift certificate, thereby increasing interactivity and customizing the user's experience.

>> This banner, which announces the "Fall Premiere" of Borders.com's site, is designed to recall the look and feel of glamorous film premieres.

>> Another successful banner in the "Fall Premiere" campaign that uses the Borders.com colors and offers direct search capabilities.

>> The simple message of this HTML banner, "Search For Books," can be executed by putting in any search word to get to a results page on the Borders.com site.

Graphic Designer.Jeremy Dybash / **Graphic Designer.**Kellie Fradette / **Graphic Designer.**Brad Lutz / **Graphic Designer.**Shirley McGrath / **Copywriter.**Meredith Sharp
Tools Used.Adobe Photoshop / Ulead Gif Animator / Allaire HomeSite

01 02 03 04 05 06 07 08 09 10 11 12 13 14

Marketing Objective:

Increase awareness of Borders' online presence while emphasizing the look and services of its familiar brick-and-mortar stores: great selection, terrific customer service, live author chats, and special events.

Creative Strategy:

Most of these banners echo the colors of the Borders.com site, which features a large selection of books, as well as music and video, to strengthen brand recognition of both logo and site.

Media Placement:

Run of Site and keywords on Infoseek; CNET.

>> Emphasizing the large selection of topics covered at Borders.com, and the fact that purchases are delivered right to your door.

>> An example of a series of "director's chair" banners used to announce live chats with special guests.

>> Borders.com has a special GRAMMY Spotlight to tie in with the music awards; this banner invites the user to select their favorite nominee and go to the site to purchase the nominated music.

>> Brand Internet's home page relies on simple, familiar icons and shapes.

>> Scroll down the page to see work for its clients.

Good Looking Brands Get Attention

> *No one uses the Internet to view banner advertising.*

> *Don't just go for clicks. Make an impact on the viewers.*

> *Create simple and interesting messages.*

>> "Buy the furniture for your office from your office" launches an e-commerce site that Brand Internet and Netch Technology built for IKEA.

>> Part of a campaign for weekend travel to Iceland through Ticket, the largest travel agency in Sweden; the words are in Swedish playfully written to sound Icelandic.

Brand Internet/Satama Interactive

Brand Internet/Satama Interactive, which was founded in 1998, specializes in the concept, design, and content of Internet solutions for some of the leading advertisers in Sweden including IKEA, NK (the leading department store), Posten (the postal service), Ericsson, and startups like Matomera (an online grocery store). Its focus, says chief executive and creative director Ajje Ljungberg, is always on the brand. The way the brand looks is critical to its success. "Quite simply, good-looking brands get more attention," says Ljungberg. "We are convinced that great design and copy is as important as efficient technological performance when you are building functional Internet solutions."

In effect, Brand Internet is an information architect for the Internet. "Though we don't build our solutions as metaphors from the real world, we still see the process as similar to developing real estate like, for example, shopping malls or office centers," says Ljungberg. "It's about solving parking problems, making nice entrances, ensuring that restrooms and other convenient services are there to make life easier for customers and tenants. In the virtual world, that means enough bandwidth, functional design, efficient search resources, and intuitive navigation."

Brand Internet has won several awards for its creative work, including Scandinavian Interactive Media Event (SIME) awards, and a diploma from Guldägget (The Advertising Award of Sweden) for a campaign for NK. "Our greatest resource is that we're gathering the best Web designers in Scandanavia," says Ljungberg.

Swedish marketers are now focusing more of their marketing budgets on online advertising. Revenue, which was 207 million Swedish crowns (SEK) in 1998, is expected to reach 500 million SEK, or about $58 million U.S., in 2000. They are targeting what is perhaps the savviest online audience in the world. Swedes enjoy an excellent telecom infrastructure, high education, and good skills in English. Nearly half of the 3.3 million people between the ages 15–79 use the Internet frequently, and 68% of those between 15–44 use it every month.

The most common online advertising in Sweden is the ordinary banner. Recent inroads have been made by ads that cover the whole screen for 10 seconds before the user can go on (interstitials), and less-intrusive pop-ups. Campaign sites, such as the ones on the following pages for Svenska Naturskyddsföreningen and Ericsson's ERICA Awards, are also popular. "Cutting-edge technology and crispy, good-looking design work hand in hand to establish great Web sites and advertising," Ljungberg concludes. "We definitely believe that if it looks good, it works better."

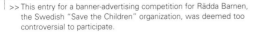

>> This entry for a banner-advertising competition for Rädda Barnen, the Swedish "Save the Children" organization, was deemed too controversial to participate.

>> Rädda Barnen approved this gentler approach but it did not generate the click-rates Brand Internet believes the banner with the crosses would have received.

Address.Birger Jarlsgatan 18D, 114 85 Stockholm Sweden / **Voice.**+46-8-506 124 10 / **Fax.**+46-8-506 124 39 / **E-mail.**info@brandinternet.com / **Web Site.**www.brandinternet.com / **Executives.**Ajje Ljungberg.Chief Executive and Creative Director

>>

>> No words, no cutting-edge technology, just an intriguing graphic.

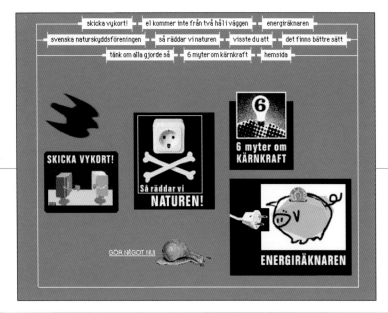

>> Visitors can choose between different pages, read about the myths of nuclear power, calculate the amount of energy used by various appliances, send postcards, and more.

>> The copy tells people they can make a difference in their own households by saving energy.

01 02 03 **04** 05 06 07 08 09 10 11 12 13 14

Marketing Objective:

Drive people aged 15–18 to a campaign site for Svenska Naturskyddsföreningen, a Swedish environmental organization, where they learn how to use less energy in their households.

Creative Strategy:

The campaign site is designed to be playful and fun, to attract young people; the sole banner consists simply of a piece of wallpaper with a light switch.

Media Placement:

The Swedish AltaVista site.

>> The skull symbol succinctly parodies the very successful "Two Holes in the Wall" ad campaign for a large Swedish energy company.

Creative Director. Ajje Ljungberg / **Art Director.** Tone Knibestöl / **Account Manager.** Jenny Rosén / **Web Designer.** Björn Strååt
Tools Used. Adobe Photoshop / HTML / Imageready

>> Many prominent names are featured in the drop-down list of Internet visionaries who conduct online seminars for ERICA.

>> The ERICA symbol.

>> The site features brief summaries of the accepted entries, as well as URLs to the existing Web sites. Site visitors can view the entries alphabetically, by category (e.g., Art & Culture), or use the search engine.

01 02 03 **04** 05 06 07 08 09 10 11 12 13 14

Marketing Objective:

Create a concept and Web Site for Ericsson that supports its efforts to strengthen its position within the Internet community and shows it understands the "soul of the Net."

Creative Strategy:

The international ERICA competition encourages nonprofit agencies to compete for prize money to build Internet solutions working with Ericsson CyberLab and nine Web developers from three continents. The Web site provides information about the entries as well as online seminars with prominent guests.

Media Placement:

Banners on pj.org, fastcompany.com, wired.com, news.com, tecweb.com/wire, and internetwk.com; public relations campaign through Edelman Public Relations Worldwide to spread the world about ERICA.

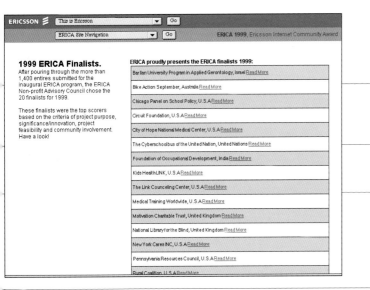

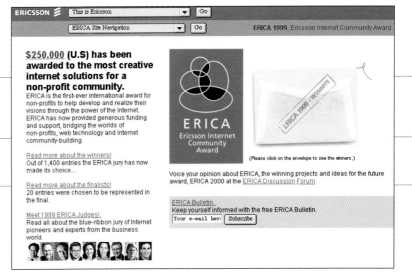

>> Complete entry information is available for the Top 20 concepts picked by a prominent panel of judges.

>> Of the more than 1,400 organizations competing, three are chosen—but the information and resources on the site continue to inform nonprofits and enhance the Ericsson brand.

Creative Director.Ajje Ljungberg / **Account Manager.**Pija Sundin / **Art Director.**Fredrik Lewabder / **Web Designer.**Johan Eklund / **Copywriter.**Christina Knight / **Database Programming.**Bazooka Interactive / **Tools Used.**Adobe Photoshop / HTML / Microsoft Access database / ASP technology

>> i-traffic's home page and a client list page.

Turning Surfers into Shoppers;
Browsers into Buyers

> Destroy what bores you on sight.

> Fast and simple is better than slow and complex.

> One-to-one marketing is the Holy Grail of online advertising.

i-traffic

Scott Heiferman, then 22, founded i-traffic in early 1995 in a cramped Queens, New York, apartment. i-traffic has since grown to more than 100 staffers with offices on both coasts. The agency's full-service marketing approach focuses solely on e-commerce—or direct marketing—on the Internet. i-traffic provides customized interactive strategic marketing planning, media services, creative executions, and performance analysis.

"Be quick or be dead," says i-traffic creative director Brad Epstein. "That's the key to effective design on the web." i-traffic creatives understand that most people on the Web are there to do something. Find a hotel. Chat. Check a stock price. Comparison shop. Download a picture of Pamela Anderson. "Not one single person anywhere logs on to look at a banner ad," Epstein says.

Television and even print are passive media compared to the Web. The Web engages the active part of a consumer's brain. Unless your design quickly conveys a simple message, your banners aren't worth the free pixels that were used to create them.

i-traffic is turning surfers into shoppers by designing communications that get their attention and then rewards them for giving it. It generates e-commerce for its clients by doing banners that offer content, banners that offer a smile, and banners that offer an offer.

As art directors have gotten better at using the 468 x 60 banner, consumers have gotten better at ignoring them. Going beyond the banner is the new challenge facing anyone trying to reach consumers. i-traffic has found effective ways to communicate in dimensions as varied as 100 x 100 buttons on portals to full-page interstitials.

In every case, the design works because it breaks through the clutter and let consumers know what's in it for them. "Consumers are selfish and why shouldn't they be?" says Epstein. "They work hard for their money and will part with it only if they perceive they're getting a good value."

Art directors creating for the Web have more tools at their disposal than their print counterparts. Besides the usual suspects of color, composition, and typography, Web designers can add animation and interactivity, Epstein points out. "The possibilities are incredible," he says. "But the most successful designs will still be the ones that manage to connect with consumers who have no interest in reading an ad."

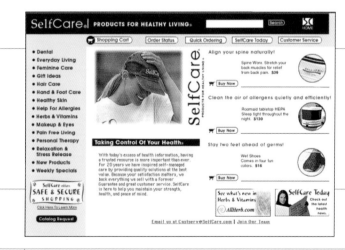

>> Banners for client SelfCare on the following pages do not lead directly to this home page, eliminating steps between click and purchase.

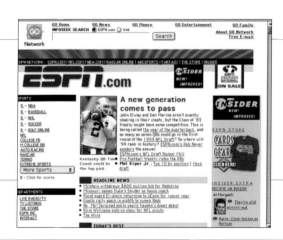

>> i-traffic created a sleek banner campaign to interest sports fanatics in membership in ESPN.com's Insider service.

Address.375 West Broadway, New York New York, USA 10012 / **Voice.**212 219 0050 / **E-mail.**info@i-traffic.com / **Web Site.**www.i-traffic.com /
Executives.Scott Heiferman.Founder & CEO, Brad Epstein.Creative Director

>>

>> Ads depicting women in a pleasant setting seemed to communicate best with the target audience.

>> Based on an initial round of banner results, i-traffic found that the highest-performing branding banners were the ones with the least copy.

>> The one-word buttons fading into a beautiful backdrop give the banners an ethereal look that helps to convey an emotional connection with the target.

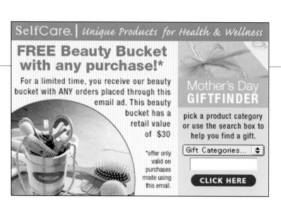

>> This Yahoo e-mailer ad is an interactive mini-site designed to go to four separate landing pages depending upon which pull-down gift option the customer chooses.

Senior Art Director.John Vukusic / **Copywriter.**Justin Kaswan / **Creative Producer.**Vina Lam
Tools Used.Adobe Photoshop / Adobe Illustrator / ImageReady / Gifbuilder / PhotoAnimator / GifWizard / BB Edit

01 02 03 04 05 06 07 08 09 10 11 12 **13** 14

Marketing Objective:

After seeing the communication, the customer should think: "SelfCare brings me products that I haven't seen before. I need to check out their Web site and learn more."

Creative Strategy:

The customer is educated and smart, and tends to shy away from the in-your-face tactics common with traditional Web advertising. She prefers a more emotional approach and is enticed by a smart, concise, direct, and honest message.

Media Placement:

i-traffic targets sites catering to SelfCare's core demographic, including health, shopping, women's, and run-of-site placements.

>> Rather than lead the customer directly to the homepage, i-traffic correlates each banner with its own landing page.

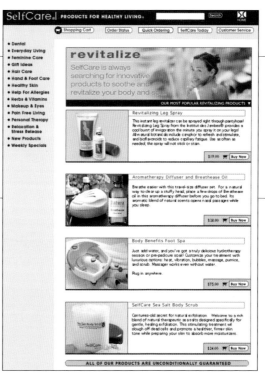

>> The "revitalize" banner, for example, leads to this custom-designed landing page, which offers four products related to the word "revitalize". This approach to going beyond the banner eliminates several steps between click and purchase.

>> ESPN.com's Insider

Are any of your kids named... | **Goose, Babe, or El Duque?** | **This is the place for you.** ESPN INSIDER Click Here.

>> The typography has a fast, sporty feel to it in keeping with ESPN's overall look and feel. Since the written message is strong and concise, i-traffic consciously avoided diluting it with unnecessary graphics and logos.

Do you like hockey?

More than your wife?

This is the place for you. ESPN INSIDER Click Here.

>> The word "hockey" attracts the attention of the sports fanatic and sets the scene, although the first frame is only on for a split second before the fanatic message appears over it.

Creative Director.Brad Epstein / **Senior Art Director.**Doug Miller / **Copywriter.**Andrew Van Hook / **Creative Producer.**Brendan Stanley /
Account Manager.Greg Reichert / **Senior Account Planner.**Ian Schafer
Tools Used.Adobe Photoshop / Adobe Illustrator / ImageReady / BB Edit

01 02 03 04 05 06 07 08 09 10 11 12 **13** 14

Marketing Objective:

To bring ESPN's unique, irreverent personality to ESPN.com's online marketing efforts; to pique the curiosity of die-hard sports fans (who likely are also ESPN viewers) and encourage them to sign up for ESPN.com's INsider; to increase Insider trial subscriptions.

Creative Strategy:

Use ESPN's irreverent personality to attract the attention of the sports-crazed ESPN viewer.

Media Placement:

Units run on sports content sites as well as ESPN.com, in order to reach the core target audience.

>> The banners lead to an information-packed page designed to turn browser into buyers.

Welcome to Left Field
The Advertising Agency

Everyone we meet asks us the same question, "Why Left Field?"
Granted, it's not an obvious name for an agency. But then, neither is our approach to advertising.

Left Field is our way of saying to clients that we will bring you the unexpected and make no apologies for it. It is our way of saying to employees that divergent thinking is everybody's job not just writers and art directors. And finally, it's an expression of our dream to create a place that thinks, acts and feels different than any other place we've ever worked.

So what's in a name? See for yourself.
The navigation is up top.

>> Since the agency's name isn't e-something, i-something, or something-Web, it feels a need to explain "Why Left Field?"

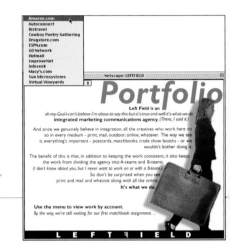

Marketing for a Wired World

> *If it doesn't move, chances are it won't.*

> *Not everything can be conceptual. But everything should be beautiful.*

> *There's no accounting for taste. Or monitors.*

>> This banner aims to inspire developers to build sites that will change the world (using Sun solutions, of course.)

Left Field

Left Field started out in Michael McMahon's basement a few years ago with three PCs, three folding metal chairs, and a Seattle-based bookseller for a client. That's when its principals established a tradition of buying pizza for the agency every Wednesday. At the time it was a one-pie shop. Now it takes 20 to feed the crew. (By the way, that first client was Amazon.)

"The first role of design in all our work is to make people look," says creative director Fred Schwartz. "That's because the people whose attention we're after are feverishly watching pages load, ready to scroll or click in a blink. At this level, our design is purely visceral—it uses color, shapes, symbols, sound, and motion to capture attention." At the next level, Left Field uses design to communicate its clients' brand attributes: their aesthetics, their values, and their emotional and intellectual underpinnings. In other words, to convey the brand's "look and feel." After that, things start to get really subjective.

"What we're after is truth, rightness, resonance," says Schwartz. "And that differs depending on what medium we're working in." Schwartz cites a *Critique* magazine article by designer Marty Neumeier to make a distinction between creating for the Web versus other media: "Print is a 'slow' medium, one that demands and rewards understanding. By contrast, the Internet is a 'fast' medium, a smash-and-grab tool for transferring information. Both media have their advantages, but it's a mistake to try to endow one with the special virtues of the other."

"On the Web, advertising is extremely disposable," Schwartz continues. "People—clients, consumers, and designers alike—get bored faster than with other media. So much so that it's nearly impossible to adhere to The One Right Way."

But boredom isn't the only enemy of consistency, Schwartz says. Left Field is continually searching for greater responsiveness, forcing it to constantly tweak, augment, and reinvent. Design has to achieve two very different goals: branding and direct response. "It's an uneasy marriage," Schwartz admits, "but one we struggle to make work every day."

>> Left Field makes it clear that it's an integrated agency, handling "print, mail, and whatnot," as well as online advertising for Web brands like Hotmail.

>> This billboard for Drugstore.com shows the influence of online design on other media, while playing up one of the great benefits of the Web—anonymity.

| | | | 18 | | | | | | | | | | | |

Address.945 Front Street, San Francisco CA 94111 / **Voice.**415 733 0700 / **Fax.**415 733 0701 / **E-mail.**leftfield@leftfield.net /
Web Site.www.leftfield.net / **Executives.** Kevin Burke.General Manager, Fred Schwartz.Creative Director, Michael McMahon.Strategic Director

>>

>> Sun Microsystems

CBS Sportsline Morphing Blimp

presented by

>> What better way to grab the attention of sports fans than to plaster a Sun logo on something so ubiquitous at today's sporting events—a blimp.

 DESTROY. competition Sun microsystems

 DESTROY competition Sun microsystems

 DESTROY competition Sun microsystems

 DESTROY com Sun microsystems

 Maybe you should let them find **you.** .COM

 Having a hard time finding **new customers?**

 Having a hard time finding **new customers?** om

>> This banner illustratively communicates a tangible benefit of online marketing: Businesses have the potential to attract and gain customers just by setting up shop on the Web.

Creative Director.Fred Schwartz / **Associate CD.**Jeff Heath / **Art Directors.**Brian Murphy, Dylan DiBona / **Account Director.**Sabrina Salzman / **Account Supervisor.**Lisa Cross /
Media Supervisor.Katie Cushmore / **Media Planner.**Matt McMahon
Tools Used.Java / Macromedia Flash / JavaScript

Marketing Objective:
To position Sun's dotcom solutions as real, effective business tools that can help its targets' businesses now and, secondarily, to firmly establish Sun as the company driving the adoption, growth, and continued innovation of the Internet.

Creative Strategy:
To breathe new life into Sun's brand campaign—"We're the dot in .com"—through compelling, innovative online extensions of the traditional advertising efforts. Instead of simply telling the audience about Sun's technical excellence, the campaign demonstrates it.

Media Placement:
Since the primary targets are technology decision-makers, media placements are heavily weighted toward IT sites.

>> An appeal to its targets' killer instinct by illustrating what Sun's technologies can help them do to their competition.

 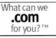

>> Amazon.com

>> This HTML-based banner allows the consumer to enter a
music or video title to get a results page from Amazon.com.

>> The frustrations of holiday shopping are a natural motivator for shopping at Amazon.com. A faux navigation arrow appears over the Buy, Wrap, Ship button.

>> As the button depresses, a wrapped book appears...

>> ...and zooms across the banner.

>> Amazon.com created a special section devoted to the latest episode in the Star Wars saga. The banner rotates through the some of the characters from the wildly popular series.

Art Director/ACD.Paula Grech Mills / **Copywriter.**Greg Mills / **Art Director.**Wayne Lee / **Copywriter/ACD.**Jeff Heath / **DTHML Coding.**David Morse
Tools used.Adobe Photoshop / GIFBuilder

Marketing Objective:

To introduce consumers to various offerings that move beyond Amazon.com's original competency—selling books online.

Creative Strategy:

Although these banners aren't strictly a campaign, they do have a design element in common: the approximation of a user interface, something that has proved successful in inviting consumers to interact with the banner.

Media Strategy:

Since Amazon.com's customer base is extremely broad—really anyone who shops on the Web—the banners are scattered far and wide among general interest sites and portals.

>> Users select a genre to hear a 30-second RealAudio snippet of the most popular artist in the category.

>> This banner uses DHTML, giving the user a high level of interactivity.

>> As the user mouses over the banner, each tab serves up a list of titles.

>> The user can then select a title and the appropriate merchandising page is served.

>> This banner appeals to the music collector by promoting one of Miles Davis' top selling titles.

>> Plus the promise of a whole lot more.

>> The color palate gives the banner the look and feel of classic jazz album covers of the be-bop era.

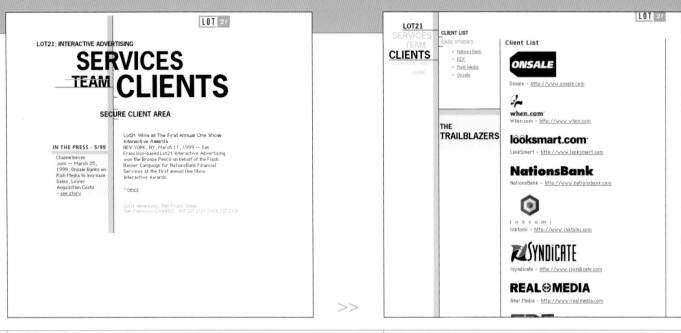

>> Lot21 uses simple, clean elements so visitors are able to intuitively navigate its site.

>> Its client list prominently displays logos, as well as links to case studies that document some of the company's brand-strategy and product-awareness successes.

>> When the Postal Service laughs at itself, people listen.

>> A seamless transition to the Web for a familiar mainstream advertiser.

>> Winner of a gold @d-tech award for audience building campaigns.

Lot21 Interactive Advertising

Lot21, launched in February 1998 by Kate Everett-Thorp, is an interactive marketing, media and advertising agency specializing in integrated marketing solutions for advertisers. It is one of the few pure-play interactive agencies, focusing solely on online advertising and the integration of the medium beyond the banner.

"Although standards and tools need to continue to mature, we feel strongly that those who only hang on to the traditional view of advertising are missing the boat," says Lot21 president and CEO Everett-Thorp. "At the speed with which the Internet is evolving, they might as well get off."

More than any other advertising medium, the Web must make information accessible. Lot 21 attributes its success to understanding what attracts viewers to an online ad, what drives them to pursue the message, and how these trends can shift rapidly. It embraces the use of new technologies to develop solutions, such as its @d: tech award-winning at Cost Flash Generator Banner for Onsale, that meet the diverse needs of interactive advertisers. "To advertise effectively," says creative director Paco Viñoly, "you need to speak directly to the audience within a flexible and innovative framework." The Lot21 team has been producing technologically innovative advertising since the early days of the Web, from banners on Wired to Java, Shockwave, interstitials, and microsites.

Viñoly's creative specialists produce compelling advertising that capitalizes on media placements. "Extensive research and branding initiatives are crucial to the development of any successful online advertising effort," says Viñoly. As a result, Lot21's ads not only reach out to the appropriate audience, but also demonstrate effective design strategy that represents its clients' brand and advertising messages.

Inventing — and Reinventing — for the Web

> To convert prospects to customers, eliminate the obstacles between people and your product or service.

> We're always inventing the future of advertising.

> When we get dogs to buy their dog food online, we'll know we have this industry perfected.

 >>

>> Seagate banners lead to a microsite that offers everything from news to shopping.

Address.548 Fourth Street, San Francisco CA 94103 / **Voice.**415 227 2121 / **Fax.**415 227 2121 / **E-mail.**mollyp@lot21.com /
Web Site.www.lot21.com / **Executives.**Kate Everett-Thorp.President & CEO, Paco Viñoly.Creative Director

>>

> Onsale

>> This online commercial, which ran glitch-free on ZDTV's "Money Machine" for three months, may be viewed at www.lot21.com/public/ex/ons_zdtv/ in a variety of QuickTime and RealVideo formats.

>> Enliven banners using Macromedia Flash banners allow Lot21 to brand while offering extended interaction.

>> Every 15 minutes, a PERL script fetches live auction information pre-selected by Onsale.

>> The ad captures the excitement of online auctions.

"hey..."

"...over here"

The best deals on brand name computers are just one click away!

>> Rich media is a perfect fit for Onsale's fast-changing bidding wars.

Creative Director.Paco Viñoly / **Director of Technical Design.**Sasha Pave
Tools Used.Adobe Photoshop / Macromedia Flash / Macromedia Flash Generator / Macromedia Fireworks / Adobe Illustrator

Marketing Objective:

Increase overall traffic flow and sales for Onsale, a leading online live-auction retailer, and bring down the cost per acquisition through informative advertising aided by rich media technologies.

Creative Strategy:

With its ZDTV spots, Lot21 created rich media ads for the first time for Onsale, running Macromedia Flash, Enliven, and Flash Generator banners with a message and a purpose creating an urgency: "Buy This Now." The ability to deliver real-time or personalized information in a compelling, interactive format with minimal custom programming allows Lot21 to extend brand while offering greater interaction. With Onsale's fast-changing bidding wars, rich media is a perfect fit.

Media Placement:

Sites that accept mainstream rich media advertising formats, such as the Onsale Generator and Enliven banners, with the appropriate demographic and psychographic information.

 >> >>

NationsBank

Signature loans
for **what you want**

I want a credit card that fits my lifestyle?

Signature loans
when **you want**

I want a credit card that fits my lifest

Signature loans
wherever
you're posted

I want a credit card that fits ?

I want a credit card that fits my budge

as low as
10.99%
APR

I want a credit card that fits both.

Apply
now.

I want a credit card that fits *both?*

we've got a credit card to suit your needs.

Apply
now.

CLICK HERE FOR THE
ONLINE CARD FINDER! **NationsBank**

Apply
now.
CLICK HERE

>> Flash technology communicates how NationsBank broadens your lifestyle.

>> Qualified (approved) applications tripled within the first week of the media campaign.

 NationsBank

 2ᴾᴹ, Maui **NationsBank**

 2ᴾᴹ, Maui
Check Your Balance, Transfer Funds **NationsBank**

>> NationsBank banners were placed in shopping areas to reach users who are comfortable making a transaction online.

 The New Color of Money. APPLY ONLINE NOW! CLICK HERE. **NationsBank**

 The New Color of Money. APPLY ONLINE NOW! CLICK HERE. **NationsBank**

 The New Color of Money. APPLY ONLINE NOW! CLICK HERE. **NationsBank**

>> This banner promotes low introductory rates for the Platinum card to attract cardholders looking to expand their financial leverage.

Creative Director.Paco Viñoly / **Director of Technical Design.**Sasha Pave
Tools Used.Adobe Photoshop / Macromedia Flash / Macromedia FlashGenerator / Macromedia Fireworks / Adobe Illustrator

Marketing Objective:

Reach the households of NationsBank's affluent target market and encourage them to use NationsBank Online Financial Services.

Creative Strategy:

Achieve consistent and prominent branding, and convey a tone of strength and power in sound money management, through the use of captivating Flash technology or sharp graphics.

Media Placement:

Geographic targeting of city guides, finance, and shopping sites to establish visibility in areas where NationsBank is highly recognized by consumers.

>>

>> Clean, crisp visuals cut through the noise for financial service offerings on the Web.

>>

 >> >> >>

>> M2K's Web site opens with an interstitial created in Flash. Its clever animations tell the story of the agency's offerings to clients.

The Idea Is To Sell Something

> The best Web advertising design is created with an understanding of the contexts — the different types of Web sites — in which it will be used.

> With business-to-business advertising, it is important that design does not compete with or, worse, obscure the copy message.

> Simplicity is always good. Design fast; communicate faster.

M2K

M2K began delivering advertising and direct marketing services to high-tech companies in 1988. Its focus from the outset has been to deliver measurable results by providing marketing services that support the entire brand-to-sale process. Today, much of its emphasis is on the Internet. It develops sophisticated Web and e-commerce sites in partnership with a Web systems integrator, and it drives traffic to these sites using a combination of online and offline advertising and direct marketing.

M2K believes that it should, first and foremost, honor the time and intelligence of the audience. "We are not great fans of 'noisy design' or executions that ask far too much of the marketplace," says creative director Chris Maher. He points out that even though Web advertising is relatively new, it is already exhibiting a maturing process.

"Despite what some may have believed, the mission isn't to impress a client—or our colleagues—with our use of this or that particular technology. We aren't resellers doing demos. We're in the business of communicating and connecting with customers." If that means that a certain new technology is necessary or appropriate, M2K will certainly use it. "With zeal," Maher adds.

M2K was among the first interactive agencies to use text link banners and blinking link (or "blinks") banners. That came from some research M2K saw that indicated Web surfers associate banners with ads (low credibility) and links with substantive information (high credibility.) "It made sense to use these kinds of banners for business-to-business buyers who tend to be information-focused," explains associate creative director Eric Sutherland. "We actually got into a little trouble with a few Web sites because our links were deliberately meant to mimic the appearance of their site's text links."

Maher says that it is difficult to avoid the clichés about the differences between Web and offline design. The Web world is all about two-way communications, dialogues, instant gratification, speed, motion, and "intense time," he points out. There also is a certain informality and irreverence associated with it. We're also on the brink of achieving mass-customized Web advertising messages on a scale that has not been possible before. "It's an exciting time," Maher says. "Especially for an agency whose roots are deep in direct marketing."

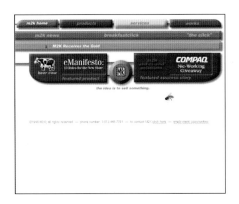

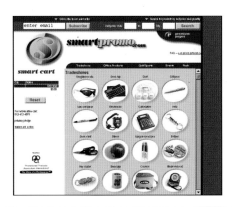

>> A bee from the last frame of the M2K interstitial leads the viewer to the home page, with its clean, graphical navigation scheme.

>> Smartpromo.com, an example of a full e-commerce solution from brand to sale, embodies M2K's trademarked "Storefront to the Forefront" concept by bringing the sales floor directly to the opening page of the site.

Address.313 South Congress, Suite 200, Austin TX 78704 / **Voice.**512 448 7791 / **Fax.** 512 448 7769 / **E-mail.**rmcewen@m2k.com /
Web Site.www.m2k.com / **Executives.**Rob McEwen.CEO, Chris Maher.Agent Provocateur

> Compaq

Compaq Deskpro EP Series PC Customers:
Follow This Link to NIC Savings.

>> A "link banner" that looks like a featured story on a news Web site is very effective in eliciting click-through.

People Finder · Shareware · Company Profiles · More...

THE RIGHT NIC FOR COMPAQ DESKPRO EP SERIES PCs GO!

COMPAQ Use Extra Search Precision within Web Sites ◄┈┈┈

>> This banner is disguised as a search box.

**To Order,
Call Now!**
1-800-544-5255

**GET A FREE
T-SHIRT**

COMPAQ

Ready to save $10 off
each Compaq Fast
Ethernet Wake on LAN
NIC with your next
Deskpro EP Series
purchase? Call your
friendly reseller or
1-800-544-5255.

Compaq Deskpro EP Series PCs &
Compaq Fast Ethernet NICs:
Get the Most from Compaq Intelligent Manageability

Built on Intel Fast Ethernet Silicon.

o Get **Intelligent Manageability** features working
 for you with our LAN-savvy Deskpro EP Series
 desktops and NICs.
o Save $10 on each Compaq 10/100 Wake on
 LAN NIC with your next purchase of
 award-winning Deskpro EP Series PCs.

Here's the deal. Order your powerful Compaq Deskpro
EP Series desktops with Compaq 10/100 Wake on LAN
NICs, and you'll save $10 on each NIC. (Let's do the
math: That's $10,000 of NIC savings with the purchase
of 1,000 Deskpro EP Series PCs.)

These aren't just any NICs. Because they're part of
Compaq's **Intelligent Manageability** solution, you get a
high-performance, safe solution with one-stop support.
And don't forget the added sweetness of being able to
use either Compaq or Intel drivers.

Intelligent Manageability: What's in It for You?

Our 10/100 Wake on LAN NIC offers these additional **Intelligent Manageability** features when
installed in a Compaq Deskpro EP Series PC:

o Network service boot for simplified setup of a new system.
o DMI 2.0 compliance for inventory control and remote system diagnostics.
o Wake on LAN technology for remote after-hours maintenance.
o And ACPI (Advanced Configuration and Power Management Interface) for reduced power
 consumption.

And the powerful Compaq Deskpro EP Series is designed to take full advantage of these capabilities.
Fact is, the combination of Compaq Deskpro EP Series PCs and Compaq 10/100 Wake on LAN NICs,
rounding out your **Intelligent Manageability** solution, just makes sense. And with $10 off each NIC,
it's a lot easier to grasp the logic. But hurry, this deal is going away as of December 31, 1998.

>> A jump page explains benefits and offers a deal.

CEO.Rob McEwen / **Creative Director.**Chris Maher / **Art Director.**Eric Sutherland / **Design.**David McKnight / **Programmer.**Tom Kiehne / **Production Design.**Jana Jacob
Tools Used.Macromedia Fireworks / Macromedia Flash / Adobe Illustrator / Adobe Photoshop / Macromedia Director

01 02 03 04 05 06 07 08 09 10 11 12 13 14

Marketing Objective:

Get Fortune 1000 Compaq DeskPro customers to order Compaq Intel-based NICs pre-installed not only because they are an obvious choice, but also because they're the *best* choice.

Creative Strategy:

An online campaign targets IT professionals who buy networking equipment; a jump page offers additional information about the product and generates leads for the sales team; a direct mail piece is sent to 50,000 IT professionals.

Media Placement:

The banner campaign ran on sites like Network Magazine, Network World Fusion, Plug-In Datamation, and InfoWorld, yielding an overall 7 percent click-through rate.

GET
Intelligent Manageability
Features Working For You
WITH
Compaq Deskpro EP Series PCs
AND
Compaq Fast Ethernet NICs.

Save $10 off each Compaq 10/100 Wake On LAN NIC—built on Intel Fast Ethernet silicon—with your Deskpro EP Series PC purchases. That's not just intelligent. That's brilliant.

COMPAQ

>> This banner is designed to complement the mailer.

>> M2K, whose roots are in direct marketing, strongly believes in integrating online and offline marketing to drive traffic to Web sites. This mailer yielded a higher-than-expected 4 percent response rate.

>> i2 Technologies' eDay

>> To establish a stronger brand, M2K's advertising has a consistent look and feel both online and in print.

>> The theme of the eDay event is "InternetTime" moving faster and faster. This ad ran in *The Wall Street Journal*.

CEO.Rob McEwen / **Creative Director.**Chris Maher / **Art Director.**Eric Sutherland / **Design.**David McKnight / **Programmer.**Tom Kiehne / **Production Design.**Jana Jacob
Tools Used.Macromedia Fireworks / Macromedia Flash / Adobe Illustrator / Adobe Photoshop / Macromedia Director

Marketing Objective:
To brand i2 Technologies' eDay concept—"the day that eBusiness finally comes of age"—with an integrated campaign.

Creative Strategy:
Mindful of campaign consistency, all the executions reflect the time/speed/clocks and stopwatches themes, and the online registration page most critically reflects the creative content created for other media.

Media Placement:
Combination of online, print, and direct mail.

>> A print ad aimed at Europeans superimposes a stopwatch on a familiar icon of time.

>> The clock hands on this registration page, which recall the print ad for *The Wall Street Journal*, are animated.

Glossary

A **Access time** Amount of time it takes a CD-ROM drive (or any other device) to locate and retrieve information.

ADSL (Asymmetric Digital Subscriber Line) The next-generation Internet-access technology for speeding data over standard copper phone lines. Currently contends with cable modems and wireless delivery for broadband market dominance. See DSL.

AOL Common truncation of American Online, and Internet service provider that offers its own content as well.

Applet Computer programs that download and immediately execute on individual computers.

ATM (Adobe Type Manager) A font rasterizer for PostScript Type 1 fonts, it converts an outline font into bitmap characters for use on printers and computer monitors.

B **Bandwidth** Data transmission capacity, in bits, of a computer or cable system; the amount of information that can flow through a given point at any given time.

Baud rate Speed of a modem in bits per second, normally expressed in kilobits per second (kbps).

Bricks and mortar A company's physical planet, usually a retail outlet.

Browser A program that allows users to access information of the World Wide Web.

Buffer A holding area of the computer's memory where information can be stored by one program or device.

C **Cache** A small, fast area of memory where parts of the information in main, slower memory or disk can be copied. Information more likely to be read or changed is placed in cache, where it can be accessed more quickly.

Chat room Multiuser programs that allow groups of individuals to communicate in real time.

CSS (Cascading Style Sheets) A mechanism for allowing Web authors and viewers to attach type styles, including fonts, colors, and so on, to HTML documents.

CGI (Common Gateway Interface) Enables a Web site visitor to convey data to the host computer, either in forms, where the text is transferred, or as image maps, where mouse-click coordinates are transferred.

Client/server A program or computer that requests services from a network or server. The client provides the user interface and performs some or most of the application processing.

Color depth The amount of date used to specify a color on a RGB color screen. Color depth can be 24-bit (millions of colors), 16-bit (thousands of colors), 8-bit (256 colors), or 1-bit (black and white). The lower the number, the smaller the file size of the image and the more limited its color range.

Compression Manipulating digital data to remove unnecessary or redundant information in order to store more data with less memory.

Convergence The seamless, trouble-free integration of the computer with television and other media.

D **Database** A collection of information organized so that its contents can be easily accessed, managed, and updated. On a Web site, information from a database can be retrieved and presented in a browser by means of templates.

DPI (Dots-Per-Inch) The number of halftone dots or image pixels per inch in an image. Many computer display monitors have a resolution of 72 DPI.

DSL (Digital Subscriber Line) Low-cost, dedicated access for small users. See ADSL.

Digitize Convert information into digital form.

Download Receive information from a server computer.

E **Electronic magazine** A Web site that utilizes a magazine format in combination with interactive features. Sometimes the online counterpart of a print magazine.

E-zine A small, self-published magazine distributed electronically through the Internet or on floppy disk.

F **FTP (File Transfer Protocol)** The high-level Internet standard protocol for transferring files from one computer to another.

Filters Controversial software that screens out Web sites containing questionable material. Also refers to programs that ingest data, transform it, and then spit it out again. Many e-mail programs utilize filters to allow you to sort your mail by date, name, or subject.

Font Implementation of a typeface design for use on a computer, usually including a set of outline-format characters that are infinitely scaleable.

Frames Horizontal or vertical division of Web pages, supported by newer browsers, which operate independently to improve or simplify site navigation.

G **GIF (Graphics Interchange Format)** A file format for images developed for CompuServe. A universal format, it is readable by both Macintosh and Windows computers.

GIF89a animation GIF format that offers the ability to create an animated image that can be played after transmitting to a viewer.

GUI (Graphic User Interface) All the visual elements of an interactive Web display.

H **Hits** The number of visits to a Web page.

Home page The Web document displayed when viewers first access a site.

HTML (HyperText Markup Language) The coding language used to make hypertext documents for use on the World Wide Web.

I **IE** Common truncation of Microsoft's Internet Explorer Web browser.

Image map A graphic image defined so that users can click on different areas of an image and link to different destinations.

Interactive Refers to a system over which users have some control, which responds and changes in accordance with the user's actions.

Interface The connection between two things that enables them to work together.

Internet A global computer linked by telecommunications protocols. Originally a government network, it now comprises millions of commercial and private users.

IP (Internet Protocol) The standard protocol that defines a unit of information passed across the Internet and provides the basis for connectionless, best-effort delivery service.

ISP (Internet Service Provider) A company that enables users to access the Internet via local dial-up telephone numbers.

J **JavaScript** An interpreted programming or scripting language from Netscape.

JPEG (Joint Photographic Experts Group) An image-compression format that substantially reduces the size of image files with slightly reduced image quality.

L **LAN (Local Area Network)** Any physical network technology operating at high speed over a short distance.

Launch Public posting of a Web site.

M **Megabyte (MB)** Approximately a million bytes.

MIME (Multipurpose Internet Mail Extension) High-level protocol that complements older mail infrastructures. MIME defines how to send messages containing formatted text, international character sets, attachments, and multimedia content.

Multimedia The fusion of audio, video, graphics, and text in an interactive system.

N **Newsgroups** Special-interest electronic bulletin boards accessed on a subscription basis as part of a news database, such as USENET.

O **Open source** Linux and other codes that provide robust, complex software applications developed by a volunteer force and freely distributed to all.

OpenType Embedded fonts in Web documents that are downloaded to a user's hard drive.

P **PDF (Portable Document Format)** The file format used by Adobe Acrobat that enables documents with complex text and graphics to be viewed and printed on various computer platforms and system with all information embedded in the file.

Plug-ins Programs that can easily be installed and used as part of Web browsers.

Portal Any stopping-off point on the Internet that helps users navigate the online world. Recently, many major search engines have morphed into portals, offering stocks, sports, and the link in predigested formats.

Pop-up A graphical user interface element—usually a small window—that appears in response to a mouse or cursor click or rollover.

Post Any message submitted to a newsgroup. See newsgroup.

Q **Quicktime** Multimedia format for displaying sound, text, animation, and video in a single file.

R **Resolution** Measurement of image sharpness and clarity on a monitor.

RGB (Red, Green, Blue) A type of display format used with computers. All colors displayed on a computer monitor are made up of red, green, and blue pixels.

Rich media Multimedia solutions that allow advertisers to implement e-commerce and lead generation and branding campaigns directly within their online banner ads.

Rollover The act of rolling the cursor over a given element on the screen, resulting in another element being displayed or a new action beginning.

S **Scrollbar** Screen feature that provides a means of reaching parts of Web page that are not already in the window.

Search engine A service that keeps track of millions of Web pages and allows users to search through them by keyword to find topics they are interested in.

Server A computer on a network that is accessed by multiple users.

Shockwave The Macromedia add-on that allows user to create or access compressed Web animations on the Web.

Shovelware Content repurposed (shoveled) unchanged from one media to the next—i.e. from a print magazine to a Web site.

Splash page An opening page used to present general information for the viewer, such as plug-ins or browser requirements.

Streaming media Technology accessed by downloadable plug-ins that allows you to view animations and listen to sound online for short periods of time.

Style sheets Allows documents in an XML format to be easily converted into HTML. See cascading style sheets.

T **TCP (Transmission Control Protocol)** The Internet transport level protocol that provides reliable, full-duplex stream service upon which many application protocols rely.

Throughput The rate a data transmission at a given point, related to bandwidth.

Transparent GIF A GIF image with a color that has been made to disappear into or blend into the background of a Web page.

TrueDoc Technology that allows embedding of compact outline fonts in a Web page, based on a document's original fonts.

Typeface Design of a collection of characters (or glyphs) united by a recognizable design theme.

Typeface family A collection of typefaces whose design includes common design elements such that the various styles relate in a harmonious way.

U **URL (Universal Resource Locator)** Standard method of identifying users or machines on the Internet. May be either alphanumeric or numeric.

V **VRML (Virtual Reality Markup Language)** The coding language used to create simulated 3D environments online.

W **Web site** A collection of HTML pages anyone with an Internet connection may view with browser software.

WWW (World Wide Web) Graphical Internet interface capable of supporting graphics, text, sound, animation, and movies, as well as hypertext linking from site to site.

X **XML (Extensible Markup Language)** Language that allows documents to be coded to identify any portion of a document, such as a quote from a specific person. With this coding, search engines can give users a more refined search, finding only those documents for example where the specified person is quoted.

Z **'zine** A small, self-published magazine often photocopied and distributed through the mail or local resources.

Directory

Artistica
1713 8th Street
New Orleans, LA 70117
504.891.4311
www.artistica.org

@tlas Magazine
Olivier Laude
Atlas Web Design
11 Carl Street
San Francisco, CA 94117
415.753.2662
www.atlasmagazine.com

BBK
5242 Plainfield NE
Grand Rapids, MI 49525
616.447.1460
info@bbkstudio.com

Beyond Interactive
5075 Venture Drive, Suite B
Ann Arbor, MI 48108
734.747.8619
www.gobeyond.com

bluefly.com
42 W. 39th Street, 9th Floor
New York, NY 10018
212.944.8000
www.bluefly.com

Brand Internet/Satama
Interactive
Birger Jarisgatan 18D
114 85 Stockholm
Sweden
+46 8 506 124 39
www.braninternet.com

Buttfaces Digital Type Foundry
3939 Rosemeade Parkway,
#6205
Dallas, TX 75287
www.buttfaces.com

The Chankstore
P.O. Box 580736
Minneapolis, MN 55458
612.782.1958
www.chank.com

chipshot.com
1452 Kifer Road
Sunnyvale, CA 94086
408.746.0600
www.chipshot.com

Citibank Hong Kong
Central One Exchange Square,
Unit 1501
15/F, Hong Kong
852 2526 5668
www.citibank.com.hk

Deepend
44-46 Scrutton Street
London EC2A 4QL
United Kingdom
+44 20 7247 2999
design@deepend.co.uk

dincType
P.O. Box 87
Lodi, NJ 07644
973.472.8765
www.girlswhowearglasses.com

Discover Card
P.O. Box 29019
Phoenix, AZ 85038-9019

DreamWorks Records
100 Universal Plaza
Bungalow 477
University City, CA 91608

EdFinder.com
337 Summer Street
Boston, MA 02210
800.252.7910
www.EdFinder.com

Emigre
4475 D Street
Sacramento, CA 95819
916.451.4344
www.emigre.com

Entertainment Weekly
1675 Broadway
New York, NY 10019
212.522.5600
www.pathfinder.com/ew/

Fast Company
77 North Washington Street,
3rd Floor
Boston, MA 02114
617.973.0300
www.fastcompany.com

Fontboy
183 The Alemedo
San Anselmo, CA 94960
415.721.7921
www.fontboy.com

Fonthead Design
20942 Estaden Lane
Boca Raton, FL 33433-1769
561.470.6187
www.fonthead.com

Fontshop Austria/U.R.L.
Seidengasse 26
Vienna A-1120
Austria
+43 1 526 5354
www.fontshop.at

Fork Unstable Media
Juliussstrase 25
22769 Hamburg
Germany
+49 40 432 948 0
info@fork.de

Herman Miller
855 East Main Avenue
P.O. Box 302
Zeeland, MI 49464-0302

International Typeface Corp.
228 East 45th Street, 12th Floor
New York, NY 10017
212.880.5450
www.itcfonts.com

i-traffic
375 West Broadway
New York, NY 10012
212.219.0050
www.i-traffic.com

iXL
363 W. Erie
Chicago, IL 60610
312.274.5600
info@ixl.com

King Cobra
National Geographic Society
P.O. Box 63002
Tampa, FL 33663-3002

La Spirale
Laurent Courau
13-15
rue de Lappe
75011 Paris
France
33 53 36 72 85
www.laspirale.org

Left Field
945 Front Street
San Francisco, CA 94111
415.733.0700
www.leftfield.net

LiveArea
75 Maiden Lane
New York, NY 10038
212.402.7868
info@livearea.com

Lot21 Interactive Advertising
548 Fourth Street
San Francisco, CA 94103
415.227.2121
www.lot21.com

Lufthansa Systems Network
Am Weiher 24
65451 Kelsterbach
Germany

M2K
313 South Congress, Suite 200
Austin, TX 78704
512.448.7791
www.m2k.com

Metropolis
Bellrophon Publishers
61 West 23rd Street
New York, NY 10010
212.627.9977
www.metropolismag.com

NextCard, Inc.
595 Market Street, Suite 1800
San Francisco, CA 94105
415.836.9700
www.nextcard.com

Nofrontiere
Zinckgasse 20-22
1150 Vienna
Austria
+43 1-98 55 750
info@nofrontiere.com

Nordstrom, Inc.
1617 Sixth Avenue
Seattle, WA 98101-1742
888.282.6060
www.nordstrom.com

OXO International
75 Ninth Avenue, 5th Floor
New York, NY 10011

Pictor
Lymehouse Studios
30-31 Lyme Street
London NW1 0EE
United Kingdom

Salon
22 4th Street, 16th Floor
San Francisco, CA 94103
415.645.9200
www.salon.com

Second Story
239 NW 13th Avenue, Suite 214
Portland, OR 97209
503.827.7155
info@secondstory.com

Swarovski
A-6112 Wattens
Kristallweltenstraße 1
Austria

T-26 Fonts/Segura
1110 N. Milwaukee
Chicago, IL 60622
773.862.5667
www.t26font.com

Time.com
1271 Avenue of the Americas
New York, NY 10020
212.522.4636
www.time.com

Time Out
251 Tottenham Court Road
London W1P 0AB
United Kingdom
+44 171 813 3000
www.timeout.com

Venice Dream Team
A Division of Eastman Kodak
Company
360 West 31st Street
New York, NY 10001

The Wall Street Journal
Interactive Edition
Dow Jones & Company
200 Liberty Street
New York, NY 10281
212.416.2900
www.wsj.com

WingspanBank.com
201 North Walnut Street
Wilmington, DE 19801
302.282.7313
www.WingspanBank.com

About the Authors

Ken Coupland writes about art, architecture, photography, and graphic design for an international roster of publications, with a focus on the digital revolution. A contributing editor for and regular contributor to *Graphis* magazine and *Graphis* Books, he has also written for *Adweek, Critique, Elle Décor, Eye, Forbes, HOW, ID, Print, Sunset,* and *Wired.* He has written and designed various Web-based works of fiction, wrote and edited *Graphic Web Design Now 1,* and has curated several exhibitions devoted to digital art and design.

Daniel Donnelly is the owner and creative director of Interactivist Designs, a multimedia design studio and new media consulting firm located in northern California. Donnelly is the author and designer of *In Your Face: The Best of Interactive Interface Design; WWW Design: Web Pages from Around the World; Cutting Edge Web Design: The Next Generation;* and *Upload: Taking Print to the Web.*

Katherine Tasheff Carlton is a freelance writer, consultant, and media content manager. Since 1995 she has worked with a wide variety of clients in entertainment, finance, and technology industries. She was the director of Internet services for TradeMedia.net, a division of Phillips Electronics, N.V. In this position, she managed the launch of more than fifteen Web sites and supervised the long-term development of electronic commerce projects, both on CD-ROM and the Internet. She lives in Rockport, Massachusetts.

Martha Gill is a freelance graphic designer, spokesperson, and entrepreneur. She is the author and designer of the *Modern Lifestyle Guides*, a book series created for people with more style than time. Martha has received national recognition through features in the *Chicago Tribune*, *New York Daily Times*, *LA Times*, *InStyle*, and on E's Style Network. When not scanning a 'zine, she enjoys spending time with her husband and two children in Atlanta, Georgia.

Thom Forbes is a journalist, speaker, and consultant, who has been involved with interactivity and advertising for fifteen years. He was editorial director of *Adweek*, *Marketing Computers* (now *MC*), and *Winners* in the 1980s. For the past twenty years, he has freelanced for business and consumer magazines. He is editor of the American Association of Advertising Agencies' interactivity newsletter *BackChannel*, contributing editor of *Agency* magazine, chair of Thunder Lizard's Web Advertising conferences, and co-author of *What Were They Thinking?* a book about new product marketing. Forbes also has developed several editorial products for the Web.